To Sharon:
Your wonderful work
nurture so many
young spirits.
I celebrate you.

John Yeh
cwc

Awakening Creativity
Dandelion School Blossoms

Lily Yeh

NEW VILLAGE PRESS
Oakland, California

Published by New Village Press, P.O. Box 3049, Oakland, CA 94609
(510) 420-1361, bookorders@newvillagepress.net, www.newvillagepress.net

New Village Press is a public-benefit, not-for-profit publishing venture of
Architects/Designers/Planners for Social Responsibility.

"Aesthete in Harlem" from *The Collected Poems of Langston Hughes* by Langston Hughes, edited
by Arnold Rampersad with David Roessel, Associate Editor, copyright © 1994 by the Estate of Langston
Hughes. Used by permission of Alfred A. Knopf, a division of Random House, Inc.

Grateful acknowledgment is made to The Nathan Cummings Foundation,
a funder of this publication.

Printed in China. In support of the Greenpress Initiative, New Village Press is committed
to the preservation of endangered forests globally and advancing best practices within the
book and paper industries. The printing papers used for the text in this book are
acid-free and certified by the Forest Stewardship Council. The binding is library quality.

Interior and cover design by Laurie Churchman with Lynne Elizabeth
All photographs by Lily Yeh unless otherwise indicated

ISBN-13 978-0-9815593-7-7
Publication Date: June 2011

Library of Congress Cataloging-in-Publication Data
Yeh, Lily. Awakening creativity : Dandelion School blossoms / Lily Yeh.
p. cm. Summary: "Awakening Creativity describes the participatory process of artistic expression
guided by Lily Yeh at The Dandelion School, a nonprofit organization in Beijing that serves the children
of poor migrant workers. Yeh worked with hundreds of students, teachers, and volunteers to transform
the school's main campus with mural painting, mosaics, and environmental sculpture"--Provided by publisher.
ISBN 978-0-9815593-7-7 (alk. paper)
1. Art–Study and teaching–China–Beijing. 2. Pu gong ying zhong xue (Beijing, China)
3. Children of migrant laborers–Education–China–Beijing. I. Title.
N365.C6Y44 2011 372.50951'156--dc22 2010048312

*This book is lovingly dedicated to
my mother Helen Hu Zhan Wang.
Her strength, dedication, and love
nurtured me throughout my life;
her confidence in me gave me the courage
to walk my own path.*

She is my tree of life.

Table of Contents

FOREWORD

Many people choose careers in art seduced by the notion that art is all about self-expression and that an artist's success depends on becoming a cultural icon. An artist tries to discover a style or a niche that separates herself from other artists and promotes her career and commercial success. This is not necessarily a bad model for an artist, but it can lead to elitism, gimmickry, and an acceptance of art being primarily valued for its ability to generate money and fame—like so much else in our culture. It's a model that pits artist against artist in a hierarchy of value. And then patrons buy art for investment—as though they can own the value of an art work and have it appreciate for them.

One word we never hear used to measure art's value is accountability. What does it do for the welfare of the community? Not, did it achieve some standard of aesthetics, but did it promote social, economic, and environmental justice and equality? I suspect that many people in the art world would find a social accountability standard for art irrelevant if not objectionable. It's assumed that art should be, not do. And standards of excellence have largely disappeared anyway. Art is what anyone says it is.

Lily Yeh has rejected the model of artist vying with artist for gallery space and recognition. Instead she uses her talents to elicit art from distressed, depressed, and broken people in order to re-build community. Her art is for communal self-esteem and hope, for affirmation of the spirit rather than for commodity. It's art born from a democratic and grassroots aesthetic and consciousness, the place where all real healing and change must begin. Accountable art.

Lily's art is about investment, but not the kind that has the wealthy buying art as though it were shares of AT&T or oil futures. Lily's art invests in community. The community does not embrace and buy her art; her art asks that they accept and embrace themselves.

A few years ago, I painted Lily's portrait as part of my on-going series, *Americans Who Tell the Truth*. If our truths as a nation are justice for all, equality, and fairness, then Lily's work, I thought, certainly advances those truths. Her work erases cynicism while it restores hope that those ideals are still attainable for everyone. She does not see these truths, however, as exclusively American values and ideals, but as human rights for all people everywhere.

After I had done the portrait, Lily asked me if I would travel to Rwanda with a small group of Barefoot Artists to continue the work she had begun in a village of survivors of the 1994 genocide. I agreed, but with considerable trepidation. I had read the accounts of the genocide. Rwanda seemed a frightening place. And I had also read about how poor this village was. After the genocide the new government built a few villages to provide a safe place for the victims. But cement floors had not been poured, water and electricity was never hooked up, septic tanks never completed. No jobs provided. The bureaucratic agencies tasked with this job had disintegrated into half-measures as the funding dried up. Extreme poverty was compounding the trauma of genocide and reinforcing it with the trauma of neglect.

After our group arrived in Kigali, we were driven several arduous hours in the back of a jeep to Rugerero and the survivors' village. I'm no longer sure what I expected when we arrived, but certainly not what happened. The back doors of the jeep were thrown open and there was a throng of joyous children calling for Lily. "Turabi Shimiya!" they shouted. "Turabi Shimiya!" "Happy to see you! Happy to see you!" On and on—ecstatic! Lily, not much bigger than the children, descended into their midst and shouted the same back at them. They all began running, shouting, around the village, on the hard dirt between the unfinished houses that had recently been painted with murals designed by these same children under Lily's direction. Bird and beast and decorative motif murals transformed the depressing gray mud brick. Then came the warm embraces of the adults, bending close and inadvertently exposing machete scars on necks and arms and legs. Then came the welcome party of singing and dancing. As friends of Lily's, we were all their best friends now. What had happened in this land of grotesque violence to provoke such joy?

What I was experiencing was the same thing I had read about in the Village of Arts and Humanities in Philadelphia, in the Korogocho dump outside Nairobi where 100,000 people live, and in other far-flung and desperate places. Lily's magic. Accountable art. Healing art. No snake oil, no secret elixirs. It's an art that fans the dim embers of spirit in diminished humanity. It's one thing to decry injustice, to expose trauma, to write a report that tells a true history. It's another to witness a small Chinese-American woman,

with an iron will, a bag of paint brushes, profound compassion, and unshakable belief that damaged people can heal themselves with their own art, come into a terribly depressed situation and begin to fix it—beginning with the irrepressible spirit of orphaned children. The children, in a sense, give re-birth to the adults, to adult hope and adult responsibility. After the art comes co-operative work, the will to heal, the will to start over.

This book you are about to read, *Awakening Creativity*, is about yet another of Lily's projects—the Dandelion School for the children of migrant workers outside of Beijing.

The results are the same—the transformation of a school that once mirrored its industrial setting and the trauma of its children. Its dreary concrete was a metaphor for the social disregard of the children's lives. Enter Lily! Here is her story of the five years she worked with the teachers and children to make the Dandelion School into a school like no other in the world. What's so special about this book is that Lily for the first time explains her own process. Each situation is different, but the process is replicable. And it should be, everywhere.

William Sloane Coffin said, "The highest form of spirituality is justice." Lily's art is in the pursuit of justice, and it raises everyone's spirit. Her art insists on accountability—the artist to the community and then the community to itself.

Robert Shetterly
Brooksville, Maine
November 2010
www.americanswhotellthetruth.org

PREFACE

Many things in life happen by chance.

A chance meeting in 2003 brought me together with Zheng Hong. Zheng Hong, who holds a PhD in Paleontology, had just earned her Master's Degree in Public Administration from the Kennedy School of Government at Harvard University. Moved by the dire situation faced by migrant workers in her beloved city of Beijing, she recruited help from her friends and numerous volunteers to create the Dandelion School for children of migrant workers. Although several elementary schools for these children already existed, there was no middle school for them in the city, and therefore no opportunity to continue their education after graduating from elementary school.

I have always been interested in working with children. This interest I shared with Zheng Hong sparked our desire to work together. Our joint effort led to the Dandelion School Transformation Project.

When we first met, I was preparing to leave the Village of Arts and Humanities, a nonprofit arts organization in inner-city North Philadelphia that I cofounded in 1989. I spent eighteen years there, working to transform a broken neighborhood into a vital, joyful community. In connection with the Village, I collaborated with hundreds of teachers and students, from primary to high school, in several public schools, sometimes on short-term projects and other times on ongoing programs. Together we created banners, murals, gardens, mosaics, dances, stories, poems, and even a full costumed theater performance.

One thing I had always wanted to do, but never had the opportunity, was to transform a whole school environment into a stimulating place for learning, filled with colors and inspiring images. Many of the public schools in Philadelphia have thick, stern-looking brick walls and windows protected by metal wires. The ground surface of the schoolyards is often paved with gray cement for parking and easy maintenance and encircled with a cyclone fence. Entering a school there often feels like entering a place of confinement. It does not inspire learning. The Dandelion School offered me a rare opportunity to realize my dream to create a total learning environment with the engagement of the whole school community.

It is easy to measure the impact of the physical transformation of an environment: we only have to compare the before and after pictures of the place. However, when community members participate in transforming their environment, the process often triggers other kinds of transformation, affecting the minds and hearts of individuals and the whole community. These changes, and especially their long-term effect, are much harder to assess or measure. My intention in writing this book is to share my experience and offer my methodology to people who are interested in doing similar kinds of work. I hope the reflections, comments, and stories that I have included will help readers detect the important, though often subtle, changes taking place in this school community, particularly among the students. My hope is that what those students have learned through their participation in the project will give them confidence in their own creative power and inspire them to dream and take action to shape their own future.

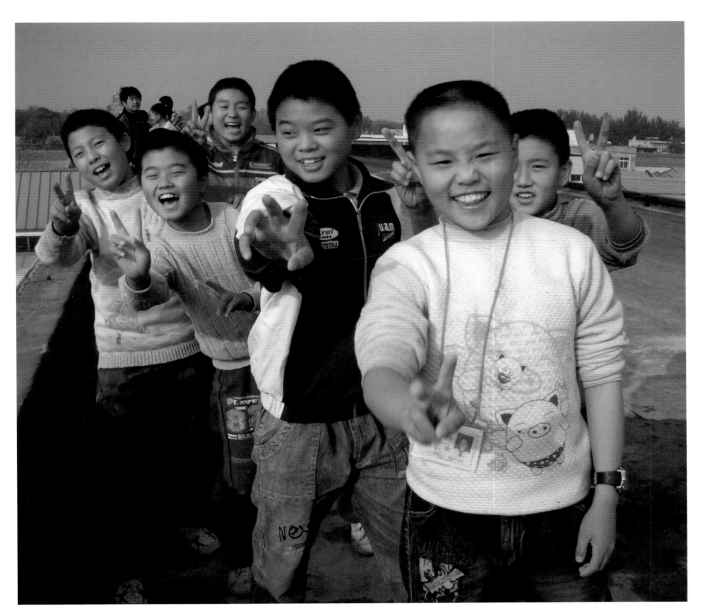

On the rooftop, Dandelion students expressing enthusiasm in helping the project.

9

1 My Development as an Artist

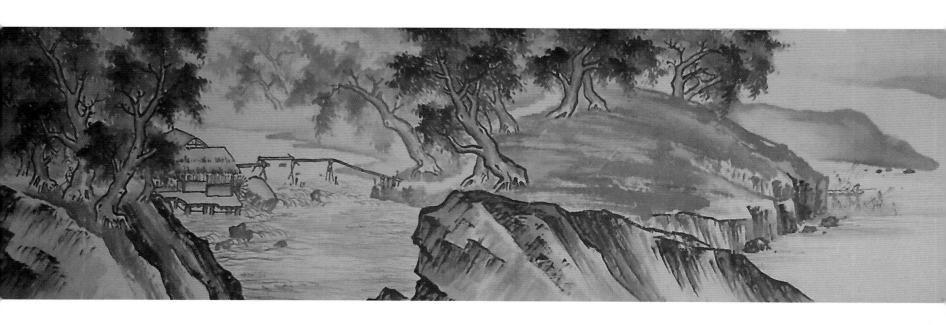

Above My painting in 1962, after Master Xia Gui of the Southern Sung Dynasty of the twelfth century.
Page 10 Drawings by Duan Xiao Lin based on my design.

I have been drawn to visual images since I was a child. I remember staring at the weeds along the riverbanks in the foreground of an extraordinary large and tall landscape painting of the eleventh century AD, *Inquiring about Tao in the Autumn Mountains* (秋山问道图) by the Northern Song Dynasty painter Ju Ran (巨然). I could feel the breeze and was carried away into the mist beyond the horizons. I also remember an unusual experience I had when I was in eighth grade, during a self-study period. I began sketching mountains and rivers in a small circular space. The vast landscape, with its tiny village at a foothill, was bathed in moonlight and utter stillness. Time stopped, and the outside world disappeared. Only when I came out of this enchanted state, did I hear my classmates talking.

I was born in China and grew up in Taiwan. I had dedicated parents, always supportive and encouraging. When I was fifteen, they set me up to study traditional Chinese landscape painting. It became the love of my life. It shaped my artistic sensitivity and anchored my later development as an artist. Still, my training as a traditional painter was not without perils. I learned painting through copying, first the works of my teachers, and then those of ancient masters. I loved the tradition and was content to be confined within its boundaries. I was like a woman of a bygone era, with my feet bound by the custom of the tradition and my mind subdued by the accomplishments of the past. My awakening came about unwillingly, abruptly, and painfully.

Upon my graduation from the National Taiwan University in 1963, I came to the United States to study painting at the Graduate School of Fine Arts at the University of Pennsylvania. During the sixties, the art scene in America was wild, experimental, explosive, and cutting-edge. I felt transported from the wispy and idyllic art world of the past into the volatile and powerful new reality of the twentieth century. I knew that if I wanted to become current, I had to make a drastic change.

My artistic taste was mostly shaped by the Chinese tradition of monochromatic landscape painting. This practice emphasizes the beauty and strength of brushworks and the evocative visual power

13

of the images. When I was at Penn, I adopted a new way of making art. Instead of painting on silk or rice paper with delicate strokes of pointed brushes, I splashed thick colors with flat, brisk-haired brushes, and at times with sponges on large canvases. Also, inspired by Paul Klee's magic squares, I created several series of paintings composed of nothing but squares in various shapes and colors. My painting teachers in Taiwan lamented, "She used to paint so well. Now she paints bathroom tiles. What a shame!"

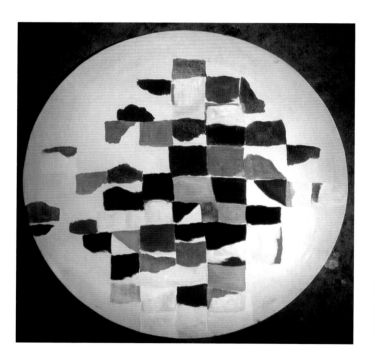

Above Magic squares inspired by Paul Klee.
Right "Philodendron," ink on rice paper, 1969.

Coming in contact with modern art in America shook to the core my understanding of art, its purpose, value, and relationship to society.

Soon after I graduated from Penn, I faced another crisis in my work. I could no longer continue to paint with splashed colors or repetitive squares. The novelty had worn off. I had to return to my roots. I picked up ink and watercolors again and painted on rice paper. I wanted to paint from nature. Living in the city, I chose vegetables and flowers as my subjects. Work went well for three or four years, and then my effort seemed to lead me to a dead end again. Out of desperation, I cut up my paintings and hung the pieces from the ceiling. I liked the floating flowers and shapes. That was the beginning of my installation work.

It was at this time that I felt a strong urge to go home—not the physical home of my parents and siblings, but the spiritual home of ease and enchantment revealed to me through my study of Chinese landscape paintings. This is a place of pristine beauty, tranquil and eternal. It is a place of this world, of trees, rivers, mountains, and mist. And yet through them, a place of wonder and mystery is revealed, a place potent in stillness and tranquility.

The Chinese call this the "dustless world."

Here the word "dust" does not refer to anything physical. It points to the mental pollution of desire, longing, attachment, and greed, all emotions emanating from the ego.

The question was how to find my way "home."

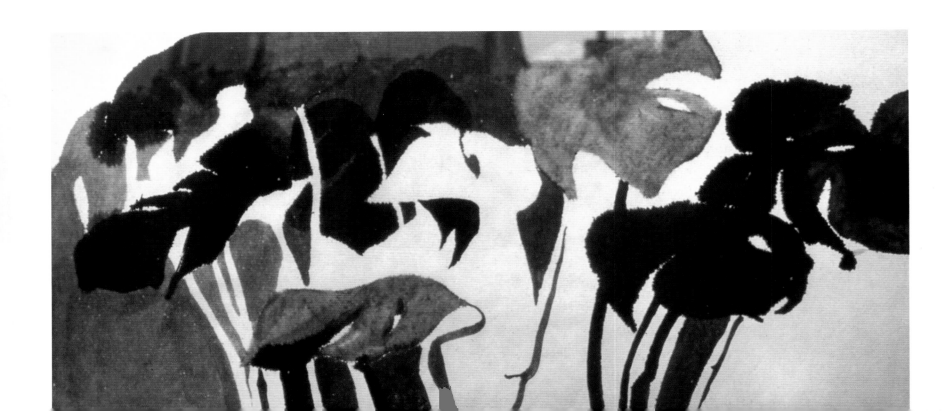

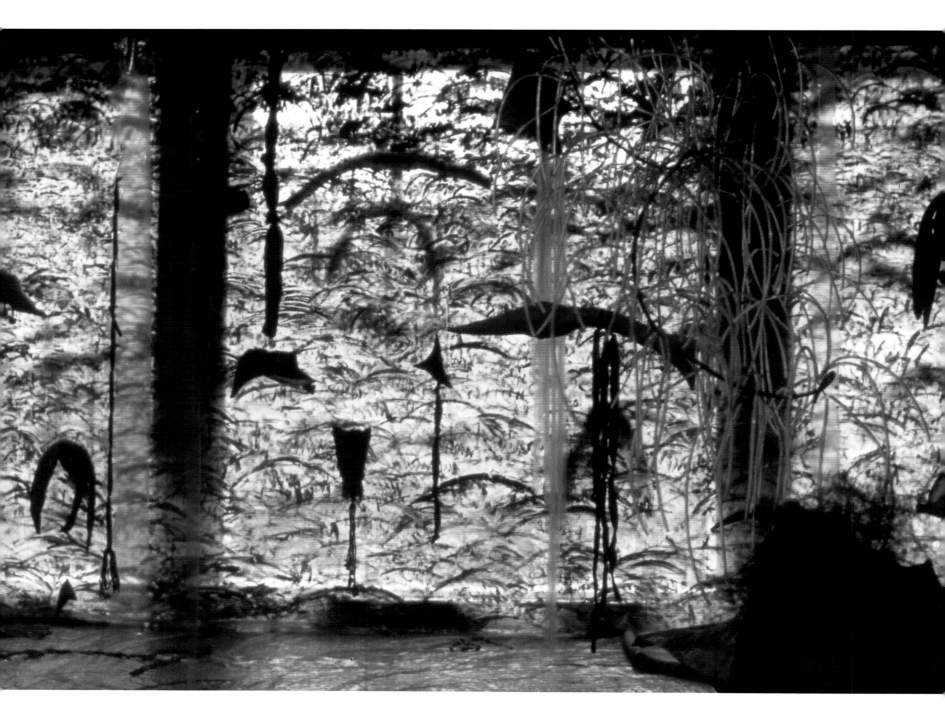

I found myself creating installations of indoor Eden-like gardens such as Amidha Buddha's Western Paradise and the Garden of Easter. I was searching for meaning. I wanted to go deep into things. Nothing is as vast or deep as the ocean, so I started to create ocean-like environments, turning plastic sheets into billowing waves and recycling waste materials into deep-sea-dwelling creatures. I feared I was a bit schizophrenic in my creating two totally different kinds of indoor environments at the same time. Looking back, I did not need to worry. In time, my different experimentations all merged into one.

During the late 1960s and 1970s, I took frequent trips to Europe. I was totally taken by the rich history and beauty of old Europe. I felt that Europe would help me understand America, since mainstream American culture seemed to develop out of the various European traditions. At that time, I was ignorant of the profound contributions made by African Americans to the building of America.

I had longed to visit China for years. I wanted to know the land where I was born. For a long time, the political situation made it impossible. In 1976, the turbulence of the Gang of Four formally ended. Under the leadership of Deng Xiao Ping, China began to open its doors to the world. In 1980 my mother, Wang Hu Zhan, my son Daniel, and I joined a tour to visit China. The country seemed behind the times, and people were immensely curious about anything coming from the outside world. Because China had been a closed society for decades, visitors were treated as though they were coming from the moon.

During subsequent years, I returned several times to do research, give lectures, present exhibitions, and set up exchange programs. One of the most memorable visits was with Professor X. R. Yong (杨先让, also known as Yang Xianrang) and his group during a trip I took in the late 1980s to research Chinese folk art.

It was my good fortune to meet Professor Yong. He is a multi-talented Renaissance man who has mastered skills in oil painting, Chinese ink painting, watercolor, printmaking, and calligraphy. He

"The Garden of Easter" installation created around Easter in 1984 at Marian Locks Gallery East in Philadelphia.

Opposite "The Sea," installation at Marian Locks Gallery in Center City Philadelphia, 1984.

is the author of several books on art, life experiences, and social issues. His astounding three-volume journal, *Fourteen Trips to the Yellow River Region,* set the standard in Chinese folk art research. His woodcut prints of the last four decades powerfully reflect the momentous changes taking place in the development of the People's Republic of China. When I met him, he was the founder and director of the Folk Art Department at the Central Academy of Fine Arts in Beijing.

Supported and supervised directly by the Beijing government, the Central Academy is the finest art college in the country. It symbolizes sophistication, accomplishment, and prestige. Thus, I was intrigued by the elite Academy's willingness to host a department devoted solely to the research and study of the arts made by common peasants, most of whom reside in the remote countryside.

In the early 1980s, I saw in Philadelphia a group of colorful paintings by peasants from the Shanghai area. The freshness, energy, and joy of the images took me by surprise. The flatness of the colors combined with an almost cubistic description of figures and spaces in some of the paintings made them look modern. They also offered amazing information. They portrayed people's everyday activities, while at the same time conveying symbols and images of early times.

For centuries, folk art in China has been looked down upon by the refined scholar-painters and academically trained artists. But in these paintings, I discovered a richness and vitality that I had not seen in mainstream art. I wanted to know Chinese folk art better.

To this end, in 1987 I joined the first folk art research trip organized by Professor X. R. Yong and sponsored by the Central Academy of Fine Arts. Our goal was to collect materials and learn from folk artists living in the Yellow River Region in the Shanxi, Shaanxi, and Henan provinces, the heartland of China. The journey made me realize the great importance of Chinese folk art to Chinese culture: it functions as the reservoir of ancient art forms, symbols, and meanings that have long disappeared from the mainstream artistic expression. I understood that it is of great urgency to preserve Chinese folk art before its myriad forms perish under the onslaught of modernism and commodification. I came to feel that this invaluable cultural tradition will help our younger generation know who they are and where they come from. In other words, folk art in its own way expresses China's soul.

Looking back on my own journey, I realize that my intense interest in Chinese folk art had to do with my desire to understand myself as a Han person, to find my cultural and ethnic roots. I have learned a great deal from my travels to the heartland of China, where China's ancient civilization developed and evolved. But strangely, my deep rooting into life did not happen until I began working in inner-city North Philadelphia.

In my effort to return "home" to that "dustless" world, I traveled far and studied religion, world culture, and art. It was in the dilapidation of North Philadelphia that I found my path of return.

Strange,
That in this nigger place,
I should meet Life face to face
When for years, I have been seeking
Life in places gentler speaking
Until I came to this near street
And found Life – stepping on my feet!

—Langston Hughes, *Aesthete in Harlem*

Above Professor X. R. Yong with a peasant artist in Mi Zhi, Shaanxi. *Below* Three peasant artists doing paper cutting together in Mi Zhi, Shaanxi.

The Ile-Ife Park in inner-city North Philadelphia before and after the transformation, 1986-1990.

I situate the beginning of my mature work in the summer of 1986, when I ventured into inner-city North Philadelphia to convert an abandoned lot into an art park. Before that, I was a studio artist and a professor teaching at the University of the Arts in Philadelphia. The experience of working with people in the poor urban community, especially children, moved me so deeply that making art in disenfranchised communities became my way of life. My space for creativity moved from an indoor studio to open public spaces; the surface for my creative activities changed from canvas to the living fabric of community life.

People called inner-city North Philadelphia "the badlands" because of its prevailing decrepitude, poverty, drug dealing, and violence. But this area contained invaluable hidden treasures. Numerous abandoned properties and vacant lots offered creative opportunities. The transformation of abandoned land into art parks and gardens became the bone structure of our art project, which evolved into the nonprofit organization named the Village of Arts and Humanities. I became its co-founder, with the intention to build community through the arts. During my sojourn there from 1986 to 2004, the Village staff, community residents, and volunteers transformed over two hundred empty lots into seventeen parks and gardens, including a two-acre tree farm. The Village became a national model for urban revitalization through land transformation, creation of beauty, and grassroots actions. It was there that I realized that art is a powerful tool for social change and that artists can be at the center of that transformation.

By 2004 the Village had become a full-fledged organization with a budget of 1.3 million dollars and over twenty full- and part-time staff members. My job had gradually shifted from being the lead artist to acting as the lead administrator, writing proposals and overseeing the smooth running of the organization. I longed for a simpler way of life where I could again be directly involved with projects at the grassroots level, doing creative rather than managerial work.

Prior to my departure from the Village, I established another nonprofit arts organization with a focus on international projects named Barefoot Artists. I was inspired by the work of China's barefoot doctors in the 1970s, who visited the poor, usually peasants living in faraway areas. They went without much pomp, practiced their art of healing, and then moved on. This felt like a good model for me. My mission was simple: bringing beauty to places in need. I designed our logo as a huge flower holding the world in its heart.

Barefoot Artists is a volunteer-based organization that requires minimum overhead and maintenance, and yet has the capacity to carry out projects with precision and effectiveness. It aims to bring the transformative power of art to the impoverished communities of the world through participatory and multifaceted projects that foster community empowerment, improve the physical environment, initiate economic development, and preserve and promote indigenous art and culture. For me, beauty and creativity are not luxuries for a few. They are essential for our well-being. Like sunlight and air, they feed our souls.

Under the auspices of the Village of Arts and Humanities and later of Barefoot Artists, I have traveled to many countries including Ecuador, Colombia, Ghana, Ivory Coast, Kenya, Italy, Republic of Georgia, Syria, Rwanda, and China, offering my methodology of healing and community building through art. I have come to realize that broken places are my creative canvases, people's stories my pigments. The art that we create together is actually alive. It is a part of life.

2
The Dandelion Community: A Mirror of a Difficult Society

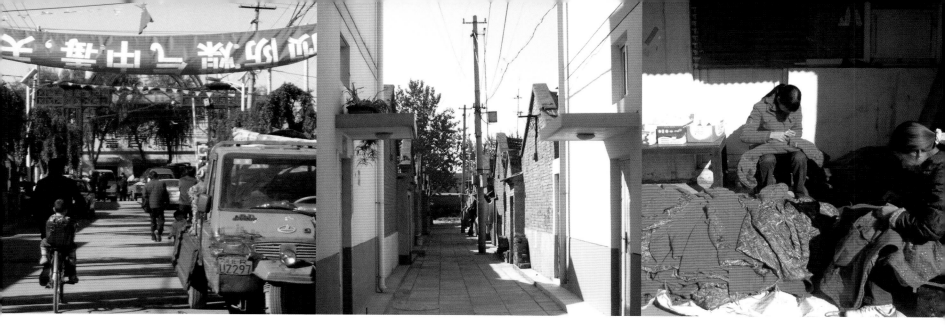

Left A secondary commercial street in Shou Bao Zhuang. *Middle* A newly developed residential area. *Right* Sewing by the street. *Below* A night scene.

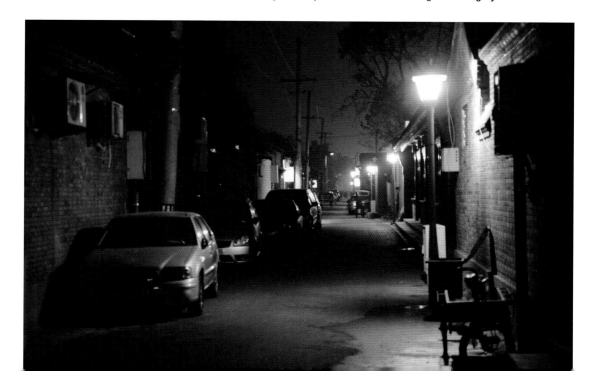

When I was in high school, I liked studying history. But I also remember the pain of studying Chinese history of the past two hundred years, filled as it was with the corruption of the court, the invasion of foreign forces, the unequal treaties, and the humiliation and suffering of common people. Now, at the beginning of the twenty-first century, China shows a very different picture: confident, powerful, and proud. Under Deng Xiao Pin's reform policy, China has force-marched its economy from poverty to prosperity, at least for a portion of its vast population. The country hosted a most impressive Olympic games in 2008, with a breath-taking opening performance, in its daring and striking new sport facilities. Also in 2008, China presented itself to the world as a new global power with the successful launch of the Shenzhou VII spaceship carrying three astronauts who would perform China's first space walk.

At the same time, China is witnessing a massive migration of over 150 million people from the countryside to cities, from under-developed to highly established economic areas, and from the central and western regions to the eastern coastal provinces. It is the biggest migration that has ever happened in human history. Traditional agricultural practices can no longer sustain villages. Families are forced apart as parents move into urban centers to find work, often leaving the old and young behind. As a portion of the population becomes richer, the other portion suffers uncertainty, alienation, and deprivation.

I wanted to witness and understand the impact of this momentous happening on the Chinese people, society, and especially the young. My opportunity came when Zheng Hong, a founder and the principal of the Dandelion Middle School, established solely for the benefit of the children of migrant workers, invited me to visit the school.

The Dandelion School is located in the Shou Bao Zhuang Village in the Daxing District, an industrial area on the outskirts of Beijing. Based on the figures provided by the police department, it has a resident population of 846 and a floating population of 11,000, mostly composed of migrant workers and their families.

Along the several main streets that feed into Tuan Ho Road, the major avenue connecting to the Beijing highway system, Shou Bao Zhuang is bustling. Situated on the opposite sides of Tuan Ho Road and facing each other diagonally stand the Dandelion School and the well-off China Performing Arts High School. Next to that school stands the entryway to Lao San Yu village.

Both Shou Bao Zhuang and Lao San Yu were farming villages with homes clustered along major roads. The homes used to be surrounded by farmland, which is now mostly appropriated for new development projects, including the construction of low and sprawling homes for migrant workers. The original residents of Shou Bao Zhuang and Lao Shan Yu no longer farm the land. They rent out rooms and lease their land to newcomers—migrants arriving from all over the country.

Shou Bao Zhuang offers many stores to support its growing population—supermarkets, restaurants, barbershops, public baths, car repairs, clothing and cosmetic boutiques, mobile phone stores, film development, and hardware stores. Residents can get almost everything they need in the neighborhood. Working in the stores is not easy. The hours are long, often eleven to twelve hours or more. Labor is cheap and competition intense.

When I first entered the area in 2006, I was struck by how gray the sky was and thick the air was with the pollution from traffic, industries, and coal-burning furnaces. The heavy smog dimmed the sunlight. Cars, buses, and trucks moved through crowded streets teeming with activities on both sides of the road. Crowds of people waited for buses, shopped, and ate in restaurants or at sidewalk stands. Crossing the street in the incessant traffic was difficult.

Some of the migrants have become urban farmers, cultivating mostly vegetables on makeshift farms with piled-up soil. They grow their vegetation either in the open fields or in large barracks covered with clear plastic sheets. They work constantly. In addition to weeding and feeding their crops with chemical fertilizers, the farmers irrigate the fields and control the temperature within the barracks. They wash their crops after harvesting and stack them up in

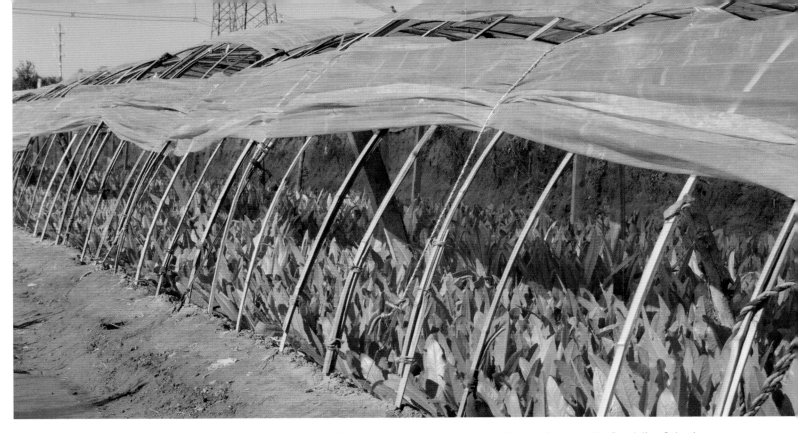

Above Vegetable growing in makeshift greenhouses, constructed of bamboo vaults covered with plastic sheeting, near the Dandelion School.
Below The dwellings of migrant urban farmers.

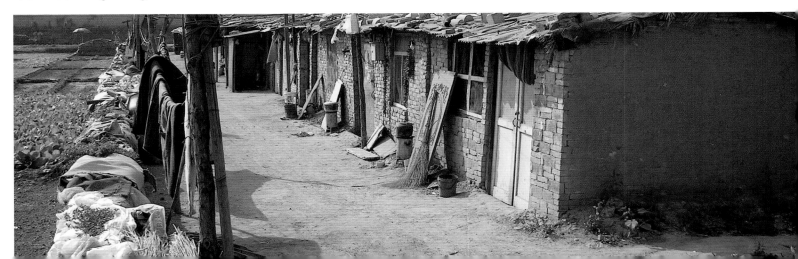

tight, well-organized bundles, discarding the ones that do not appeal to the eye. A farmer told me, "Dealers will not buy them because they don't look good." They work very long hours for a very low margin of profit. But even that is better than being without income back at home.

During my last visit in May 2009, I saw that multistory buildings had mushroomed in Shou Bao Zhuang. The frequent crackling of firecrackers indicated the intensified building activities, as workers celebrated the installation of main posts in new constructions. The crackling can start as early as 5:30 in the morning. Clearly, people are excited about the progress, but there is a dark underside to it as well.

On my first impression, the Dandelion students, with their laughter and energy, seemed happy. I imagined them blessed with a lifetime full of possibilities. After working there, however, I became aware of bleak undercurrents, the result of the unforgiving economic situation that tears families apart. During special workshop sessions, students often expressed sobering emotions through drawing and writing.

On one occasion, students were asked to draw images that told stories about themselves. One drawing showed a tattered tree with broken limbs. Placed below the image were the words, "I am like this tree, worn out by the wind and broken." In another a student imaged herself as a cluster of floating leaves and wrote, "Torn from the tree, I am like these leaves, rootless and without direction." Another image revealed a little girl kneeling on the ground. With raised hands held together and tears running down her face, she begged her parents for patience and understanding. I realized that many had already experienced much pain in their young lives.

That spring, I read a series of articles by students that deeply moved me. The writings exposed the loss and intense yearning of some of the children, left behind by their parents when they were little. Their anxiety and fear of living in today's society is in part rooted in their sadness and insecurity.

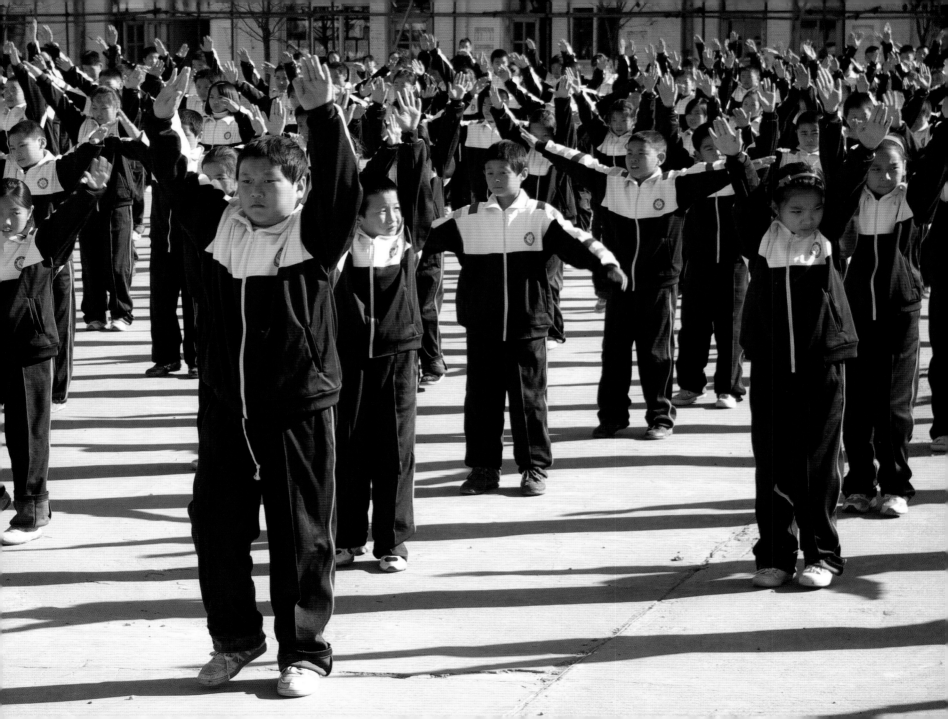

These are two of the students' stories. They are in their early teens.

LONGING, MY HEART'S JOURNEY
by Lu Ping

Under the hot sun, standing alone in the wide-open farm field, I gazed at a faraway place. There might live my most beloved mother. I imagined that maybe one day I could live together with her, even if in poverty.

To live is hard. In order to make a living, my mother took off, leaving me behind to stay with my grandmother. My grandmother's severe scolding of me at times made me realize that I was an abandoned child.

My days passed by very slowly. I would sit on a stoneroller under a big tree counting from one to ten and then repeating, one to ten. I had grown in age, but my world remained so small that it could be counted within ten numbers. But I knew then that one day I would leave this smoke-covered little village. I did not want my world to be limited by ten numbers. I did not want to be confined within this misty and smoky farming village.

I eagerly waited for that day when my mother would earn a bit more money than usual. When she would relax and recover from a day's tiresome work, she would suddenly think of me. She would remember that she left a daughter back at home in the village. How I wished that this would become real.

Finally, I was not disappointed. One day, my relative and I took the train to Beijing. I was coming to find my mother. I knew her in my mind but could not remember what she looked like. I trusted that she would love me.

Life in the city was much better than in the quiet village. Mother took good care of me. Even when she was very tired, she still smiled kindly towards me. It seemed to be in every mother's nature to look after her children.

One day I was separated from mother again. I came to a new and strange environment, which was filled with children of my age.

I cried. I did not want to be with strangers. Where were you, Mother?

What I remember about attending primary school is changing schools. Because I came from another province and was not a resident of Beijing, I was not accepted by public schools established by the government. Only private schools would receive me. It made me feel unwelcomed and distraught.

When I was ready to enter middle school, Mother chose to send me back home to attend school there. She entrusted me to a family at our home village. What an awful feeling that was! My health deteriorated. Mother fetched me back to be with her in Beijing. I thought that my future might be ruined at this point.

Now I know that I have no means to make a choice about my life. Maybe my fate will decide for me. But I don't want to concede and I must not concede. I have walked such a long path and it must not be in vain. I need to control my destiny. I will change my future.

It does not matter how vague and confusing everything is. I must insist and hold on.

The sun is sizzling hot. Alone, standing on the high bridge in a dark evening, I dream about the future.

YEARNING, MY JOURNEY
by Yu Ping Ping

I am like a little flower,
The rain has broken its tender stem.
I yearn for the sun.
I am like a little bird,
The wind has wrecked its wing.
I yearn to fly.
I am a girl who has endured
life's challenges.
I yearn for a beautiful future.

Fourteen years ago in October, I was born in Beijing. Here I lived with my parents in a little brick house which Father built with his own hands. He also established a plot of farmland on which he grew vegetables. We made a living by selling those vegetables. Every day, carrying me on her back, Mother would pick vegetables from the farm. After washing them, Father would sell them on the street. If the sale was good, Mother and I could have a nice meal. If not, we would just have the leftover vegetables for our meal. Fourteen years went by like this. When my parents heard of a school that would accept migrant children, they sent me here.

Studying at Dandelion made me feel happy every day. My fellow students are kind and teachers show deep concern about students. We often see volunteers from overseas. Sometimes famous people we saw on TV came to school to teach us English. Here I can be happy and enjoy my studies. But I also feel worried. Although at Dandelion we can participate in the entrance exam for high school, we are not allowed to attend high school in Beijing. Thinking about this problem makes us all sick with headaches. Since I was little, I dreamed of going to college and then graduate school. Confronting the problem that even attending high school here is improbable, I have to convince myself that there are more ways to gain success than studying. Even though I try to think this way, I don't feel good inside. I am not willing to submit to the limitation of this situation. I yearn to become somebody. I yearn to have a bright future.

Repeatedly I asked myself, what should I do? I feel that I am losing momentum to move forward for a lack of goals. Fortunately, I have figured it out for myself. The day passes whether I study with or without purpose. It is better to do my best to prepare for the entrance exam. I believe that opportunity will present itself.

I am like a little flower,
The rain has broken its tender stem.
But I believe that one day the sun will smile on me,
I am like a little bird,
The wind has wrecked its wing.
But I believe that one day I will fly again.
I am a girl who has endured life's challenges.
But I believe that one day I will realize my dreams.

The story of two siblings haunts me. Domestic violence and the imprisonment of their father led to the breaking up of the family. After he was released from prison, the father returned to his homeland. Staying behind in Beijing, the children lived with their mother in a tiny two-room apartment. In order to support the family, the mother had to start working in the underground economy, but that work was deeply damaging to her children. The son finally left home to live with his father. Unfortunately, the father's despair at his inability to find work led to his becoming an alcoholic. The son returned to Beijing, where his anger led to an act of violence, preventing him from returning to the Dandelion School, which he obviously cherished. People have found him lingering at the school gate. He now works as a day laborer wherever he can find a job. Life is already closing in on him.

His sister's reaction to her situation was quite different. She stared into space all day long and had very little response to her surroundings. One day she drew a portrait of herself, saying, "I am like this wooden puppet. I have no heart." She also wrote these poems.

A PUPPET DOLL

It does not matter
How you treat me
Because I am a puppet doll
A puppet doll without a soul.
I don't have life
So I won't die.
I don't have life
So I have no pain.
I don't have life
So I have no tears.
Joy, laughter, I have none
Because I am always a puppet doll.

FREEDOM

Freedom
My friend
I need you.
Although I am a puppet
I do have a soul.
Although I am a puppet
I do have a dream.
I urgently need you, my friend.
I am like a dried-up river,
Waiting for the falling rain.
Release me from the horror of that oppressive prison.
Do not curl and twist my wings, my dream.
Let me dash out of the prison
Spread my wings in the vast and spacious sky.

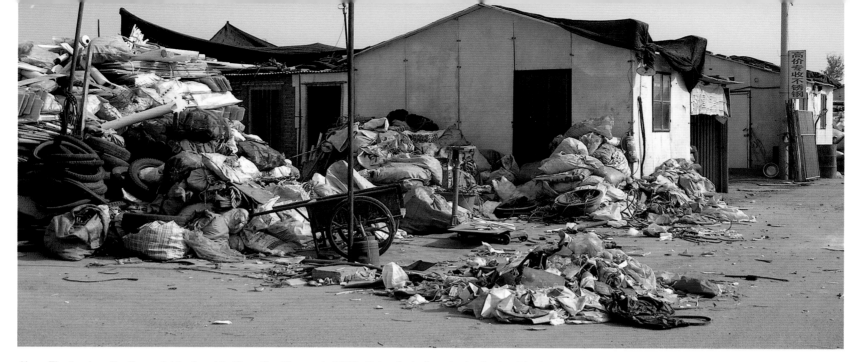

Above The trash-collecting neighborhood in Shou Bao Zhuang in 2006. *Below* A pig farm in the Daxing District.

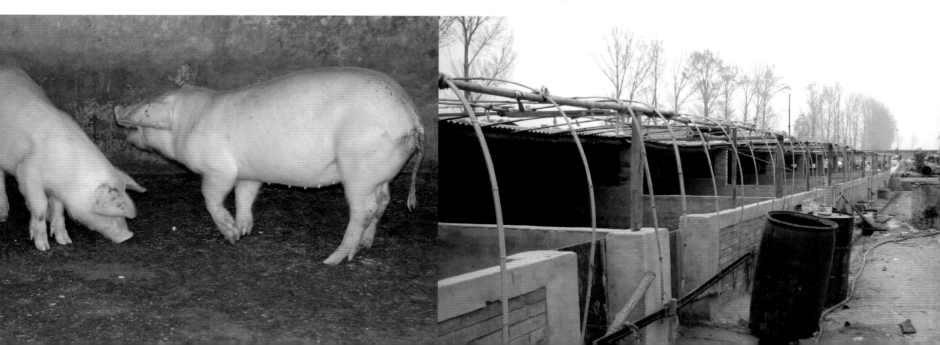

In the United States many schools host parent and teacher meetings, but not home visits. So when I heard that the Dandelion School requires its teachers to do home visits for every student in their classes, I was intrigued and impressed. I figured that if I really wanted to understand the living condition of the migrant families, I should do some home visits. Asking the school leadership for help, I was accompanied to visit a special family, whose livelihood depended on recycling trash. During my first visit to Dandelion in 2006, I was struck by a large area allotted to trash collection near the school in the county of Shou Bao Zhuang. It contained many subdivisions, each hosting and recycling a different kind of trash—glass, metal, paper, tires, old clothes, plastics, and foam materials. Families lived in the trash compounds for cheap housing and easy access to goods. Even though migrant workers in general are on their own, with no rights, no land, and no legal protection, a powerful hierarchy has firmly established itself in the trash-collecting business. Mr. Ku, the owner of Zheng Jun Hotel where I stay during my visits to Dandelion, began his career collecting trash. Due to his keen sense of business and shrewd maneuvering, he is now a millionaire owning several properties and businesses—an amazing accomplishment common among daring entrepreneurs in the new China.

But many families are not as lucky. The family I visited was composed of the parents and four children, three girls and one boy (the youngest), ranging in age from seven to seventeen. The girls had not had the opportunity to go to school until they came to Dandelion. In 2010, the middle two children were studying at Dandelion under a scholarship plus room and board.

Due to a leg injury, the father lost his ability to do any work other than trash collecting and recycling. The mother and children all help with the work. They built their modest house in the middle of the trash ground. They are allowed to collect only the cheapest materials, plastic foam boards, and nothing else. Although born into this big capital city, the little boy has grown up in this humble house with no facilities. His playground is the trash land. The smelly, polluted air is what he has breathed since infancy.

The family's most prized possession is an abandoned white puppy they found on the street. Their situation seems dim and grim, but still I found glimmers of hope. The children have decorated their home with colorful plastic flowers, which they found while rummaging. Displayed on a mud wall is the pride of the family, two rows of awards in red and gold colors, announcing the children's various academic achievements.

Another family Teacher Zhang and I visited raised pigs for a living. They lived on the edge of the Daxing District, the huge industrial area where tens and thousands of migrant groups have settled. It took the elder son at least two hours each way to get to school and home by public transportation. To save money, sometimes he walked part of the way.

Principal Zheng Hong: "My first home visit was to a pig farm. It was in July. What an intolerable situation the family had to put up with! The insufferable summer heat, the rancid smell, and thousands of flies. It helped me to understand where our students and their families were coming from. Since that experience, I ask our teachers to do home visits."

Veering off the main road on the way to the pig farm, we drove by a series of large, austere buildings. Prisons. Next we passed the dirty water and sewage treatment plant, then the animal slaughterhouse. The output from these facilities had turned the nearby stream into a dark and smelly sludge. This is where the family could afford to live.

After joining the family's relatives on this humble stretch of land, the father borrowed money to enter the pig-raising business. The family purchased 120 piglets. The plan was that after the piglets had grown to a certain size, they would be sold for a profit. But sixty piglets perished before reaching maturity. A young man in the community told us that twenty years ago it was relatively easy to have pigs reach healthy adulthood, but now the air was so polluted that the piglets easily got sick and died.

The family did its best to feed, clean, and care for the pigs so that they could stay healthy and grow big. To get the feed, the father and other pig farmers had to go to various restaurants at midnight to collect leftover meat, vegetables, rice, oil, and salty broth, often mixed with plastics and other things. They then poured the soupy slush into a huge caldron to be treated and boiled. The father was deep in debt, half of his investment having disappeared with the death of the piglets, and he had to continue borrowing money to purchase feed for the remaining pigs. "Whenever you ask him how he is doing, he laughs," Zheng Hong told me before our visit. "He has no more tears."

Among the 150 million migrant workers in China today, 18 to 20 million are school-age children. Beijing alone has 500,000 migrant youth. The sadness, hurt, anger, and despair expressed by some of the children in the Dandelion School reflect the hidden wounds of numerous migrant children. We must call attention to this social phenomenon because so many emotionally ill people cannot make a healthy society.

Although recently admitted to the Dandelion School, delicate and pale Liao Shu Li had a will of iron and had distinguished herself in her study and service. Her parents grew and sold vegetables. We decided to pay them a visit.

Migrating from the countryside of Henan, they had toiled for seven long years in the urban farms, hoping to create a better future for their two children, Shu Li and her brother. "Not only have I not made a penny, I am tens and thousands of yuan in debt," the father sighed. Shu Li's mother had been badly injured while working in a factory. They did not have money to care for her properly, and a piece of low quality metal was inserted to restore her shoulder blade temporarily. This often caused her great pain. They hoped that someday they would earn enough money to have the shoulder properly fixed. When we talked about school, Shu Li's mother broke down. "I feel so sorry that we cannot sufficiently provide for our children. Many young people have the means but they do not want to go to school. We don't have the resources, but our children excel in studying. They want to attend school so much. We had originally decided that all of us, including Shu Li, would work to support the son to get an education." But Shu Li was determined to get an education, too. She and several of her girlfriends managed to find the Dandelion School, which offered them tuition and room-and-board scholarships. Her parents thought that it was some kind of scam to trick them out of their children. The mother told me, "Although we are poor, we will manage. If we die, we want to die together."

Shu Li's story has a happy ending. In addition to being an outstanding scholarship student, she has recently won top prizes in creative writing, with good cash awards to take home. As a top student in every field she commits to, Shu Li has a bright future.

Right **Liao Shu Li and her parents.**

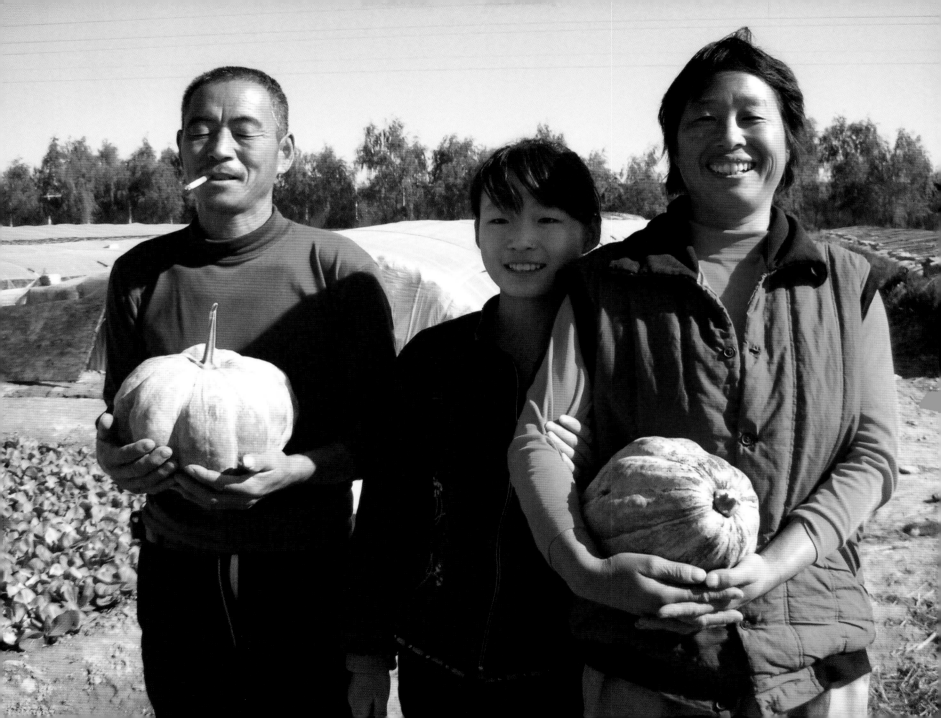

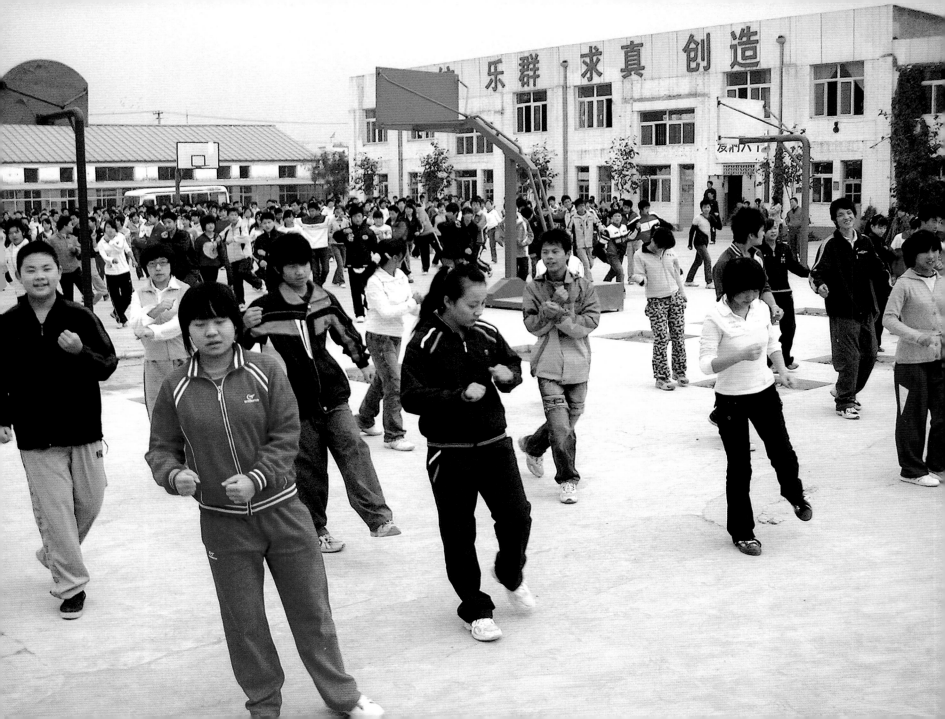

Dandelion, what an appropriate word to name a school that serves the children of migrant workers! The dandelion's seeds, feathery and light, drift with the wind to wherever they land. The tenacity of the plant helps it endure, put down roots, and live on. It is a perfect symbol of the situation tolerated by many migrant families, driven to wherever they can find jobs. Unassuming but tenacious, they endure, raise their young, and hope for a better future. They form the force that builds the enormous urban landscape in China; their labor brings the country its confidence and prosperity. Yet they live on the fringe of the cities they built and are often invisible to mainstream society.

According to Sandy Chou of World Education, a nonprofit organization based in Boston, "Home visit is a practice mandated by Dandelion School. At the beginning of every semester, homeroom teachers and subject teachers work in pairs to visit the families of all students in their class within a month. It is the most basic and practical way for teachers to get to know their students and the confusions, problems, and worries that students or their families are dealing with. I interviewed several other migrant schools in Beijing. Not every school conducts home visits. But it is obvious that after Dandelion teachers had completed home visits, students' parents showed much more trust, confidence, and appreciation of the time and energy Dandelion teachers spend on their children's learning. As a result, more than 80–90 percent of parents show up at Dandelion's parents' meeting, compared to less than 50–60 percent (sometimes only 30–40 percent in a class) of parents attending the parents' meeting at other migrant schools."

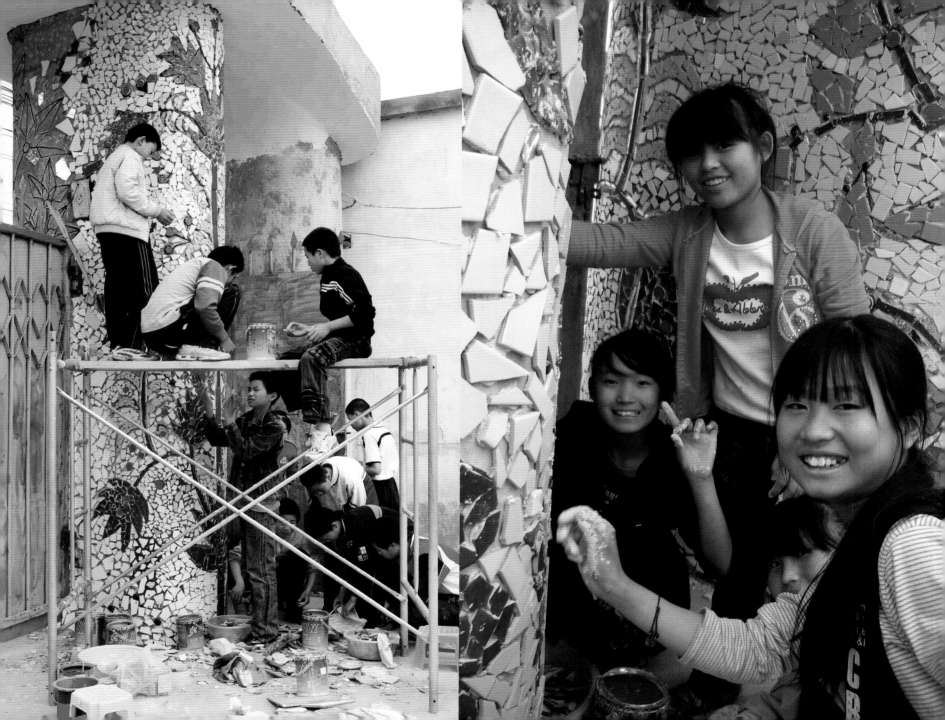

3

Introduction:
The Dandelion School
Transformation Project

The first time I saw the Dandelion School compound, I was struck by the sterility of its environment, made of blank broken walls and uneven gray concrete floors. This was after the school founders had converted dilapidated factory buildings into a clean solid, and usable place.

The Dandelion School entrance was composed of several bulky pillar-like columns holding a large rusted metal gate for cars in the middle and a small side door for pedestrians. Long slabs of white ceramic tiles covered the whole façade of the columns. These weather-worn tiles reminded me of bathroom finishes. It seemed to be a common practice decades earlier to decorate façades of new construction with these drab white tiles.

Over one of the columns on the west side of the entrance hung a wooden slab with Chinese characters reading "Pu Gong Ying Zhong Xue," the Dandelion Middle School. If I had not been looking for the school, I could have easily passed it by.

Behind the faded metal gates lay an ample schoolyard covered with cement. Surrounding the yard were education buildings, offices, and student dorms. All were painted white. A dim corridor led to the back section of the campus, which contained a humble library, more classrooms, and a dorm for teachers. Again, most surfaces were covered in cement. The gray sky combined with the gray environment made the place feel bland and featureless. The energy of the students enlivened the space, but I wondered how color and beauty might influence their ability to learn and to imagine their future.

In recent years, many private schools have been created to respond to the needs of migrant children in Beijing. They are all for-profit elementary schools. Dandelion is the only nonprofit middle school for migrant youth in the city. Because of its dedication to education and its transparent management style, it gets support from the government, some foundations, NGOs, and numerous volunteers. Still, due to the tremendous needs of the migrant community, the school struggles daily to fulfill its mission to provide high-quality education for its youth.

When the school first opened in the fall of 2005, it had fourteen teachers and took in 120 students. In a short four years, it grew to house sixty-seven faculty members and 668 migrant youth from China's twenty-two provinces and special state-run cities. By 2008, its facilities had expanded to thirty-seven spacious classrooms, handsome and well-stocked physics, chemistry, biology and computer labs, a music room, an art studio, an ample and well-lit exhibition space, offices for teachers, as well as a newly renovated substantial library, a gift from the Pepsi Company. Today, the library contains over 15,000 volumes, received over the years from numerous donors and organizations. In addition, the school has boarding facilities for 540 students, which provide them with basic living and study conditions that they lack at home.

> Principal Zheng Hong: "Providing dorms is a necessary step for many students because most living conditions in migrant homes are very poor, with not enough space or light for studying. Often these kids won't have enough time to study because they need to help their parents around the house and with cooking."

Dandelion students impress me as down-to-earth, vital, spirited, and a bit rough-edged. They look natural and real; they are respectful of their elders. Unsure of their position in the world, they seem eager to learn, impress, and make their life count. The school allows no makeup for girls and no dating. In the fall of 2008, all students were required to wear uniforms to keep students' life on campus simple. Even though some of the students do court unusual haircuts, often after the styles of their favorite cartoon characters, in general they focus their energies on studying.

According to 2008 records, the Dandelion School has a total of eighteen classes, which include seventeen classes from seventh to ninth grade, and a "School to Work" vocational training class for a group of special students. The age of the students ranges from twelve

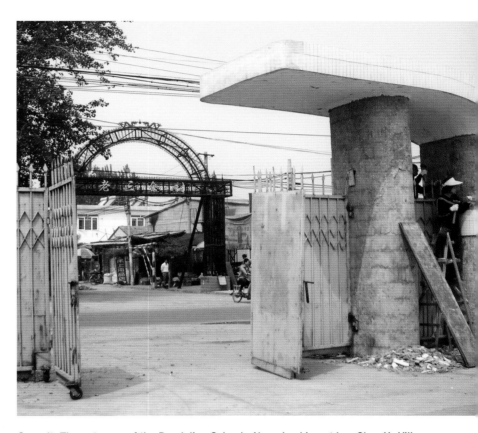

Opposite The entrance of the Dandelion School. *Above* Looking at Lao Shan Yu Village entryway from the school.

43

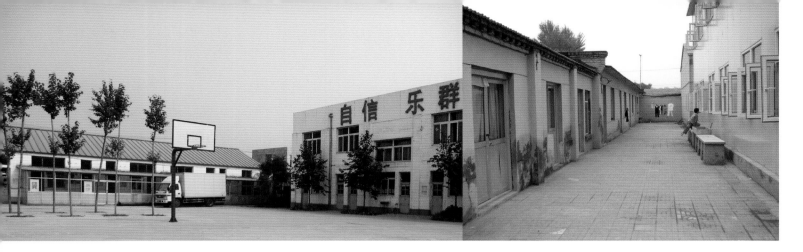

Views of the main campus and the corridor leading to the inner courtyard. *Lower right* classrooms and dorm rooms in the inner courtyard.

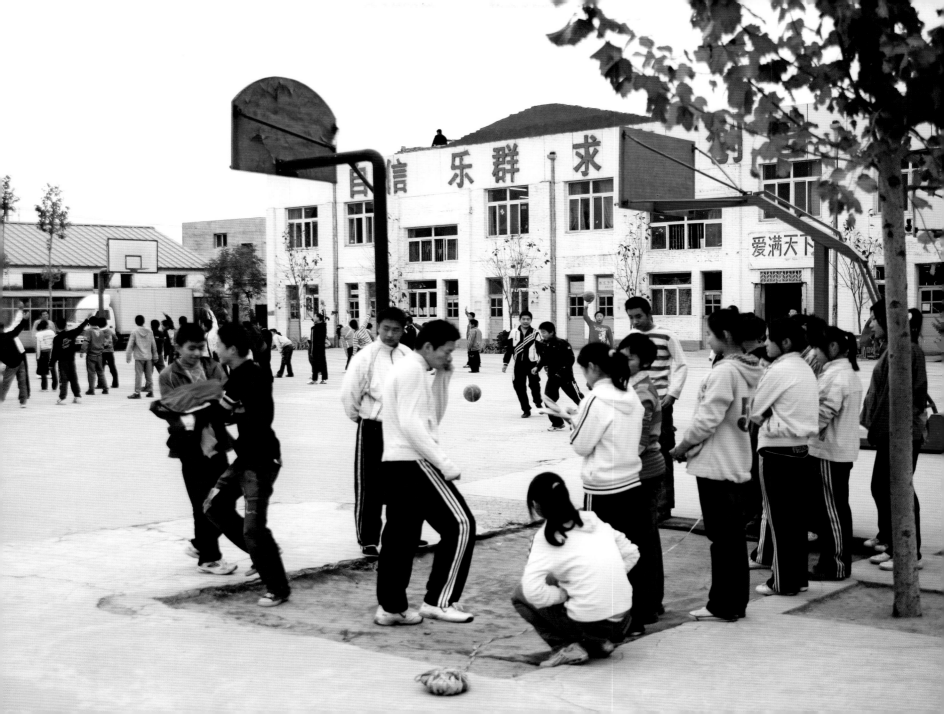

to eighteen, somewhat older than in regular middle schools, due to various circumstances, such as students starting school late or returning after interruptions. Although the school does charge tuition, its fees are much lower than those required by other schools in Beijing. To the most needy, who form about 20 to 25 percent of the student population, Dandelion manages to offer tuition scholarships plus room and board.

> Principal Zheng Hong: "Recognizing the fact that many young people who wanted to enroll in our school could not pass the entrance exam due to their migrant way of life, we created a special class named 'From school to work.' Preparing students with some basic vocational trainings, we work with various industries to provide them with job opportunities when they leave school."

There is a sense of joy during recess and after school hours. Students busy themselves playing ping-pong and basketball, skipping, jumping, and sharing games together. Those moments of unscheduled time are precious, since most of the day is tightly programmed. Routinely, students who live in the dorm rise at 6:00 in the morning and go to bed at 9:30 at night, when the lights are turned off. They have four classes in the morning, one hour and a half for lunch and rest, then four more classes in the afternoon. Afternoon classes are followed by one hour of recreation before dinner. After one hour for dinner and rest, students have two self-study sessions in the evening, then wash up. Everything closes down at bedtime.

Students in general behave congenially and cooperatively. For example, at school-wide gatherings taking place on the main campus or in its large and empty auditorium, students bring their own chairs, diligently follow directions, and take their proper place for the occasion. After the event, they pick up their chairs and return to their classrooms in a quiet and orderly manner.

Students' drawings of the school in 2008. Through them, students express their deep affection and appreciation for the school.

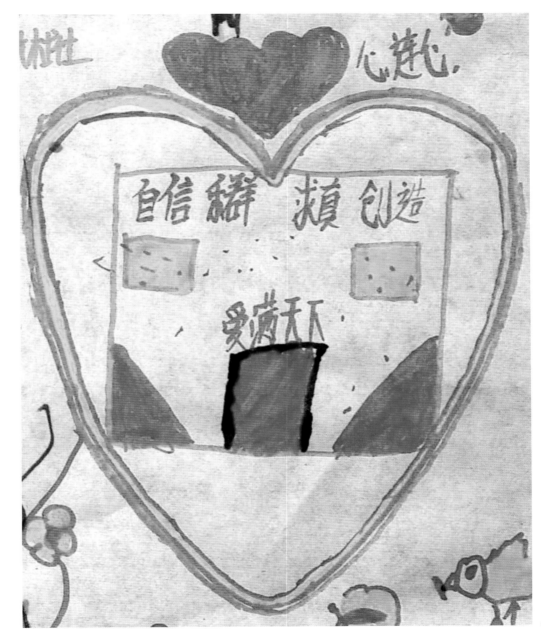

*For Tao Xin Zhi creativity was
an essential part of education,
as proclaimed by his
Declaration of Creativity:*

Every location is a place for creativity.

Every day is a time for creativity.

Every human being is a person

capable of creativity.

Let us strive head-on, even with two steps

forward and one step backward.

We march on the road of creativity.

During the months of May, June, and July, the atmosphere on campuses throughout China gets tense. Students prepare to take entrance exams to move from primary school to junior high, from junior high to high school, and from high school to college. I know China's examination process well because I grew up in Taiwan under a similar education system. This procedure began over 2000 years ago during the Han Dynasty (206 BC–AD 220). Influenced by Confucian philosophy, the system strived to recruit men of intellect and virtue to serve the government. Under this arrangement, men were to be chosen not because of family or political connections, but because of merit and learnedness. Thus education has been highly regarded throughout Chinese history because it provided the key to success.

This scenario still holds true today. The Chinese population has increased exponentially in recent decades. Competition among young people to gain access to good schools has become ever more intense. Good grades lead to good schools. Good schools lead to good jobs and social success. As a result, the emphasis on education has become more and more focused on how to get students to score well in examinations so they can enter good schools. As Teacher Sun Yin Yin describes it, "From small schools in remote villages to well-attended ones in big cities, from students in primary schools, even kindergartens, to graduate students in colleges, the focus of their studies is about examinations. How to get their students to score the highest grades is what captures the imagination of teachers, especially those teaching in the primary, middle, and high schools. No matter how many times the school textbooks have been revised and upgraded, scoring is the preoccupation of everyone."

In contrast to the many schools caught up in the snare of grades and mundane achievements, Dandelion, in addition to teaching academic subjects to its students, focuses on ethics, character building, and the true meaning of education. The educational philosophy and methodology of Tao Xin Zhi, the twentieth-century preeminent educator in China, has shaped Principal Zheng Hong's approach to education. Tao felt strongly that the purpose of

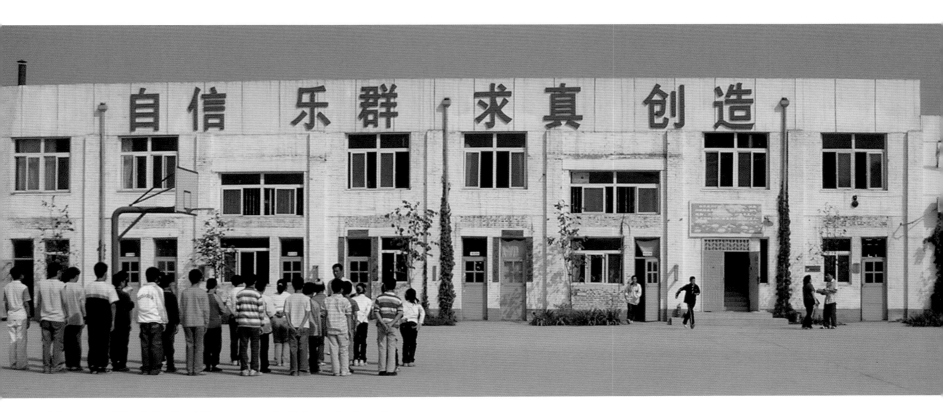

The main building in the Dandelion compound with four sets of words:
Self-Confidence, Enjoying Community Life, Seeking Truth, and Creativity.

Words on boys' dorm at the Dandelion School: Teach one thousand or ten thousand times. Teach students to seek truth. Study one thousand or ten thousand times. Learn to become a truthful and authentic person.

education lies not only in transferring knowledge, but also in teaching creativity and social conduct, with special emphasis on the cultivation of the whole person. His visionary holistic approach to education and his understanding of the interrelationship of school and society are evident in Dandelion's mission: "We cultivate a child's character through education. By cultivating a child's character, we make the world a better place."

How extraordinary that these words speak not about high grades or academic accomplishments, but about truth, love, and self-cultivation. Dandelion has the courage to be different and dares to strive for its ideals. I feel lucky to have had the opportunity to bring art and creativity to an environment that fully understands and supports the effort.

Since I began the Transformation Project at the school in 2006, Dandelion has tripled in size. Aware that the project would take years to complete, I knew my plan had to be highly flexible and responsive to a changing, expanding school. My experience working with inner-city communities in North Philadelphia taught me that the more I engaged the community, the more sustainable and meaningful the project became to it. At Dandelion, I not only wanted the campus to be beautiful, I also wanted to raise issues such as identity, self-empowerment, democracy, and equality. Working with Dandelion officials, I was able to set up a process that engaged the whole school community—students, teachers, staff, and volunteers—in a multifaceted, multileveled, and interconnected program that expanded the imagination of the community while celebrating its diversity and deep cultural roots. It took the first three years to shape the program and tailor it to the school's needs and its tightly regulated curriculum and schedules.

During the five-year period of the project, I have conducted many activities at the Dandelion School, some preplanned and some on the spur of the moment. Some were played out once, while others were repeated and became part of the standard curriculum. The clearest way to communicate the methodology and structure of the project is to discuss step-by-step the different activities that we carried out during and after each of my visits and their impact.

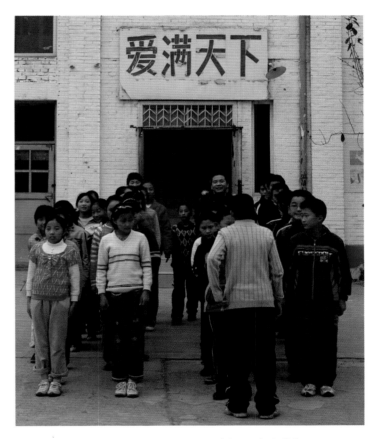

Four red characters above the entrance of the main building announce, "May heaven and earth be filled with love."

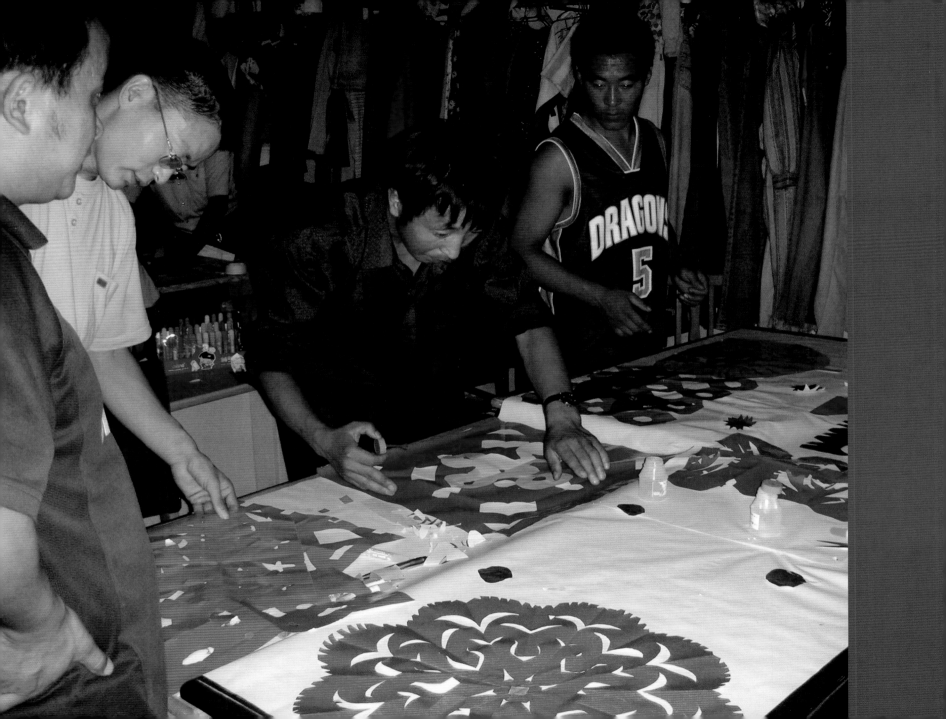

4

Fall 2006:
Meet, Listen, Inspire, and Explore

1. LISTENING: THE FIRST MEETING WITH STUDENTS

To launch the project, I asked the school officials to set up a school-wide meeting so that I could personally introduce the concept of the transformation project to the students. Rather than talking about my ideas or telling them what I wanted to do, I asked them what they would like to see on their campus. What did they deem to be beautiful? "Trees, flowers, birds, sun, stars, sky, mountains, and rivers," they responded. "Yes, nature, colors, and green."

2. WORKSHOP FOR TEACHERS: PAPER CUTTING AND COLLAGE MURALS

I understood from the beginning that if I wanted to impact all the students, first I had to engage the teachers—who, like the students, gathered here from many other places including Hepei, Henan, Helungjian, Inner Mongolia, and Xinjiang. Although deeply attached to their homeland and family members, many had traveled to Beijing to find work.

Teachers work long hours. The lead teachers stay into the night to oversee students' study periods. Most of them take room and board at school. With the rising costs of living, congested boarding arrangements, and strenuous schedules, teachers often feel highly stressed. Additionally, teachers are under constant pressure to get their students to perform well in China's highly competitive and tightly regulated examination system.

I knew that if I wanted to get the teachers' attention and involvement, my workshop had to be relaxing, participatory, and fun. The aim of the workshop was to get teachers to experience the joy of creativity and working together.

About twenty teachers attended my first workshop. Dividing them into five groups, I provided each group with scissors and a stack of colorful paper. I asked each person to create a paper-cut piece according to his/her personal inclination and then paste it onto

FOLK ART AT DANDELION

Paper cutting has been an important aspect of Chinese folk art for centuries. Coming from the countryside, some of the teachers are not only familiar with the shape and meaning of the most popular paper-cut art, they also show a mastery of the technique. See the character *xi* (喜), which means happiness. When the character is doubled, the new character is called double happiness. It is an auspicious character that always appears at weddings.

Another favorite symbol is *tuan hua*—circles filled with floral patterns. It signifies wholeness, abundance, and good fortune. During our workshop, teachers also created images of flowers, birds, stars, and children holding hands. One mural contained characters saying, "Seeing happiness every day." Another mural included these words, "Good things come in pairs. Over the five lakes and four seas (all over the world) happiness has arrived."

Flowers, blue shapes, and the red characters of double happiness in one teacher's work.

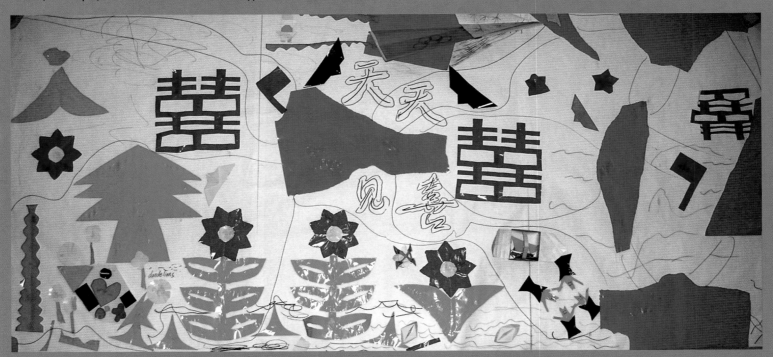

a mural-sized paper on the wall. Most teachers used scissors to do the cutting; a couple experimented with tearing out shapes.

Working together within their groups, teachers managed to create five paper-cut murals. The whole group responded to each piece of work, exchanging stories and interpretations of the images on the wall. The teachers liked the novelty and playfulness of the activity and the interactive process of discussing and sharing.

In respect for each other's work, teachers placed their paper cuts on the wall in such a way that their artworks rarely overlapped. They used traditional shapes and techniques, and were polite and cordial toward each other. To me, the images and words in all the murals expressed the teachers' desire for order, harmony, good fortune, and happiness. Their outlook for the future seemed cheerful and bright.

3. WORKSHOPS FOR STUDENTS: EXPRESSING THE NOW IN PAINTING, PRINTING, SMEARING

Parallel to the workshop for teachers, I also conducted a series of workshops for students in the seventh grade. I wanted to offer this group the opportunity to experience creativity and self-expression early in their education at Dandelion.

A classroom at Dandelion is a serious place for learning. It contains a blackboard on one wall, a desk for the lead teacher on one side of it facing the classroom, rows of desks, and chairs for students. The arrangement reflects hierarchy and order.

In an effort to set up a more relaxed atmosphere and to create a bigger work surface for the students, I changed this rigid arrangement. I asked the students to turn their desks around to form a bigger surface on which four students could work together at the same time. The motion of rearranging classroom furniture and making art standing up helped break old habits and create a fresh start, even though the students stayed in the same classroom and worked

at the same desks. Working together on a large piece of paper was also a new experience for the students. They felt excited, full of expectations.

Each class session lasted forty-five minutes. To make the first project accessible without a lot of explanation, I asked students to share with their teammates the thoughts and feelings they had at that moment. "Discuss and then express them on paper." Even though the workshop process was similar to that of the teachers, their works came out dramatically different.

Although some of the students' works showed restraint and even timidity, the majority of the images expressed enthusiasm and defiance. If the works of teachers expressed order and optimism, those of the students reflected curiosity, openness, energy, and at times a chaotic ebullience. In addition to producing paper cuts, students painted in ink and watercolors. This made some of the works look fluid and rich in texture. Unrestrained by the concept of boundaries, students overlapped their shapes, creating lines that crossed over and collided. The abstractness of their images plus the daring juxtaposition of colors aligned their works more with contemporary art than with Chinese folk art.

4. PAINTING BIG AND PAINTING TOGETHER

Before involving students in the design for the school environment, I wanted to open up their minds and have fun making art. Students are usually given some letter-size paper, pencils, pens, and sometimes colors to paint. Most of the time, they work by themselves in their own space. This time, I wanted them to paint big and paint together. I wanted them to paint themselves and each other.

For this project we worked with the eighth graders. In each of the four classes, we organized the students into teams of ten to twelve. The school happened to have many large, bed-sized orange and blue sheets in storage. We used them for this painting project.

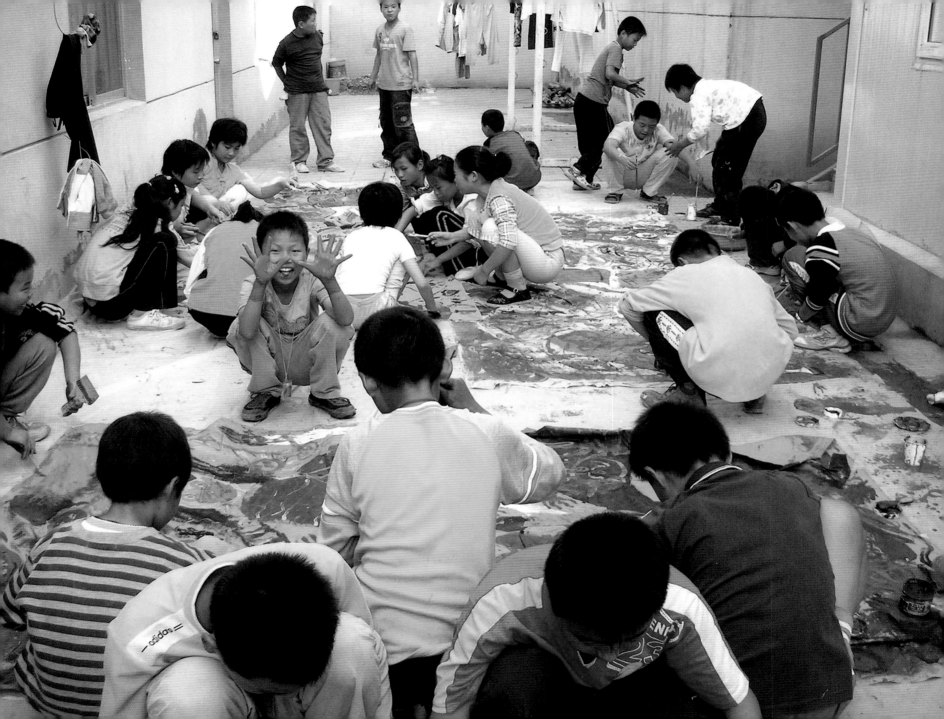

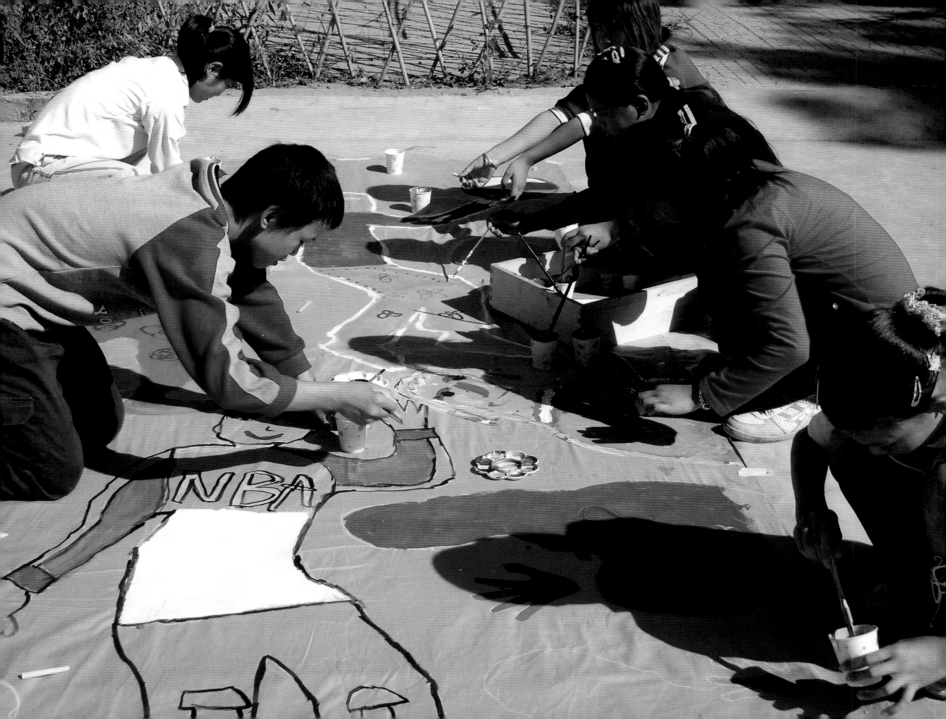

"Painting, printing, smearing—putting paints wherever—a huge big mess! What freedom and what fun!" Students comment.

Half of each team lay on the large sheet placed on the floor in the open over a large piece of plastic, while the other half traced the silhouettes of their fellow students. Afterwards, they painted together in any way they wanted. This method is widely known and used, but at Dandelion it felt daring and new. "Painting big and painting together is fun. I love particularly the discussion part. So many different ideas!" said Wang Yen. Another student, Wang Kuo Tin, commented, "The whole process of painting on large canvas together with our classmates is exciting. I can express myself freely. I can develop my painting skill while building up relationship among friends."

Working with their silhouettes gave students a certain comfort of familiarity and the confidence to begin creative exploration. At the same time, these shapes, so unlike their real images, offered the students freedom to invent and express. Even with its various challenges, painting with other people on a large surface is freeing. Taking liberty in inventing forms and applying colors, students created vivid images of people, plants, stars, skies, and many different kinds of abstract forms and patterns. Most of them immensely enjoyed getting their hands dirty and the feeling of diving into activities. Li Ya Jun commented, "When I paint small on paper, I have to be so careful. But this time, I can let my imagination run free and I have plenty of room to express myself."

Another student commented, "Before, we drew on pieces of paper. We used watercolor and crayons. This time we painted ourselves on such a big piece of canvas. I have never painted myself before. It makes me happy to paint myself. This time we also experimented with acrylic colors which we have never used before. It is fun and refreshing. Now I am deeply interested in painting."

5. CONVERTING STUDENTS' WORKS INTO COMMERCIAL CARDS

These large paintings do not quite hold up upon closer scrutiny. Paying little attention to the background, students focused their energy mainly on the figures. Yet these paintings also contain surprising details filled with free-flowing brushworks, innovative color combinations, and bold compositions. Thoroughly impressed by the photos we took of the striking details of the paintings, the school officials had them printed into sets of cards, 10,000 cards in total. These cards contain not only the pictures but also a simple description of the genesis of the cards and the poetic titles given by students: Dreams of the Universe, Kaleidoscope River, The Rhythm of Youth, Loving Hearts Turn and Turn and Turn, Soaring Dandelion, and Rainbow Behind the Storm.

The school officials use them as thank-you cards, give them away as gifts, and also sell them as Dandelion's crafts product. These cards are successful because they are unique and come with a story. People at Dandelion began to realize that art created by students could become assets.

Cards made from works by students produced in the "Painting Big and Painting Together" workshops.

5

Fall 2007: Discovering the Creativity Within

1. THE FIRST EXHIBITION: TO INSPIRE, EMBOLDEN, AND DEMONSTRATE

Although I had conducted a series of workshops for both teachers and students in 2006, I still faced a challenge in sharing with the community the vision and potential of the project. It could not be explained in words. It needed something visual. Yes, an exhibition—to inspire, embolden, and demonstrate what is possible! I set up the first exhibition to show the power of art in transforming environment and community.

When I first started the Dandelion project in 2006, I had no budget for an exhibition and the school had no proper space to present it. So I carried a suitcase filled with sets of documentary photos showing my transformation projects at the Village of Arts and Humanities in North Philadelphia, Jamestown in Accra, Ghana, Korogocho in Kenya, and Rugerero Survivors Village in Rwanda. The exhibition also contained original art pieces such as banners, handmade books, sculptures, and crafts created by other artists, children in Africa, and myself. Dandelion cleared out a multi-purpose room to accommodate the displays. It was a humble beginning in the art of presentation, but an important step that opened up a new dimension in the project and in people's minds.

Even though the space was small and the viewing intense due to the large number of students, the exhibition created a sensation. Seeing the transformation of places from desolation to jubilance, filled with colors and vivid images, stirred up a lot of emotion. Teachers renamed the exhibition, changing its original title, "Building Community Through Art," to "From Abandonment to Enchantment." From the enthusiasm of the students, I knew that the exhibition had expanded their idea of what was possible for Dandelion.

Students commented:

"After viewing the exhibition, I got excited about how Lily Yeh turned broken pieces of tiles and stones into lovely passageways and gardens. I hope that together we can create something like that in our school."

"When I think of Lily Yeh's work in Africa and the artworks created by the Rwandan genocide survivors, I can find no words to express my deep feelings other than 'so extremely beautiful.'"

"From my childhood to now, I have never been interested in painting. My own art pieces always looked awful. But that day I was deeply impressed by the art works created by common folks under Teacher Yeh's guidance. These images contain vitality and mystery. So fantastic! Then I began to have a feel for art."

"It helps me to realize my own potential. Everyone can make art."

Before and after of Kujenga Pamoja Park,
Village of Arts and Humanities, North Philadelphia.

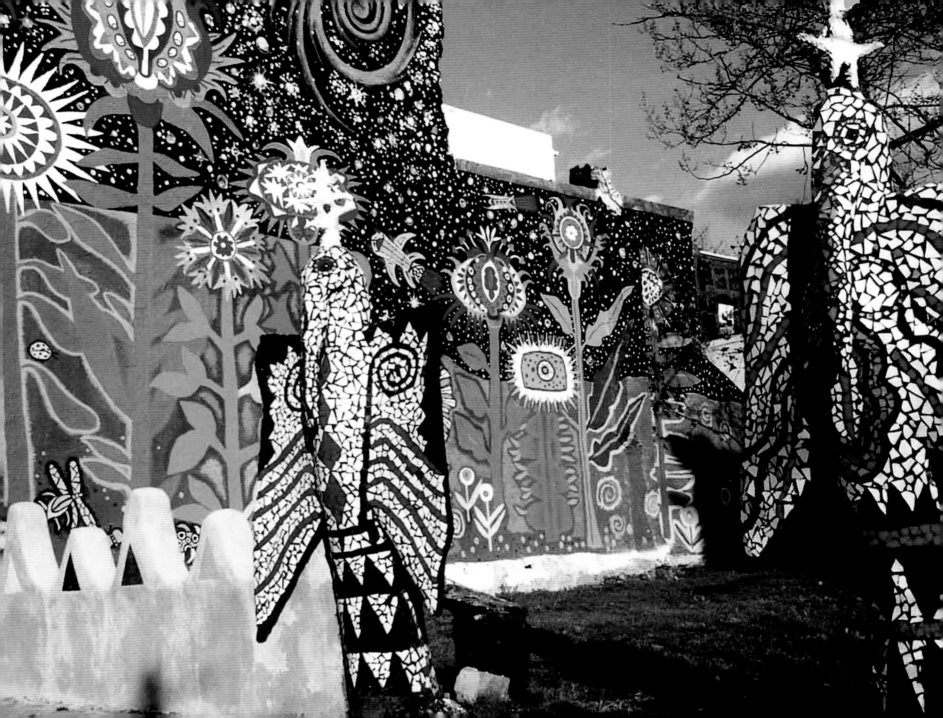

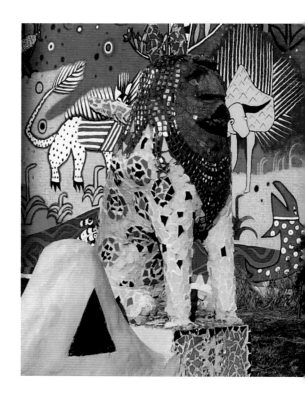

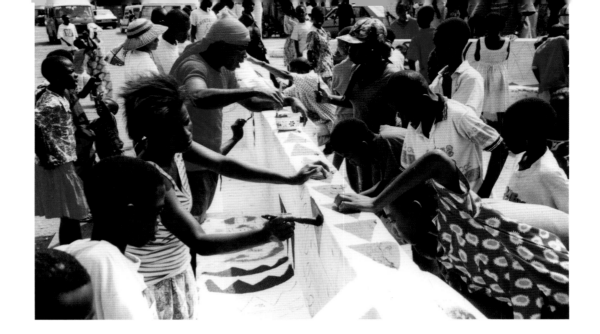

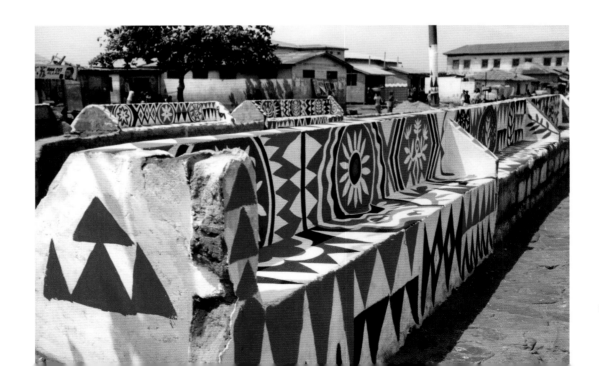

Left Before and after of Lions Park, Village of Arts and Humanities, North Philadelphia. *Right* My community engagement transformation project, Jamestown, Accra, Ghana.

69

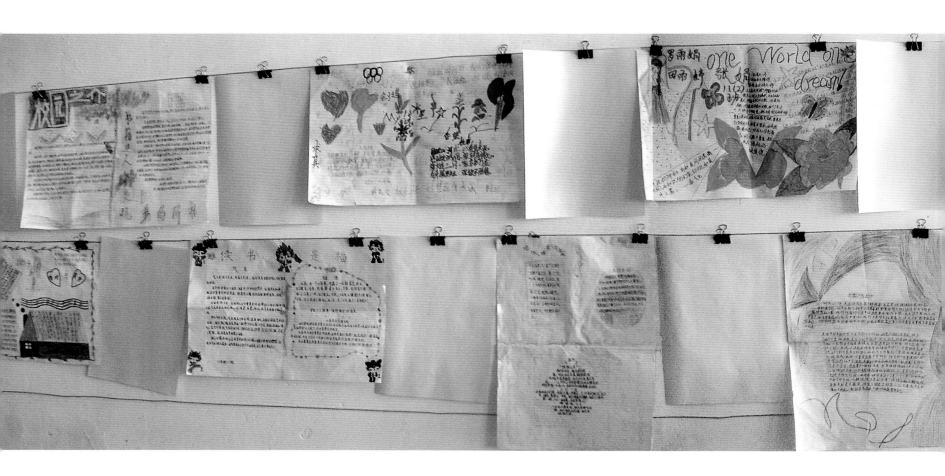

2. AN EXHIBITION OF STUDENTS' WORKS

Having witnessed the impact of the first exhibition on the school community, Mr. Zhang Wei Guang, the director of the journalism program, followed up with a show of students' works. It contained a series of handwritten and decorated newsletters that described activities and sentiments on campus. He hoped that this would be the first of a series of exhibitions showcasing works by students.

The way Zhang organized the students so that they would collectively produce these colorful newsletters deserves some mention. He asked each of the seventeen classes in the Dandelion School to select three members who showed talent in creative writing. They were called "little journalists," and played a crucial role in the student exhibition project.

Each class decided on a subject of interest for each publication. Everyone participated through writing or creating images. The journalists then selected and organized the works submitted by their fellow students in their respective classes. Working with classmates who had good handwriting and art skills, they oversaw the production of the newsletters, which were then regularly collected and exhibited either in the small exhibition room or on the walls outside the different classrooms.

This exhibition program gave students opportunities to express themselves, cultivate teamwork skills, and develop leadership.

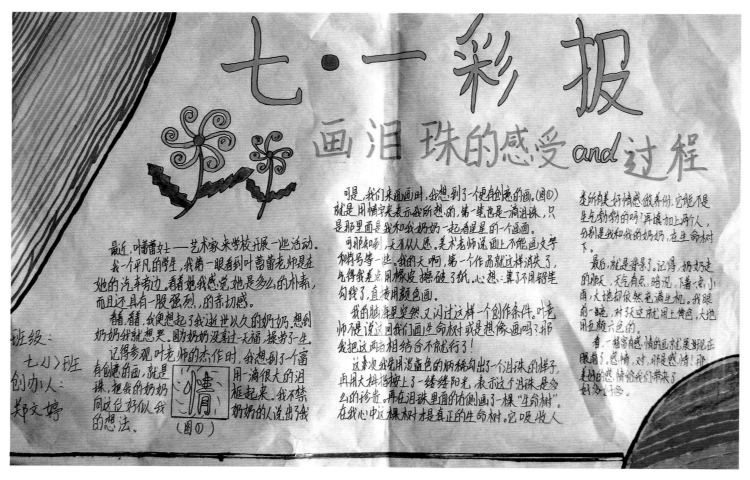

Zheng Wen Ting expressed the aching loss and nostalgia she experienced for her late grandmother, "I want this big tear drop to contain all the love we felt toward each other."

3. CREATING PERSONAL STORIES

Noticing how excitedly Dandelion students responded to the colorful murals and the images freely painted by African children shown in the exhibition, I suggested that they too express their feelings through words and images. "Be truthful to your feelings. Then your stories and images will become powerful."

One afternoon I took a walk on campus. A student, leaving her group behind, walked towards me. With great urgency she asked, "Can I write about my grandmother?" "Yes, of course, tell your heart's story. Do it," I answered.

Zheng Wen-Ting's narrative began: "Recently an artist named Lily Yeh came to our school to launch some activities. When I first saw her standing by her car, she looked so simple and plain. I felt a strong sense of connection to her. She reminded me of my grandmother who passed away recently. Thinking about my grandmother made me want to cry. Working so hard all her life, she never enjoyed even one easy day."

Zheng Wen-Ting felt very close to her grandmother, who raised her when her parents went to work in big cities. When the grandmother passed away, she became melancholic and despondent. Here is the poem she composed about her grandmother.

A TEARDROP, MY GRANDMOTHER AND I

Here are my grandmother and I together
in a teardrop.
We are looking at the Tree of Life.

When my grandmother died
a big tear
ran down my face.

The earth, as always,
is still filled with life and energy,

But the sky darkens a bit,
accompanied by rain,

Continuous, without stopping.

4. EXHIBITION OF STUDENTS' LETTERS AND A MOVING ASSIGNMENT

During my visit at Dandelion in 2007, an exhibition of a series of beautiful handwritten letters came to my attention. Seventh graders in Teacher Wang Jien Hua's class wrote these letters, each to one of their parents, sharing their innermost thoughts and feelings. Teacher Wang is a strict, stern, and totally dedicated teacher. She never gives up on a student. Her students fear, respect, and love her.

With the help of the Beijing-based Xin Lian Xin (Heart to Heart volunteer project), Dandelion has set up an activity to address the gap between many students and their parents. Every year, students are asked to write personal letters to their parents, which are then read during parents' meetings at school. Many students feel estranged from their parents, while the latter cannot grasp what is going on emotionally with their children. This letter writing assignment has become a powerful tool to heal these wounds and reconnect the two generations.

While reading these letters, I came upon a moving assignment given by Teacher Wang. She asked her students to wash the feet of their parents. Many students were deeply affected by this project. The feet-washing assignment not only had an impact on the psyche of the students, it also touched the lives of some members of their families. Zhang Bing Xin's father was so moved when his feet were washed that he made a special trip home to wash the feet of his mother. Bing Xin said, "I want to wash their feet often now when I have the opportunity to show my appreciation and gratitude."

The story of Liao Shu Li, the award-winning student mentioned earlier, testifies to the power of Teacher Wang's assignment that students wash the feet of their parents.

Before Liao Shu Li became a student at Dandelion, she would start arguments when her parents did not satisfy her demands. Rarely did she help her parents with housework. Shu Li's brother was a college student. In order to earn enough money to pay tuition for their two children, Shu Li's parents worked long hours everyday at Daxing, planting, harvesting, and selling vegetables. Every penny earned came from their sweat and labor. But Shu Li seemed indifferent to her parents' situation. She took everything for granted, until the day she was given the assignment by Teacher Wang.

At the beginning, her parents refused such a practice. Her father said, "I am a peasant. I am not a big shot. How can I accept to have my feet washed! I am not able to provide well for my daughter. How can I allow her to wash my feet!" Shu Li insisted. Her parents reluctantly complied. During the washing, tears filled her father's eyes.

Yet the one who was most affected by the assignment was little Shu Li. When she touched her mother's feet, so hardened by the long years of labor that the skin was cracked, she understood the meaning of the assignment and why her parents could not grant her every wish.

From then on, Shu Li became a different person. She no longer demanded money. She started helping her parents with their work, placing thin straw mats on top of their makeshift greenhouses every morning and bringing them down in the evening. She helped them in the fields and with housework as well.

Students' letters to their parents.

TO MOTHER, WORDS FROM MY HEART

...Thank you for raising me. For me, you have given everything. Through great difficulties, you nurtured me. For me, your hair turned white, strand by strand. Your body bent due to exhaustion. For me, you have savored bitterness and swallowed the sour taste of life. There is no way I could ever repay such infinite love from you.

The first day I attended my class at Dandelion School, our teacher taught us to be grateful for three things: our parents because they gave us life; our teachers because they educate us; and for all the compassionate volunteers and donors of Dandelion because they made the school possible...

My determination:

Mother, I know how much you have suffered and the numerous tears you have shed for me...I am determined to study hard, to earn money so that you can have a good life. I want you to enjoy the happiness that I will bring to you.

I wish my hardworking mother happiness everyday, good health, and that your dreams be realize=d.

Loving you deeply, Gao Ke

SHARING MY HEART THOUGHTS WITH FATHER

I remember that when I was little my school grades were not good. You left me behind at home. Every time I took an exam I got just over sixty points [a barely passing grade]. My classmates often laughed at me. I felt that this was all your fault because you did not take good care of me. While I was in third grade, you brought me to Beijing. You discovered that I was rather stupid. So you gave me extra homework to improve my study. You would hit me when I could not understand some of the assignments you gave me. I was afraid of you and hated you then. Whenever you saw me, you would order me to study or do homework. So I tried to hide from you. I remember that one time you raised your hand. Thinking that I would be hit, I lowered my head and closed my eyes. But you did not hit me. Because my grades were so low, I was often transferred. My IQ remained the same no matter where I attended school. But you did not think so. You continued to search for the right school for me.

Do you remember what happened last semester? I was listed among the top twelve students in my class during the final exam. You smiled with such joy and happiness. But you did not know that I got only sixty-six points in my math. If I got seventy points I wonder where I would be listed. I did not have the heart to tell you what my grade was. I was afraid that you would be disappointed with me again.

You and Mother searched continuously for a good school for me. Finally you found the Dandelion School. I have heard that this is a very fine school. I thought that I would feel very lonely here and that the teachers would criticize me often. To my surprise, the teachers are gentle and kind.

Our teachers taught us to be grateful to our parents because they gave us life and nurture us to grow up; to our teachers because they educate us on how to be a decent human being; and to all the caring volunteers and benefactors because they helped to establish Dandelion. During our first lesson about being grateful to our parents, we were asked to wash their feet. That was the first time I realized how hard my parents labored.

Talking about study, I want to attend a very fine university when I grow up. I want to earn a lot of money to pay back society and my parents. I want to be like the kind people in society, helping the needy.

Of course, it is no use just thinking without acting. From now on, I want to study hard and do everything well.

I wish you, Father, good health and that your dreams come true.

Your daughter Ye Jin

5. SITE DESIGN WORKSHOP

Once the students saw the exhibition, they understood the potential their own school held for them. After experiencing the "painting big and painting together" activity, they felt more comfortable and confident in making art. To further expand their imagination and build their self-confidence, I shared with a group of eighth-grade students some of my favorite art books containing images of painted and sculpted environments from India, Saudi Arabia, North Africa, and Ghana. It was an eye-opening experience for many of them.

"The images in these books show such daring ways of using color," wrote one eighth-grader. "This made me understand that when we design things, we don't have to be restricted by reality. We can use whatever colors we want to in order to fully realize our imagination." "I always painted trees in green color and flowers in red," commented another student. "But in these books, trees can be red and flowers can be black. I must be freer in my imagination and create images according to my own style."

The first step in opening up the process of designing the physical school to the students themselves was asking them to draw directly on photocopied images of the actual sites on campus. I wanted to see where their imagination would lead them. "I feel so proud that I am designing our campus," wrote a student. "I am a member of our school. I want to contribute to making our school beautiful."

Student comments included:

"I am in a state of great excitement. This is the first time I created something according to my imagination. I feel happy to design something for our school."

"I feel that I now have the courage to paint whatever is in my mind."

"I feel so happy and proud. I had never imagined that I could design something for our campus."

"I feel something I have never felt before, a sense of accomplishment and success."

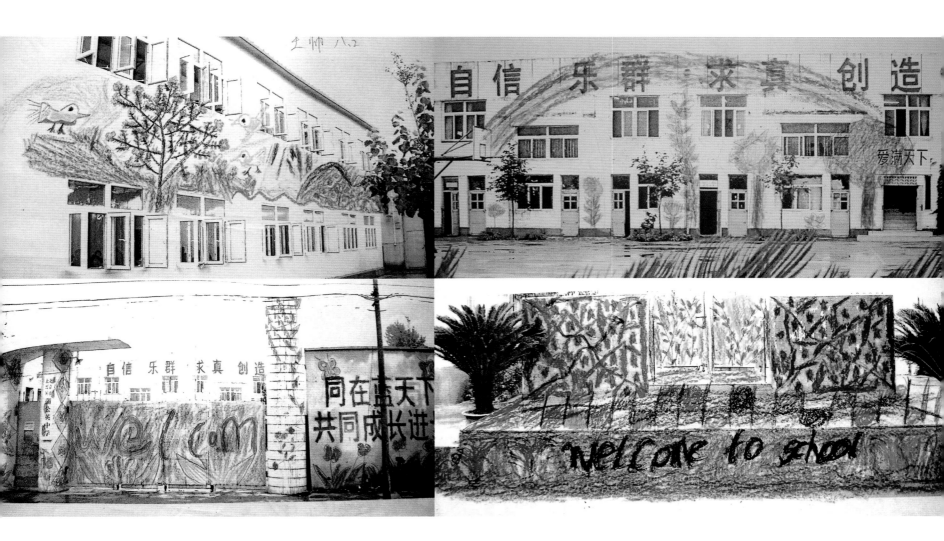

Teachers look at students' works and write down their responses.

6. AGAIN, PAINTING BIG AND PAINTING TOGETHER

Since students in 2006 responded so positively to the "painting big and painting together" project, we repeated the activity in the spring of 2007. Students in 2006 were not able to complete their paintings on the huge blue and orange cloths, so I decided to get new groups of students to finish the work by completing the unpainted areas, mostly the empty background. Students, however, did not understand my intention; they painted over the figures and, again, paid little attention to the background. For some of the students, working on surfaces that already contained images was confusing. The colors in most of the paintings turned dark and muddy due to their mixing. These paintings were folded away, since no one knew what to do with them.

Sometimes it was like that. We felt confused and disappointed. But times like that are important for they teach us patience. We learn to wait until insight and clarity dawn on us.

7. WORKSHOPS FOR TEACHERS: EXPERIENCING SPONTANEITY AND CREATIVITY

In my workshop with teachers in 2006, I learned a lot about their skills, optimism, and reservations. I wanted the teachers to further experience spontaneity and the joy of creating together through an activity that required their engagement in multiple areas—visual, literary, and presentational.

This time I scheduled two three-hour workshops for teachers. Both were held in the library/multipurpose room, which at that time hosted many large green paintings of nature produced by the students during my previous workshop sessions with them. Fresh and vibrant, these images were a delight to the eye.

Over fifty teachers attended the workshop this time. Again, I divided them into groups of six or seven. Each team received a large piece of white paper.

Since we were surrounded by students' artworks in the library, I asked each group of teachers to look at a set of four or five paintings near them on the wall. After five minutes, everyone had to respond. Trusting their gut feelings, they wrote down words or simple phrases on the large piece of paper. This was something new and exciting for the teachers.

One group, for example, wrote these words: abstract, serene, broad green, fresh, life, harmony, joyful, spring, love, beauty, lively, lovely, quivering, forlorn, tough, dirty and chaotic, detached, not in sync, creativity, bright and beautiful, natural, brilliant, child-like, rational, boring, suppressed, and calm and steady.

I then asked the teachers in each group to collectively create a story, a poem, or a narrative based on the seed words and phrases they had just written. Each group had ten to fifteen minutes to negotiate in this collaborative process, and another ten minutes to figure out and rehearse a short presentation of their work to the whole group. Some groups chose one or two people to be their spokespersons, while others recited their poems together. The last group sang their words with vivid gestures.

I structured the workshop so that teachers had time to create but not to get worried. At the end, they experienced that working together was very pleasurable, especially when they had the opportunity to show off their talents.

One of the groups mentioned above turned the random words they had written into the poem at right.

LET US ACCEPT THE BEAUTY AND WONDER OF SPRING

Serene, quivering, delightful fresh green
Rational, forlorn, detached creativity
Oh, the hope in my heart!
Let us leave far behind the suppressed, monotonous, and heavy and secretive colors.
Say goodbye to those beauty of disharmony
Return to the heart of a child, natural, bright, abstract and lovely
The life of harmony, warm, sweet, and joy!
Let us raise the wind sail of hope
Begin our journey toward the new, bright, beautiful spring!

Below Teachers showing off their poem.

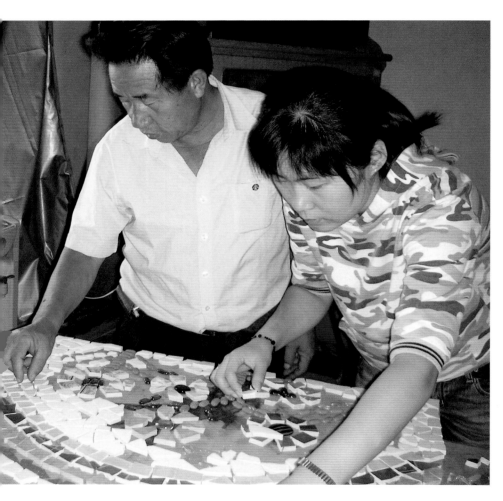

Teachers experimenting with mosaic-making.

8. WORKSHOP FOR TEACHERS: MOSAICS

I have always liked using mosaics in my public art. As a medium, mosaic is tactile and enduring. Its inclusive nature allows any small pieces of materials such as glass, tiles, ceramic pieces, stones, shells, and beads to be incorporated into the design. The process of making mosaics, turning broken pieces of materials into something beautiful and whole, is a powerful symbol of transformation through creative action. I wanted to teach this skill to all the students at Dandelion. Through the experience of making mosaics, I hoped to show them that their lives, though unstable and maybe even broken, could be made whole through their own will and imagination.

Once again, to get the students excited about mosaics, I started by mobilizing the teachers. I felt that this would also be fun for teachers to learn since few people knew about mosaic, not to mention the technique of making it.

I asked the teachers to create some simple designs on paper, which they then transferred onto eighteen- by twenty-four-inch wooden boards that the school had prepared for them. Following their designs, teachers created their own mosaics with tiles and colorful glass pieces. The tactile nature of the process and the ability to see the immediate result delighted them. Although this training session was short, it was enough to build a support system that helped us to launch a school-wide participatory mosaic project.

Teachers' comments included Kang Rei-Juan, "We all have creative sparks inside of us, but they've gotten buried. When one is engaged in creating art, one feels relaxed and feels a sense of accomplishment coming from the heart. What a wonderful feeling!" and Jiao Ming-Li, "There is beauty everywhere. We only lack the creativity and ability to discover it. In a nurturing and relaxed environment, we get stimulated more easily and can become more creative. We were afraid that we might not be able to imagine. Now we are more likely to discover the sparks of creativity within ourselves. We are not afraid that we might not be able to do it."

9. DESIGN SUGGESTIONS FROM TEACHERS

I would have liked to conduct another workshop for teachers to create some designs for the school environment. Due to time constraints, I asked them for design ideas instead. Their suggestions turned out to be very helpful. "Take the whole as a design unit. Turn the campus into a garden-like environment," wrote an eighth-grade teacher. "The design needs to be crisp, clear, and colorful. The place of importance for transformation is the school entrance. It will make the Dandelion School unique." "The overall design for the project needs to be broad and simple," commented another. "Subject matters need to come from nature." "The design concept for the campus needs to be broad and generous," suggested a third. "Images in murals need to feel full in content and big in scale."

10. THE FIRST MURAL: THE DANDELION TREE OF LIFE

By the end of spring, the school community was excited about the transformation project we had been carrying on through exhibitions and workshops. Now something on the ground had to happen. The school entrance with its tiled surfaces, curved walls, and large twin metal doors was too complicated to tackle for the school's first public art project. We needed to do something impressive, meaningful, straightforward, and easy to carry out. A mural.

Dandelion had many blank walls waiting to be embellished. However, windows, rainspout pipes, buttressing bars, and bulletin boards fragmented all the walls but one, which was situated in the school's inner courtyard, surrounded by the library, classrooms, and women's dorm. The wall would be a good place to host the first piece of public art at Dandelion. The question was what to design.

Uprooted from their homelands, students at Dandelion often feel homesick and alienated, especially when they sense discrimination because of their migrant status. I wanted to create a visual image that nurtured their spirit and provided comfort and stability.

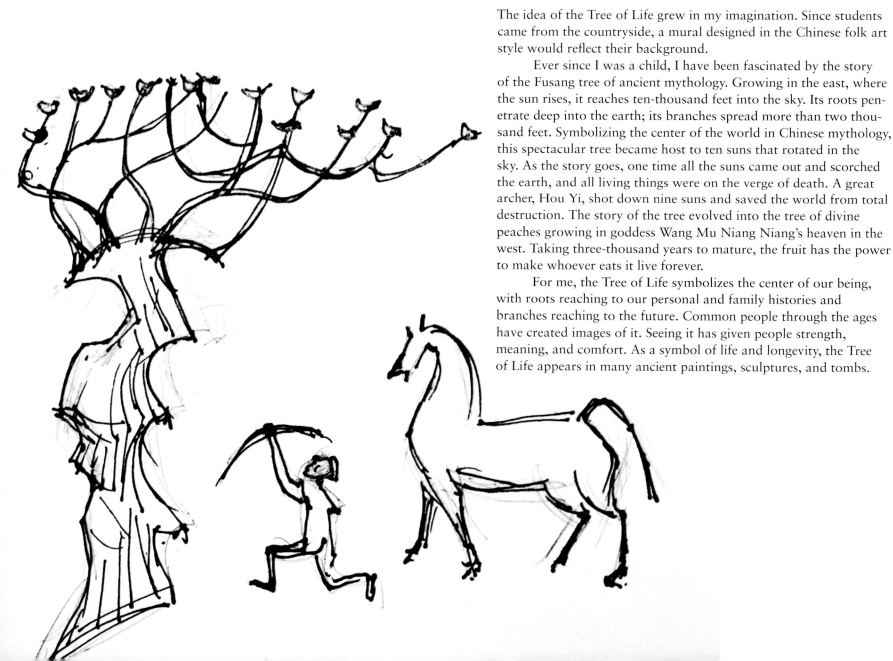

The idea of the Tree of Life grew in my imagination. Since students came from the countryside, a mural designed in the Chinese folk art style would reflect their background.

Ever since I was a child, I have been fascinated by the story of the Fusang tree of ancient mythology. Growing in the east, where the sun rises, it reaches ten-thousand feet into the sky. Its roots penetrate deep into the earth; its branches spread more than two thousand feet. Symbolizing the center of the world in Chinese mythology, this spectacular tree became host to ten suns that rotated in the sky. As the story goes, one time all the suns came out and scorched the earth, and all living things were on the verge of death. A great archer, Hou Yi, shot down nine suns and saved the world from total destruction. The story of the tree evolved into the tree of divine peaches growing in goddess Wang Mu Niang Niang's heaven in the west. Taking three-thousand years to mature, the fruit has the power to make whoever eats it live forever.

For me, the Tree of Life symbolizes the center of our being, with roots reaching to our personal and family histories and branches reaching to the future. Common people through the ages have created images of it. Seeing it has given people strength, meaning, and comfort. As a symbol of life and longevity, the Tree of Life appears in many ancient paintings, sculptures, and tombs.

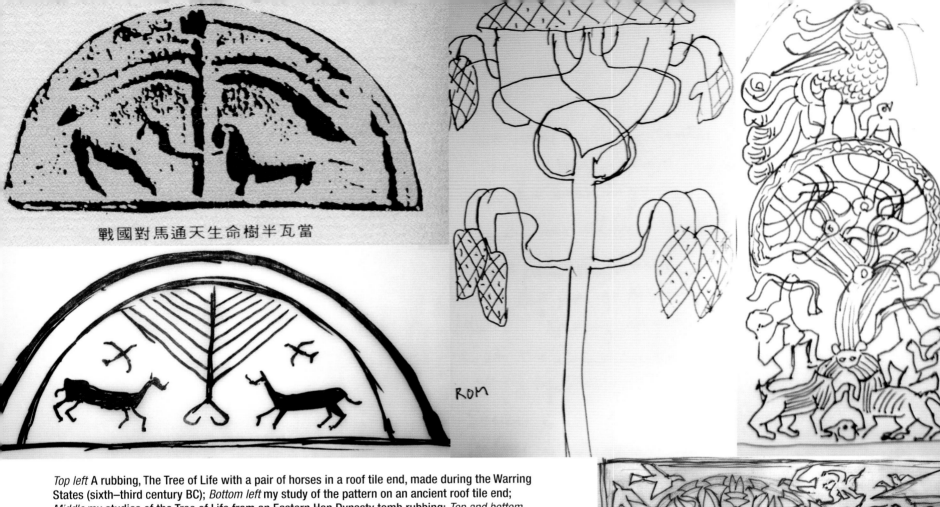

戰國對馬通天生命樹半瓦當

Top left A rubbing, The Tree of Life with a pair of horses in a roof tile end, made during the Warring States (sixth–third century BC); *Bottom left* my study of the pattern on an ancient roof tile end; *Middle* my studies of the Tree of Life from an Eastern Han Dynasty tomb rubbing; *Top and bottom right* my studies of tomb rubbings; the Fusang Tree with intertwining branches and archers trying to shoot down the sun birds.

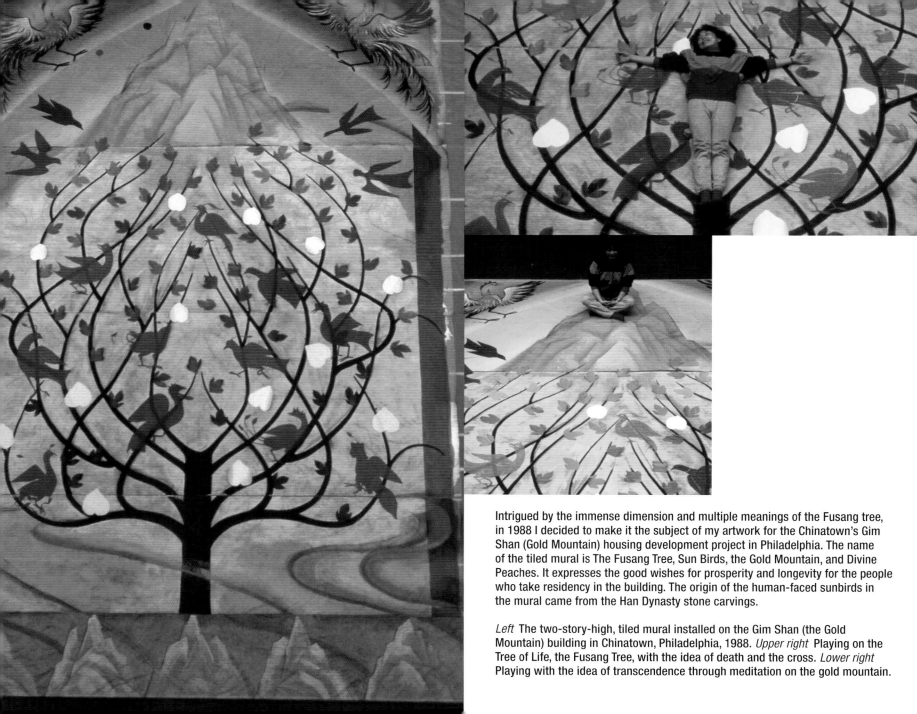

Intrigued by the immense dimension and multiple meanings of the Fusang tree, in 1988 I decided to make it the subject of my artwork for the Chinatown's Gim Shan (Gold Mountain) housing development project in Philadelphia. The name of the tiled mural is The Fusang Tree, Sun Birds, the Gold Mountain, and Divine Peaches. It expresses the good wishes for prosperity and longevity for the people who take residency in the building. The origin of the human-faced sunbirds in the mural came from the Han Dynasty stone carvings.

Left The two-story-high, tiled mural installed on the Gim Shan (the Gold Mountain) building in Chinatown, Philadelphia, 1988. *Upper right* Playing on the Tree of Life, the Fusang Tree, with the idea of death and the cross. *Lower right* Playing with the idea of transcendence through meditation on the gold mountain.

I have long cherished a photocopy of a folk painting. There is no signature, date, or place on the painting, suggesting that it was painted by a peasant artist somewhere in central China. In the loess land in central China, many people live in caves as their ancestors did. On the background of a pastel yellow earth, a pink house and a pale green sky, the painting depicts a lovely domestic scene in a courtyard in front of a cave turned into a home. Surrounded by her animals, under two fruit-bearing trees, a woman in blue is spinning wool in her garden. Bright, colorful flowers with lush leaves grow from the green grass on top of her roof. This soothing image of harmony and serenity became a source of inspiration for the Tree of Life that I designed for the Dandelion School.

As I was figuring out how to include a dandelion in the Tree of Life mural design, I saw lovely dandelion flowers painted in delicate white brushstrokes on a cement wall of the school. Tang Ya Kun, a student in the School to Work class, had painted them for fun. With his permission, I incorporated his design into the root of the tree. A full-grown dandelion placed against the blazing reddish orange of an evening sky sends out tree branches with their heavy blossoms into the sky. I wanted the mural to showcase the aspiration and accomplishment of the school.

When I completed the design of the Dandelion Tree of Life for the mural, art teacher Fu Tao sketched it onto the wall. Under his supervision, volunteers and students carried out the painting. I gave it the final touch by enhancing some colors and revising some details. The vibrant colors of the mural immediately energized the school environment. It became the most popular spot for taking pictures on campus.

Facing the Dandelion mural were the gray blank walls of dorm rooms. I sketched out simple floral and abstract patterns, which volunteer Duan and some students painted on the wall. The frontal image of the *feng huang* came from the Han Dynasty tomb paintings. It was added the following year.

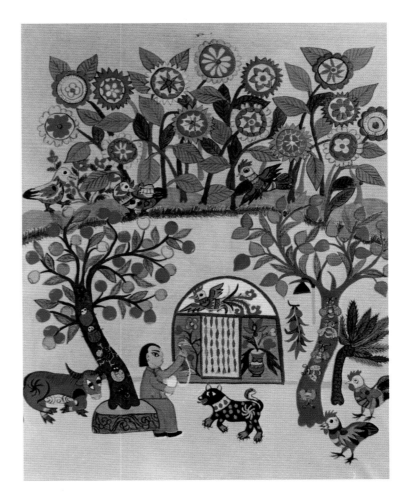

A Chinese folk painting, artist unknown.

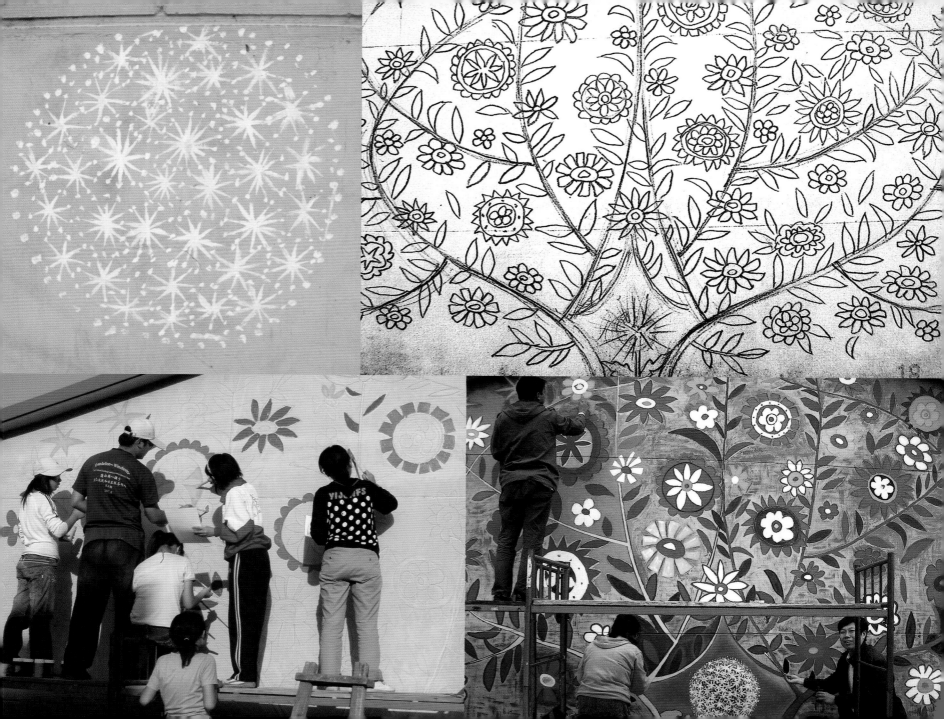

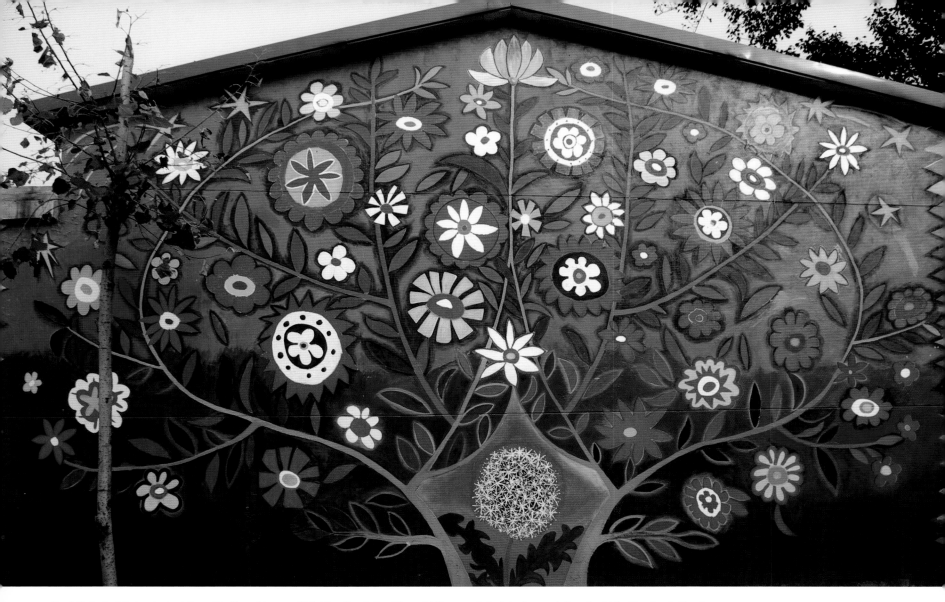

Far left A sketch by student Tang Yia Kun. *Upper middle* The Dandelion Tree of Life mural sketch. *Lower left and middle* Mural painting in progress.
Above The completed Dandelion Tree of Life mural, designed by me, painted by Fu Tao, Duan Xiao Lin, with the help of students.

6

Spring 2008: Teamwork, Leadership, and Re-Creation

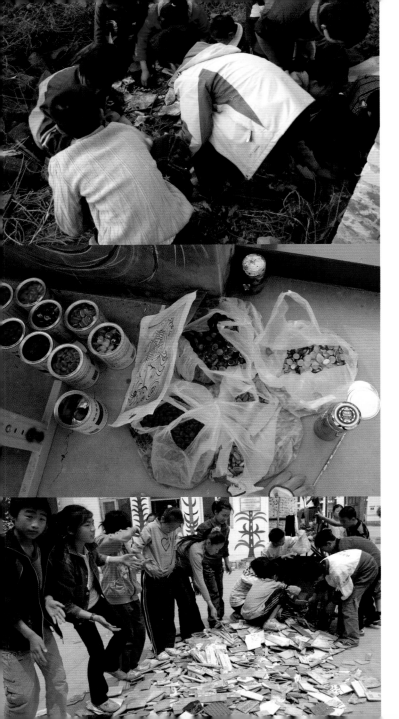

After two years of preparation, I felt it was time to launch a full-scale transformation project that would engage the whole school community. To realize the project was no easy task in an environment highly regimented according to the different schedules and obligations of teachers and students. In order to ensure a smooth operation, at the principal's suggestion we formed a core team, which included art teachers Fu Tao and Pei Guang Rei, volunteer Duan Xiao Lin, mason/builder Zhang Fu, and me. I provided implementation methodology and final designs based on my personal inspiration and the artworks that had emerged from the student workshops conducted the previous year. The other team members worked on planning and coordination.

Mason/builder Zhang Fu assisted me in all the projects that I launched. After having learned and mastered the various techniques, he would teach, support, and supervise the students and volunteers. Based on the needs of the different projects, art teachers Fu and Pei organized students in various art classes. Often in the enthusiasm of the moment, students wanted to help. Duan was extremely resourceful in engaging those interested students.

Our core team was well supported by the school principal and by the party secretary, Wang. In addition to their personal involvement in different aspects of the project, they oversaw its smooth operation during all implementation phases.

1. COLLECTING TILES

The first step was collecting tiles and getting some of the walls ready for mosaic work. We purchased boxes of square or rectangular commercial tiles in various colors, and asked students to break them and place the pieces in different containers for easy access. We also actively looked for broken tiles and ceramic wares that could be recycled. The students showed us where to find them. Excited and proud, they led us, climbing over walls, to an abandoned site where broken tiles lay buried in dirt. The students gathered the tiles and

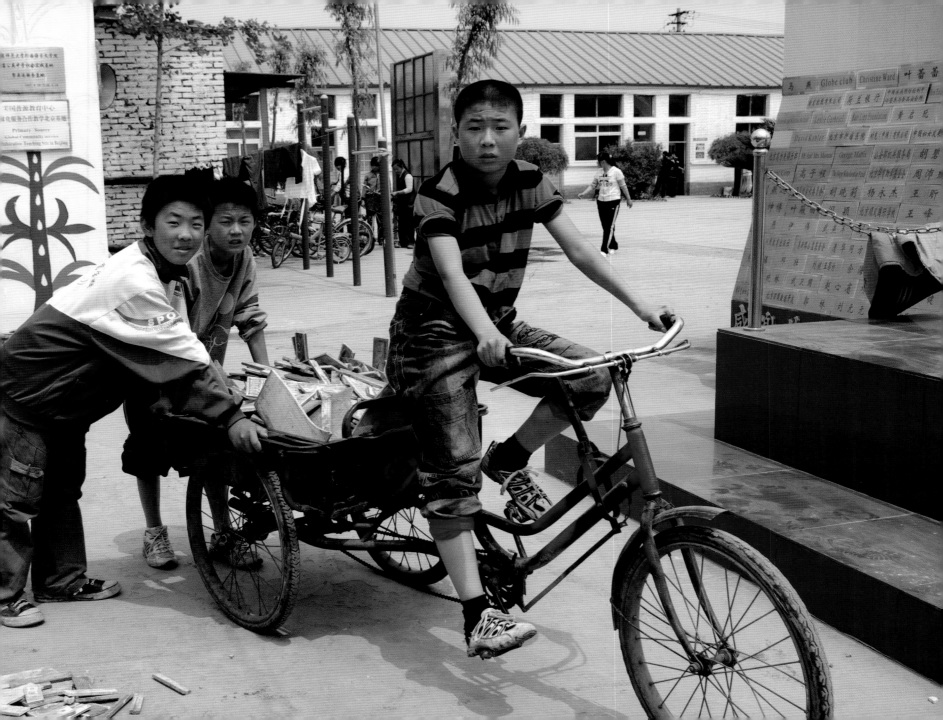

Mosaic details composed of commercial and recycled tiles, broken mirrors and glass beads. The mirror fragments in the rotating star on the right generate surprising details by reflecting images in the surroundings.

transported them to the schoolyard, where they spilled them onto the ground. They then washed and sorted them in buckets so that they could be ready for use.

The surface of commercial tiles is smooth and a bit monotonous due to its predictability. Recycled tiles, on the other hand, have varied thicknesses and patterns. Some are brightly glazed, some have impressed motifs, and some even have decorations painted in gold. They added diversity, surprise, and a touch of the past to our mosaics. In addition to tiles, we also gathered broken mirrors and glass beads for special effects.

2. THE DESIGN

The Dandelion School's main campus consists of a large, open, and cemented schoolyard surrounded by buildings and a bicycle shed. With the exception of the two-story main building, all the other structures are low-slung and one-story high, mostly made of whitewashed walls broken up by windows, doors, and utility pipes. Our goal was to make art that would energize the spread-out, seemingly featureless campus. Simply putting one mural on a wall would do little to change the feel of the campus. To transform the environment, all the walls had to be addressed.

My solution was to create a set of designs based on a major theme and its variations that could be applied throughout the campus, providing unity, cohesion, and interconnectedness.

The beautiful mosaics of Umayyad Mosque in Damascus came to my mind. I have been an ardent admirer of Islamic culture, especially in the fields of art and architecture. Built during the Umayyad Dynasty in the eighth century, this mosque contains history and mystery. On my trip there in 2007, I witnessed its power and splendor. I had the opportunity to see the age-old mosaics depicting buildings and landscapes that decorate the façade of the lofty veranda, softening the stern majesty of the space and giving a sense of continuity. One motif, the fruit-bearing trees, caught my eye—especially the one

Mosaics from the Great Mosque of Damascus, Syria.

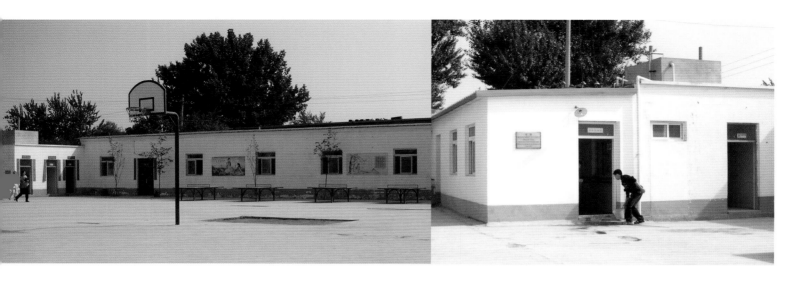

The buildings facing the main campus. *Above left and right* Boys' dorm, utility room and lavatory. *Below* Classrooms.

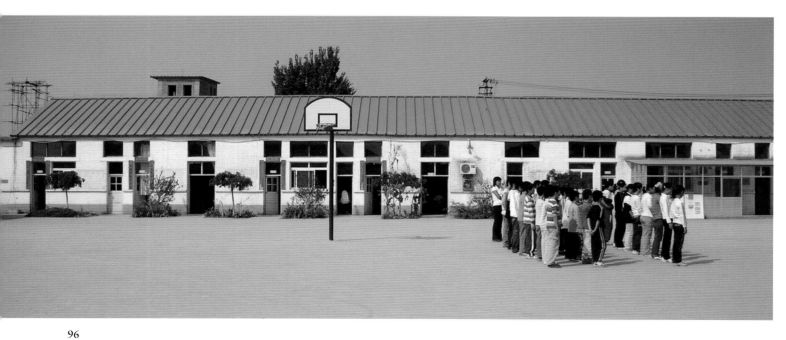

that stood in the center of the mosaic panel. It was the Tree of Life. In the Village of Arts and Humanities in Philadelphia, the Tree of Life murals that I designed for the Meditation Park and the Eagles Park were both strongly influenced by Islamic art in their composition, subject matter, and color.

I also remembered what students had said they wanted to see on campus: nature, trees, flowers, and anything green. Their paintings clearly expressed their wishes and dreams.

I felt again that the Tree of Life should be the theme for the main campus. The Islamic religion began in the desert land of Saudi Arabia. In the early days of their development, Islamic countries occupied difficult and arid terrains mostly in the Middle East and North Africa. The intense blue and green colors used in their art and architecture reflect a desire for water and trees. In the Koran, paradise is described as a place located in a lovely garden surrounded by four rivers.

The cement environment at Dandelion reminded me of the sterility of the desert. This is why the students craved something growing, water, and blue and green colors. I wanted to introduce the blue and green dominated, tiled murals of Islamic architecture to Dandelion, to fill the walls with colors of sky, sea, forests, and gardens.

Once the concept was clear, the design part was easy. I sketched out on a piece of paper the structure of the Tree of Life based on my work at the Village of Arts and Humanities. Art teacher Fu organized the students in the special vocational training class to carry out the painting on a piece of nine-by-nine-foot canvas. When they finished painting in flat colors, I showed them how to make the painting come to life by adding more layers in certain areas to enhance contrast or a sense of depth. So here at Dandelion we created a Tree of Life that originated in Islamic Iran.

Left The Tree of Life mosaic mural, Meditation Park; *Right* The Tree of Life of Life painted mural, Eagle's Park; The Village of Arts and Humanities, North Philadelphia

3. THE FIRST MOSAIC MURAL

Starting in 2005, I had been leading a community-based art project in Salt Lake City, Utah, called Bridges over Barriers, sponsored by NeighborWorks Salt Lake. The mission is to transform a dark, oppressive, and foreboding twenty-two-thousand-foot concrete viaduct that separates communities into a place full of colors and images that celebrate community accomplishments and bring people together. The first phase was completed in 2009. Local artists and hundreds of people from the community decorated sixteen huge twenty-foot-tall columns with brightly colored mosaic tiles. This project showed how even hostile places like viaducts can offer opportunities for creative action and community building.

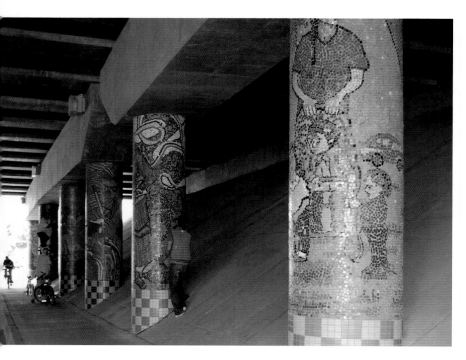

Completing the mosaic columns at the underpass of Interstate 15 freeway, Salt Lake City, 2008.

INDIRECT APPLICATION METHOD

Working in Salt Lake City, I learned a new indirect method of installing mosaics and brought this new technique to Dandelion. In indirect application, we create a mosaic mural over a painted canvas on the floor, cut the canvas into small pieces, and then transfer the pieces onto allotted wall spaces according to a numbered sequence. This method is particularly helpful when multiple inexperienced participants are working together.

To start, we created the design on a large canvas and then placed the tiles on the canvas according to the laid-out patterns—white tiles on white flowers, brown ones on branches, etc. This kind of application is rather restrictive, but for beginners it is an easy way to learn the art of making mosaics. To make the mosaic design successful, we paid attention to the outlines of images. Once outlines were clearly defined, placing mosaic pieces inside the outlines could be done in a more relaxed way.

When placing tiles next to each other, it is necessary to leave some thin interspaces for grouting later in the process (Grout secures the tiles in place and also protects them from weather and water erosion).

Placing tiles over the large painting of the Tree of Life took patience. The art teachers set up a flexible time schedule to allow more students to help. Some parts were carried out during class time under the tight supervision of a teacher, while others were implemented through the students' spontaneous participation.

After all the mosaic pieces had been properly placed on the canvas, we put a heavy clear plastic sheet over the design. The plastic sheet had a sticky side so it could glue itself to the tiles. Four people worked together, each holding one corner of the plastic sheet to ensure its proper placement. We pressed the plastic sheet against the mosaic, making sure that it adhered to every piece of tile.

Because the entire plastic sheet with tiles stuck to it is too large and heavy to be installed in one piece, we cut it into smaller sections for easier handling. It would have been easier to have used two-by-two-fot square sections; but because of the shapes in the mural design, we had to cut the sections according to the position of the tiles. Then we labeled each section carefully to mark its exact location within the mural.

We put adhesive on the backs of the tiles, section-by-section, and started the process of installing the sections on the wall. When all the sections were firmly glued to the wall, we applied the grout (If the surface is relatively smooth, one can use a trowel for grouting. If not, the cracks have to be grouted by hand).

It is important to wipe off any excess of grout before it dries. Once dry, it is very hard to remove. When properly polished, the mosaic surfaces should have a jewel-like richness that delights the eye and beautifies the surroundings.

DIRECT APPLICATION METHOD

Later I introduced the simpler mosaic method at Dandelion School that I had used for years in Philadelphia—a direct process that requires gluing each mosaic piece directly to the wall individually. First the design is traced on the wall, then the tiles are glued to it piece-by-piece. Again, attention must be paid to define clearly the design contours to give the composition structure. After that, one can be more casual in placing the rest of the mosaic pieces.

When the glue under each tile is dry, grout is added to the mosaic, filling every space between the tiles. When the grout is almost dry, the surface of the tiles must be polished with newspaper or dry cloth (wet cloth will mess up the surface). Once the direct method was introduced, people at Dandelion stayed with this simpler way of making mosaics. It provided more flexibility in scheduling and demanded less space to carry out the work. It also required less planning than the indirect application method, and thus allowed people to participate more easily.

The unusual and tactile quality of either mosaic process generated a great deal of excitement among students.

Above left Sketching the design on a piece of heavy fabric.
Above right Setting a plastic transfer sheet over a mosaic section.

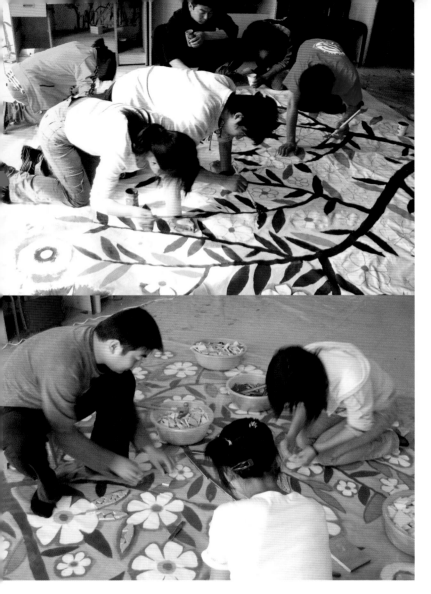

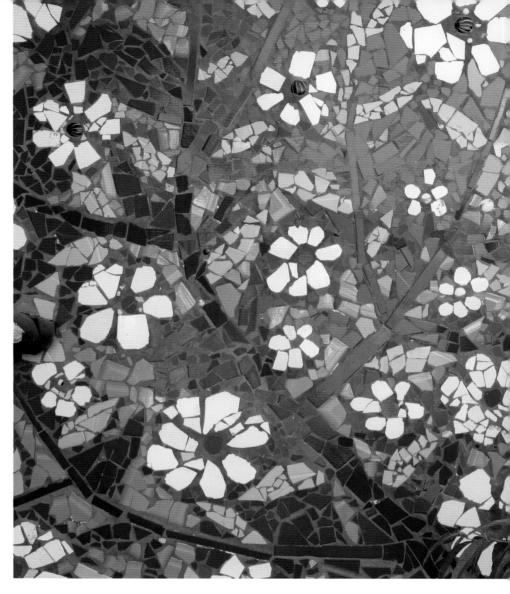

Upper left Art teacher Fu Tao and students painting on The Tree of Life canvas. *Lower left* Following the established colors and patterns, placing mosaic tiles over the Tree of Life painting. *Middle* The completed mosaic mural. *Above far right* A piece of the cut up sections of the mosaic mural with the transparent plastic sheet still adhering to its surface. The purpose of the plastic sheet is to hold all the tile pieces together for installation. *Below far right* After placing all the cut up sections in place with tile adhesive, masons Zhang and Yu grouting the mosaic mural.

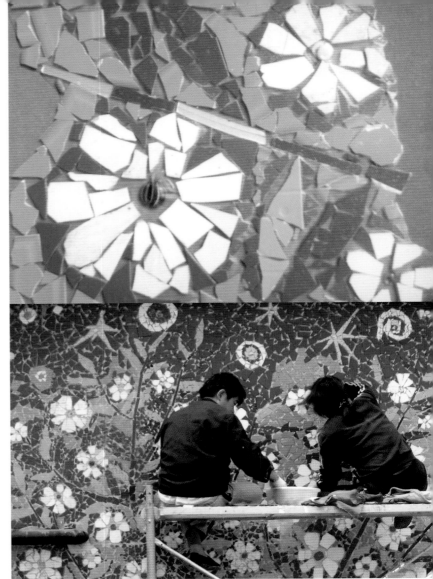

4. STUDENT-LED MOSAIC MURAL

To make the Dandelion School project sustainable, it was important that work would continue after my departure. In the spring of 2008, while I was showing students how to do mosaics, Huang Chao Ran, a student in the vocational training class, created a lovely drawing of swaying branches loaded with blossoms. He made this for the other bare walls, continuing the same theme of trees and flowers that I had designed for the front wall of the campus. His smooth, curly lines reminded me of Persian drawings. A fellow student sketched the design on the wall, and participants from different classes completed the mosaic work. The fact that the Dandelion community completed this mural installation project without any help from me was an achievement to be celebrated.

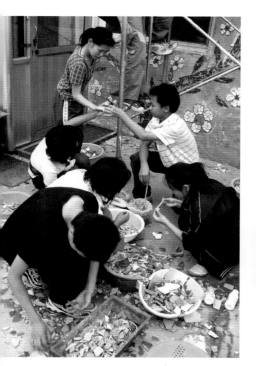

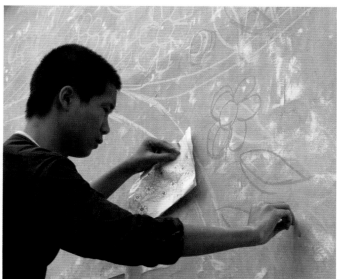

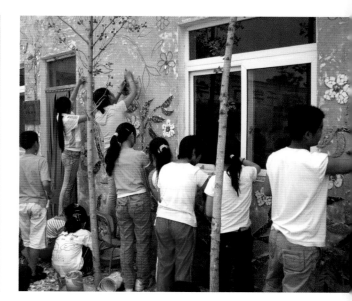

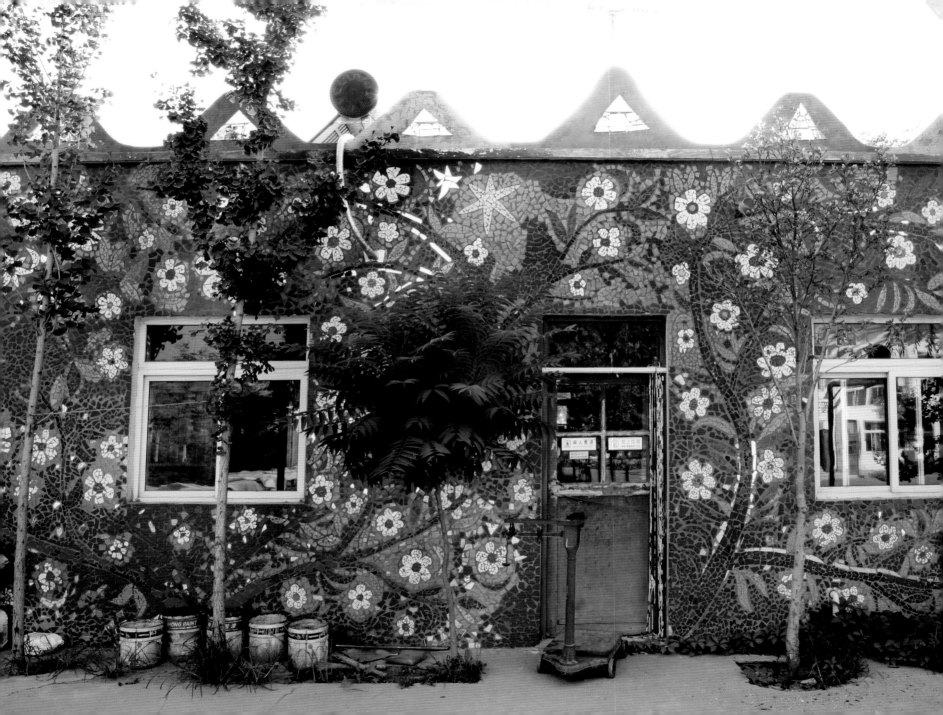

KU SHU LAN AND HER TREES OF LIFE

The first time I saw Ku Shu Lan's work, in the late 1990s, its power shook me to the core. Her medium is paper-cutting. Breaking out of the limitations of traditional paper cuttings, which are usually monochromatic and small in scale, she created multilayered, multicolored grand-scale pieces that transformed her environment and people's concept of folk art.

Ku Shu Lan was born in 1920 in Xun Yi, a poor and remote rural village deep in the loess cliffs in the faraway region of Shaanxi province. This vast, formidable, and near desert land was home to the ancestors of the Han people. It has witnessed the rise and fall of many empires in China's history. The art people created there throughout the ages contained the dreams and aspirations of the generations who lived, toiled, and perished here. Folk art became a reservoir of images that reveal ancient tales, knowledge, and beliefs.

Even within this richly endowed folk art tradition, Ku Shu Lan's work explodes like a forest of summer flowers, dazzling in its content, colors, and forms. Through her insatiable desire for beauty and with her talent and imagination, she transformed her life from one of poverty, abuse, and suffering into one of abundance, hope, and joy. In 1985, she was in a coma for forty-some days after falling from a cliff near her house. The first thing she did after regaining her strength, following a slow and difficult recovery, was to pick up a pair of scissors and start paper-cutting. Calling herself the Lady of Flower Paper Cutting, she worked feverishly to tell her tales and to share her vision of beauty with the world.

Although paper-cut art is widely practiced in many rural regions in China, Ku's work stands out in its innovation and complexity. The bird in the image to the right, for example, is called the "downward looking" bird. Supposedly it is looking downward and straight-ahead at the same time. Crowned with its beak and a pair of circular ears, the bird has a feathery body, which is composed of layers of colorful cutout shapes and dots.

The figure on the lower left, the man-faced fish, is an impressive paper cutting in my collection by an unknown artist from the loess region of Shaanxi. The origin of the form came from faraway times when hybrid beings appeared on ancient bronzes and stone carvings. Most of the paper cuttings were done in one color, mostly red. By contrast, Ku's work contains multiple layers of shapes and colors that tell complex stories of life, dreams, and the future. Her work was the guiding light throughout the whole design process at Dandelion.

Ku Shu Lan's works helped me to envision the theme of the designs for the school entrance. The Tree of Life is pictured in mosaics on the columns of the entrance, their tall blossoming branches reaching to the ceiling of the platform over the columns. I filled the ceiling with swirling, shining stars, which carry my wishes for these young migrant students. Although their lives are full of struggles, they can nurture their dreams and aspirations. Their education and hard work will carry them to the stars.

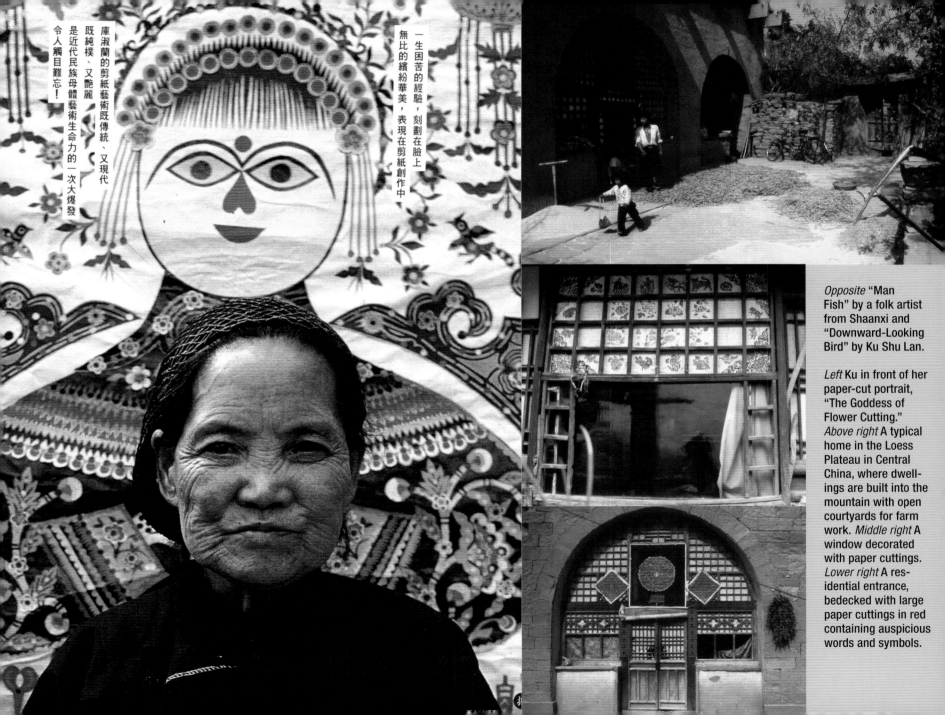

一生困苦的經驗，刻劃在臉上
無比的繽紛華美，表現在剪紙創作中

庫淑蘭的剪紙藝術既傳統、又現代
既純樸、又艷麗
是近代民族母體藝術生命力的一次大爆發
令人觸目難忘！

Opposite "Man Fish" by a folk artist from Shaanxi and "Downward-Looking Bird" by Ku Shu Lan.

Left Ku in front of her paper-cut portrait, "The Goddess of Flower Cutting." *Above right* A typical home in the Loess Plateau in Central China, where dwellings are built into the mountain with open courtyards for farm work. *Middle right* A window decorated with paper cuttings. *Lower right* A residential entrance, bedecked with large paper cuttings in red containing auspicious words and symbols.

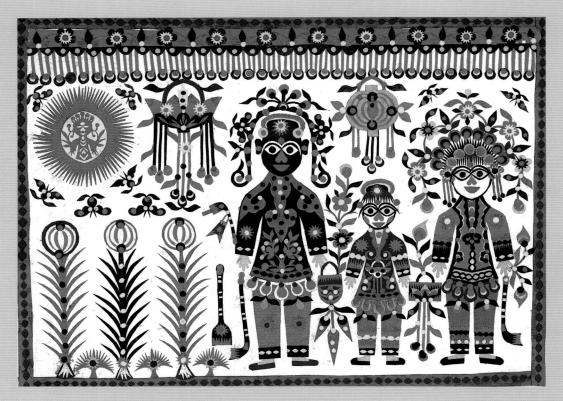

Above Ku Shu Lan's works impress us not only because of the vibrancy of color and tight structure of composition, but also for the complexity of the pictures and the meanings they reveal. This 15"x 21" multi-layered paper cut contains iconic images, such as the life-giving force symbolized by the mythic figure of Zhua Ji Wa Wa (抓髻娃娃) dwelling in the sun, the good luck butterfly-like bats (*fu,* 蝠) scattered throughout the picture, and the tree of life plants in the lower left corner, which inspired the creation of many images at Dandelion. *Right* The people in her works are beautifully bedecked like brides and grooms, often surrounded by flowers, trees, and colorful household utensils. Her creativity empowered her to transform her impoverished bleak environment into a land of wonder and enchantment.

5. THE SCHOOL ENTRANCE

The shabbiness of the school entrance weighed on people's minds. "Improve the school entrance," wrote one teacher, and one student commented, "The first time I saw the Dandelion School, it had nothing. Very ordinary. The same like all the other schools. It looked dilapidated. I did not even enter."

Dandelion School is located in a crowded, hectic urban area, frequented by gang fighting. Dandelion's principal requested that the main entrance be designed in such a way that it commanded deference and respect. "We want the visual design to be so powerful," she stated, "that it will discourage lingering, littering, gang fighting, and other uncivil behaviors."

After the entrance had been transformed, a student commented last year, "I came to Dandelion only last semester. I have visited several schools before I came. I chose this school because the campus is so lovely."

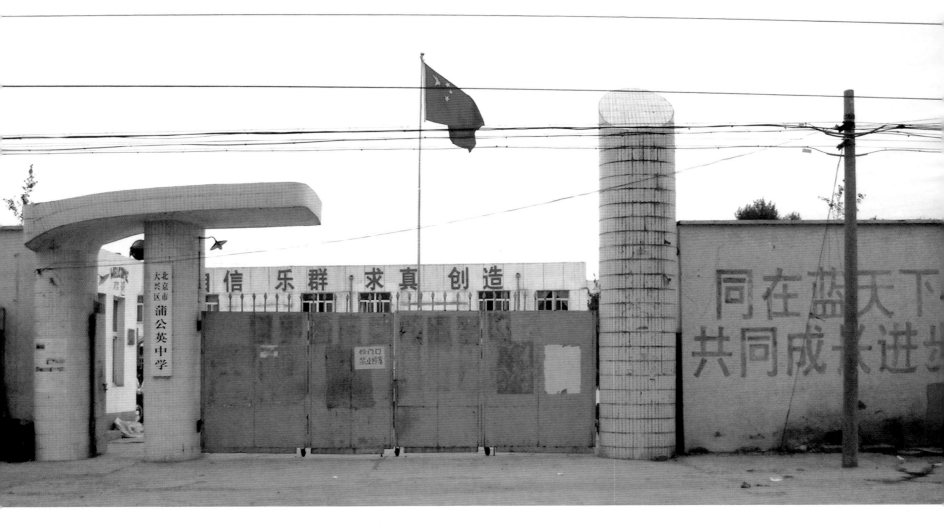

The school entrance before improvement. The red characters on the right-hand wall say, "Together under the blue sky, we grow and make progress."

Above My sketch, inspired by Ku Shu Lan's Tree of Life paper cuttings.
Right The school entrance after transformation.

112

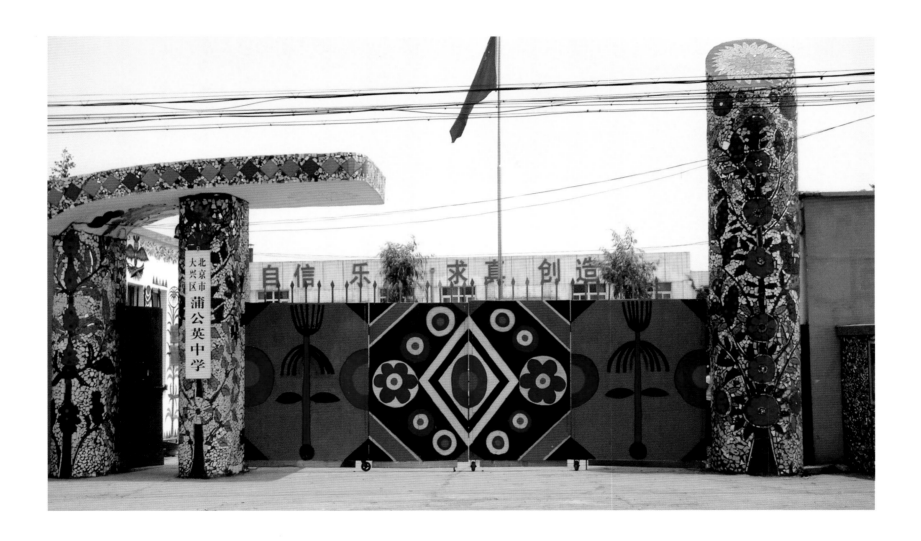

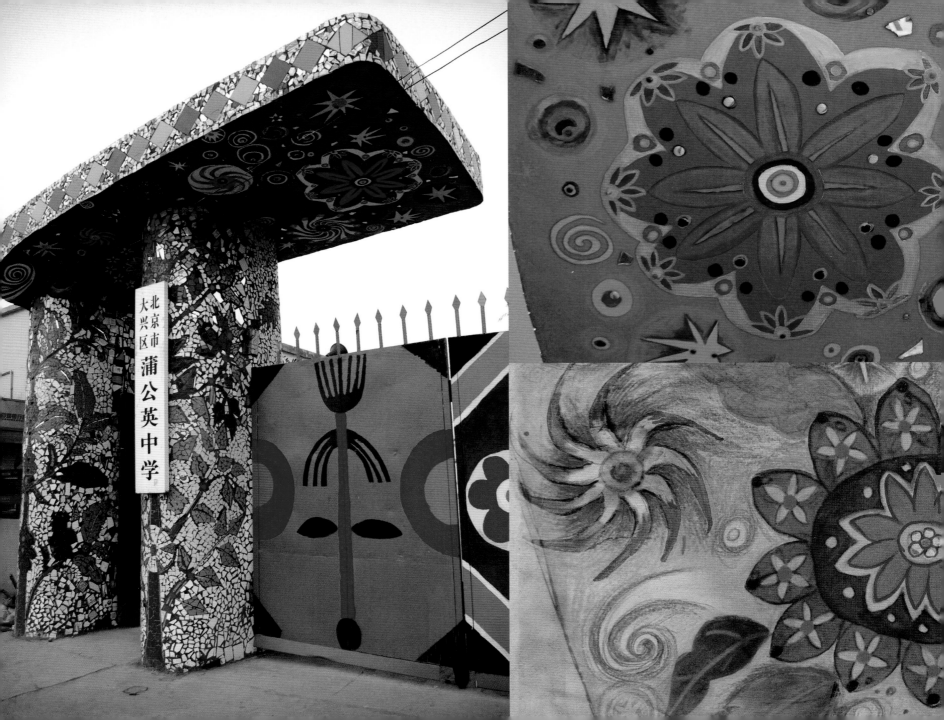

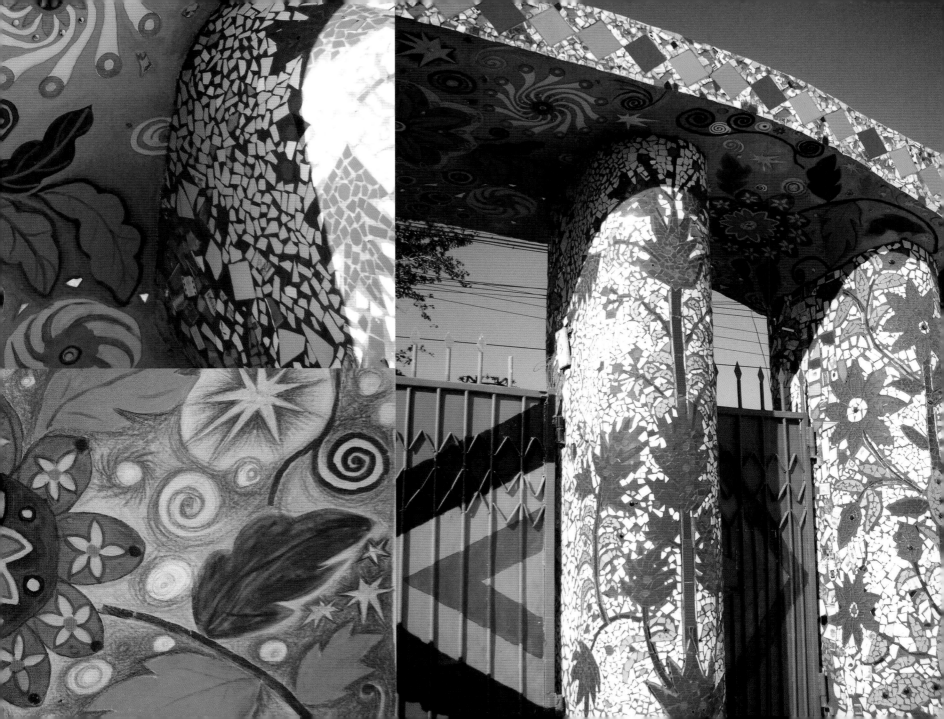

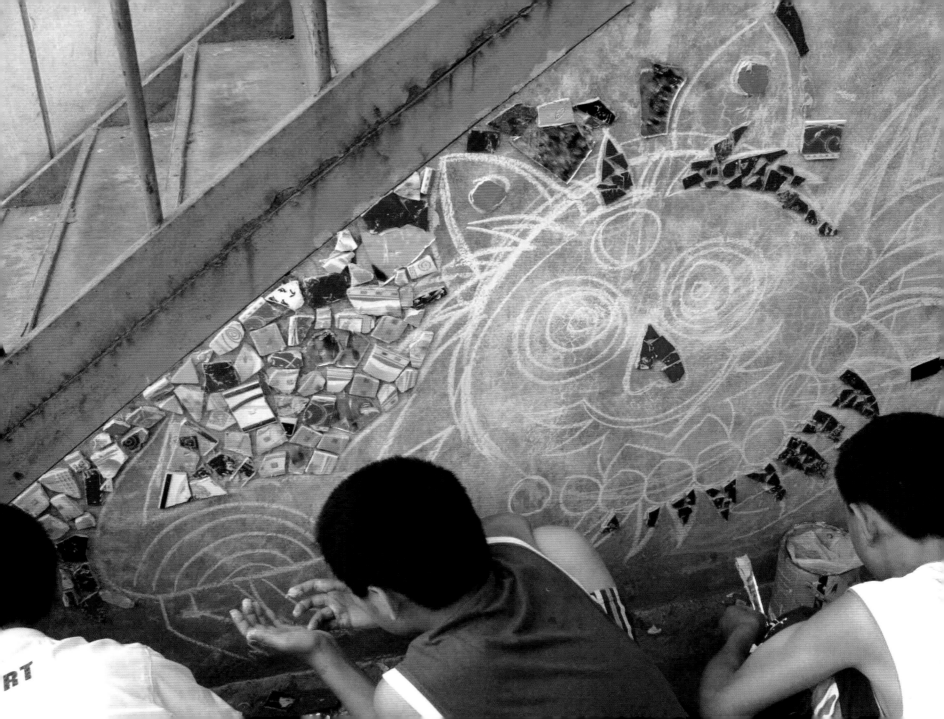

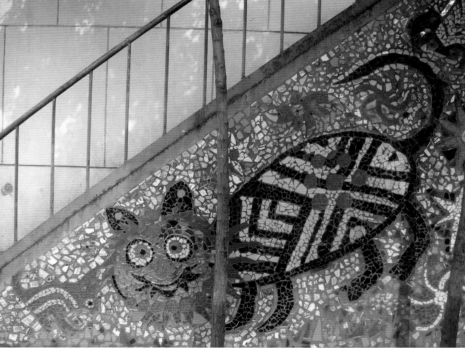

Opposite Students making mosaics on the staircase wall. *Upper right* My design, based on Ku Shu Lan's magical cat with big round eyes and a heart-shaped nose, carrying stars on its back. *Above* the completed celestial cat amidst the stars and smiling at the red mouse with yellow stripes.

6. THE MAGICAL CAT

Right across a narrow passageway, and facing the utility room and lavatory, stood a blank triangular wall that supported the rusted metal stairway leading to several offices on the second floor of the building. Every day after meals, hundreds of students washed their utensils in the utility room. The utility room and lavatory were quite clean despite being heavily used by so many people daily. But I still imagined the possibility of food attracting mice and cockroaches, so I wanted to put a powerful cat there as a guard. The inspiration for the cat also came from Ku Shu Lan's paper-cuts. Adapting her design to the shape of the triangular wall, I placed the cat in the company of a potent scorpion amidst swirling stars. Under the supervision of teacher Fu Tao, students helped to complete the mosaics.

7. PASSING ON THE BATON: A COLORFUL CORRIDOR OF MOVEMENT

To make a project last, it is important to pass on its methodology. Fu Tao, the young and gifted art teacher at Dandelion, had been assisting me from the beginning of the project. He had seen how I planned and carried things out. He excels in the traditional academic painting style, which emphasizes precision in rendering details. I thought that doing some design for the project would be a good opportunity for him to expand his talent and imagination.

In 2007 the Dandelion campus contained only two open areas, the main courtyard and a small yard between buildings in the back. A dim, dilapidated corridor connected the two open spaces, and the experience of passing through it was unpleasant. This was a perfect opportunity for re-creation. I asked Fu Tao to take the reins on this project. Basing his design, once again, on Ku Shu Lan's works, he collaborated with school officials and students and successfully transformed the space into a delightful passageway.

Teacher Gao Wen-Ying said "Ever since I came to this school, it has been improving day by day. It is becoming more and more beautiful, so full of colors. I can feel that students are happy here and teachers work joyfully in this environment."

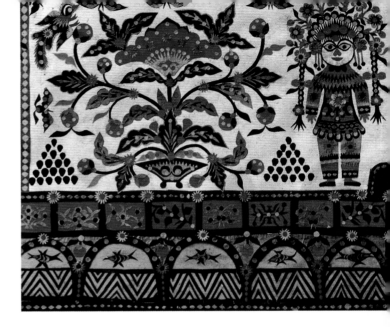

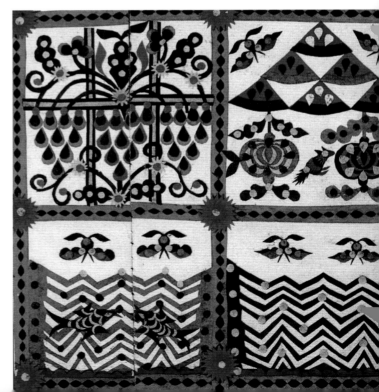

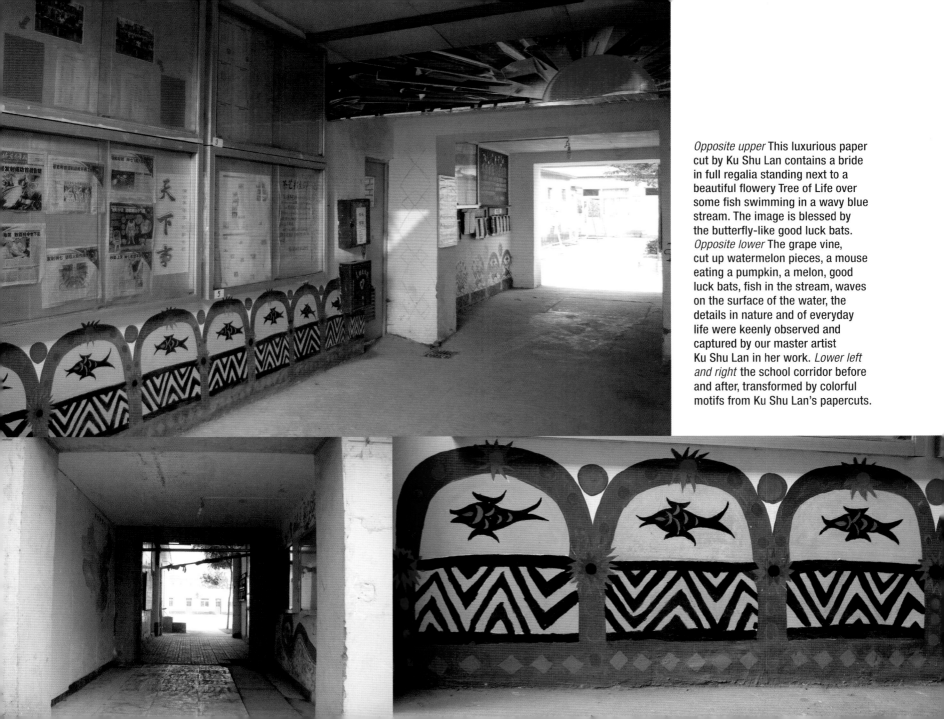

Opposite upper This luxurious paper cut by Ku Shu Lan contains a bride in full regalia standing next to a beautiful flowery Tree of Life over some fish swimming in a wavy blue stream. The image is blessed by the butterfly-like good luck bats.
Opposite lower The grape vine, cut up watermelon pieces, a mouse eating a pumpkin, a melon, good luck bats, fish in the stream, waves on the surface of the water, the details in nature and of everyday life were keenly observed and captured by our master artist Ku Shu Lan in her work. *Lower left and right* the school corridor before and after, transformed by colorful motifs from Ku Shu Lan's papercuts.

Details from two dark paintings, each 4'x 6', acrylic on fabric sheets, created collectively by students during the Paint Big, Paint Together workshop in 2007.

Activities in the fabric workshop studio, Duan Xiao Lin
sewing and talking with Principal Zheng Hong.

8. QUILTED WALL HANGINGS AND CREATIVE WRITINGS BY STUDENTS: RECYCLING THE DISCARDED INTO ART

In the spring of 2008, I noticed that the window shade of the art room was one of the dark, chaotic paintings made by my students during the Paint Big, Paint Together workshop in the spring of 2007. Then I noticed a big pile of rumpled sheets in the corner of the room—more of the dark paintings of the previous year. "Don't discard them. Let's discover the treasures hidden within them," I suggested.

Although on first glance the paintings looked messy and random, I sensed a raw power in their bold, spontaneous brush strokes. With the help of some volunteer students, we reworked some of the surfaces and turned some others into collages.

Wang Xieu-Mei, a staff member at Dandelion, excels at embroidery. Together, she, Duan Xiao Lin, and I set up a fabric workshop studio in which we produced a series of collaged paintings framed by quilted and embroidered borders. This body of work looked fresh and exciting because no one at Dandelion had seen this kind of art before. They were, however, very much in the tradition of Chinese folk art made by women.

I felt that this body of work would provide a good opportunity for students to observe and comment. Several teachers engaged their students to respond in writing—narratives, poems, and even short stories. Following are three samples of the poems.

THE TREE OF LIFE
by Yang Jian Yu, seventh grade

On the right is a tree of winter
Against a snowy white sky
I see a blue planet, earth
Floating amidst blue clouds.

In the middle is a tree of summer
Lush with leaves, it has so many red flowers
It feels like a person in his youth
Full of energy and life.

MESSAGE FROM THE OCEAN
by Jian Huey, eighth grade

Along the ocean
Humming a deep heart song
Gentle waves accompanying
What belongs to us is always happiness
Not sorrow
Facing the fiercely rolling sea water
Let go what needs to be let go
Imagine freely what needs to be imagined
Standing on the bank of the ocean is not the sun.
It is we who are holding within not dead water
It is the ocean waves.

On the right stands a tree of autumn
No more leaves on the tree
Bright green sun shines on the tree
Like the love from a mother
Gentle and selfless.

A DWREAM-PRODUCING PICTURE
Jin Liao Wang, seventh grade

Two little children on a basket court, shooting a basketball
Failing repeatedly, not even one went in the basket
Gradually they seemed to gain some understanding
They must not shoot aimlessly
Taking the aim, they shoot the ball with determination
Shua! It went through.
A simple dream. They succeeded.

The sky is so blue.
Standing under it,
I too have many dreams.
I can't bring all of them into reality.
But they motivate me
To work hard to realize them.

9. SPRING 2008 EXHIBITION

The first exhibition in the fall of 2007 had taken place in a small multipurpose room. I had to display the documentary photo images one next to the other in double rows due to the limited wall space. When teachers brought students to see the exhibit, they had to stand very close to one another.

This time we were given a large room on the second floor of a newly constructed, factory-style building with high ceiling and big windows. The room was not quite complete. Tables and chairs were scattered across the white tiled floor, and parts of the plaster walls were unfinished. There was dust everywhere. Our first task was to clean up the space. It took three days of thorough cleaning and scrubbing to get the space ready.

The next challenge was the insufficiency of exhibition materials. Although I had brought what would have been plenty of photographs and original works for the old space, they felt thin and anemic in this huge new area. This small crisis offered us an opportunity. I improvised by presenting many of the new works that had been produced at Dandelion since my last visit. The intention of the exhibition evolved from inspiring through other people's works to displaying and honoring the works created by the Dandelion community itself, particularly the students. It made the exhibition all the more relevant and appropriate for the school population.

The main theme of the exhibition—to celebrate life with music, art, and dance—explored the meaning and form of an arts festival, including exhibitions, performances, and ritual celebrations. As the last activity of the transformation project, I hoped to launch an arts festival at the Dandelion School with school-wide participation, including parents. I wanted to create a celebration that reflected the roots and cultural diversity of this particular group of people. Its structure and shape would emerge from the process of working together to create the festival. The result would nurture and strengthen the community, deepening its members' understanding of each other and themselves. I brought as examples the images

of the various festivals that were carried out at the Village of Arts and Humanities in North Philadelphia, at Korogocho community in Kenya, and at Rugerero Village in Rwanda. I hoped that these images would inspire the Dandelion community to create its own festivals and rituals.

Because of the ample wall space, we proudly presented the series of quilted fabric wall hangings collectively created by students, volunteers, and folk and visiting artists. This body of work best expressed the process and result of co-creative activity, providing room for different participants to offer their talents and creating a vision that none of the participants could accomplish on his or her own. The exhibition also included a series of test samples of creative crafts made from recycled materials.

In addition to the series of documentary photos on festivals, I also brought samples of art books made by artists and students in Philadelphia and children in Damascus, Syria. Some books are tiny and playful, with glued-on folding papers. The anchor piece in the book section is a thirty-page-long handmade book in large square accordion format created by first-grade students in teacher Jane Laties' class in the Project Learn School in Philadelphia. This book, put together by Laties with the help of a group of six-year-olds, though rough in appearance and primitive in techniques, shows so much joy and creativity that I used it to inspire the Dandelion students when the time came for them to make their books.

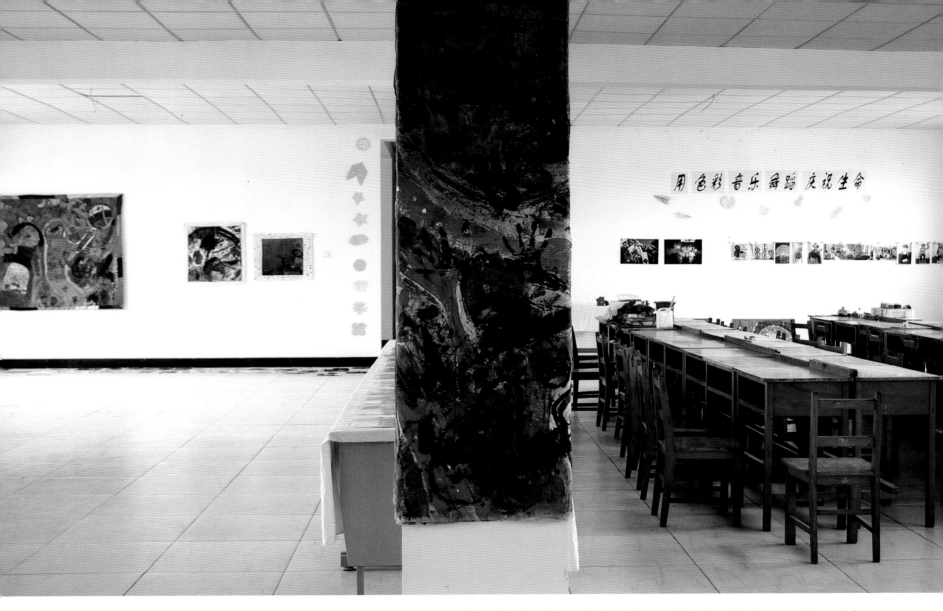

用色彩音乐舞蹈庆祝生命

Images from the exhibition: *Opposite* The title of the exhibition "Celebrating Life with Colors, Music, and Dance." *Above* A large painting by students covers the central pillar in the room, quilted paintings hung on the left side of the wall while its right side was taken by a series of documentary photos.

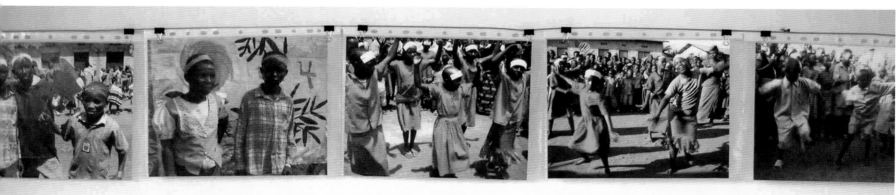

I did not fully realize how complicated it would be to carry out the idea of a festival. First, we needed to get the teachers interested. We had to plan a year ahead so that creating an arts festival would become part of the school curriculum. What activities and how? All of the aspects required much discussion. The idea of a festival was continuously pushed back because the school leaders were bombarded daily with urgent issues, teachers felt overstretched, and students were preoccupied with their studies and grades, especially during the months of May, June, and July. The graduating students existed in a pressure cooker during those months, focused solely on studying for the national entrance exams, which often decide their future. Dandelion, in spite of its philosophy of education, did not escape that pressure.

The more congested the space, whether physically, emotionally, or mentally, the more engaged I become in organizing an arts festival. It is a wonderful way to create new spaces and new experiences that help participants feel relaxed and rejuvenated. So I remain hopeful that an arts festival will take place on campus sometime soon in the future.

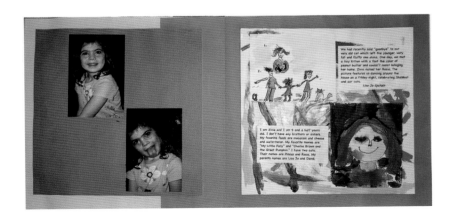

Opposite and left The book section in the exhibition and one page from a children's art book, "Meet Jane's Group & Their Families." The students and I are looking at and discussing the accordion book format.
Opposite lower A series of documentary photos about festivals I have launched in the Rugerero Survivors Village in Rwanda.

10. BOOKMAKING ABOUT SELF

Dandelion students are often wounded and deeply affected by the economic and social conditions of migrant workers. The most effective way I felt that would help them to heal and gain self-esteem was to provide them with opportunities to tell their stories. Since the spring of 2008, during each of my three visits to the school, I have conducted bookmaking workshops, engaging hundreds of children in different grades. Since I am not a book artist, I have learned bookmaking alongside the students. In their books, I wanted students to narrate in words and images who they were, where they came from, what they left behind, their families, their most precious memories, and their dreams for the future.

After discussion with Principal Zheng Hong, I began the first series of workshops with the ninth-graders. This group of graduating students was under considerable pressure, as they were preparing for the entrance exam for high school. Making art to express their emotions and thoughts, we felt, would help them to relax a bit and gain some kind of balance in their rigorous schedule. In addition, this would be their only chance to take part in the bookmaking project before leaving school.

I held the workshops in the spacious exhibition room, hoping that the students would be inspired by the images hung on the wall and the handmade books on the display tables. The students jumped in with enthusiasm.

The workshop for each group lasted one and a half hours, two classes combined into one. Still the session was intense, since our goal was for each student to complete all the pages for his or her book. The students took action and produced. Although many of the images were rough-edged, they showed an untamed, refreshing energy. And although their writings often lacked depth, some began to reveal inner worlds. It was a good start.

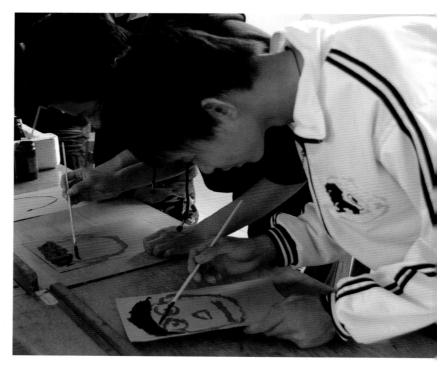

Book-making workshops for ninth-graders in the fall of 2007.

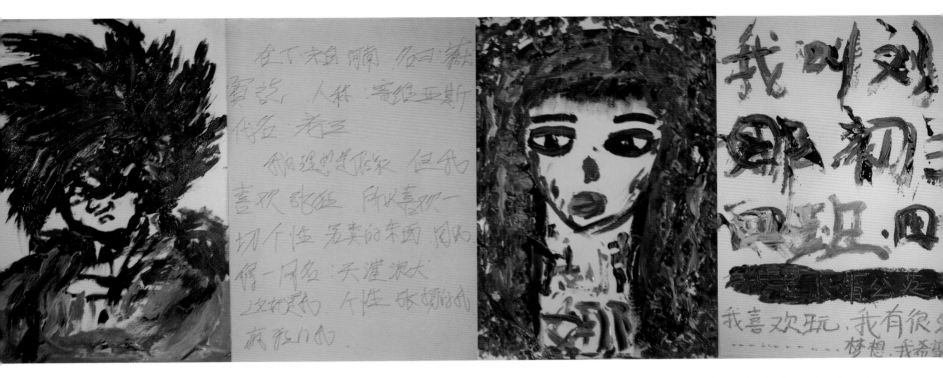

I came from Henan, a place named Yu Bing Zhi. People call it Selvias. My nickname is Lao Shan, number 3.

My dream is to become a writer. But I like to brag and inflate. As a result, I like everything that shows character and daringness.

That is how I got my web name, vast horizon with turbulent waves. This is me, with proclivity to craziness and exaggeration.

My name is Lui Na, in ninth grade, class 4. From Xichuan. I like to play. I have many many dreams.

I hope.

7

Fall 2008:
Personal Journeys and
Cultural Heritage:
Developing Awareness
Locally and Globally

1. CAMPUS TRANSFORMATION CONTINUES: PREPARING WALL SURFACES AND SHAPING ROOFLINES

Facing the main entrance gate stands the most important building on campus—a long, rectangular, and white-painted brick structure two stories high. The façade is decorated by the four sets of twin characters that signify the goals of the Dandelion School. The building looked worn and fragmented with its peeling paint, mustard-colored door, windows, buttresses, and rusted rain pipes.

My design had to celebrate the meaning of those characters and at the same time energize and unify the building. It had to be bold, simple, and colorful. The design created by a student in the previous year's workshop came to mind. The student had brilliantly placed a huge rainbow over the whole building. That was the answer.

But a rainbow hovering high upon the building would have been static and aloof. It had to shower down, sending its multicolored rays to enliven the building façade. To give a sense of unity, I covered the doors, window frames, and the eleven two-story-high treelike buttresses in blues and greens. Now the design looked harmonious and dignified. The next step was implementation.

Preparing the walls and windowpanes posed no difficulty. What was difficult was the construction of the long protruding curve over the two-hundred-foot-long roofline for the painting of the rainbow.

Our construction crew set up an extensive scaffold with wooden planks covering the passageway of the top two levels. Students would have loved to go up with us, but understandably it was strictly forbidden. Foreman Liu insisted that I, who had climbed scaffold more times than I cared to remember, wear a safety chest belt. He was ordered to hold on to the rope that was attached to my safety belt during all the hours I worked on the scaffold or rooftop. I was quite annoyed at the beginning. Once I accepted it, I felt the care and love of the people in Dandelion. It was a blessing to be working here.

The straight lines of the buildings and the cemented surfaces, legacies of the original abandoned factory, felt harsh and utilitarian. I decided to turn the horizontal rooflines on the main campus into gentle wave-like curves composed of rhythmic undulating shapes. We needed many bricks to construct the rainbow at the center of the main building and to shape its rooftops. We were confronted with the problem of how to transport the bricks from the ground to the rooftop. Again, students came to the rescue.

Sometimes low-tech and low-skill solutions can be impressively effective. Teachers lined up students through the main campus and over the stairway to the second floor and asked them to pass the bricks by hand. They had to haul some of the students up over the rooftop to continue the delivery line. The students were excited to be in action, especially the ones on the rooftop. They got the chance to show off and do something adventurous. In no time, all the bricks arrived on the rooftop.

On my first effort to paint the rainbow, I completely miscalculated its scale. The rainbow looked all right from where I stood on the scaffold. But from the ground, it looked like ribbons, trivial and lifeless. One student rightly commented, "Too narrow. Ungainly. Need to broaden all the color strips." I did that and the colors began to vibrate. I placed the blue as the top color of the rainbow.

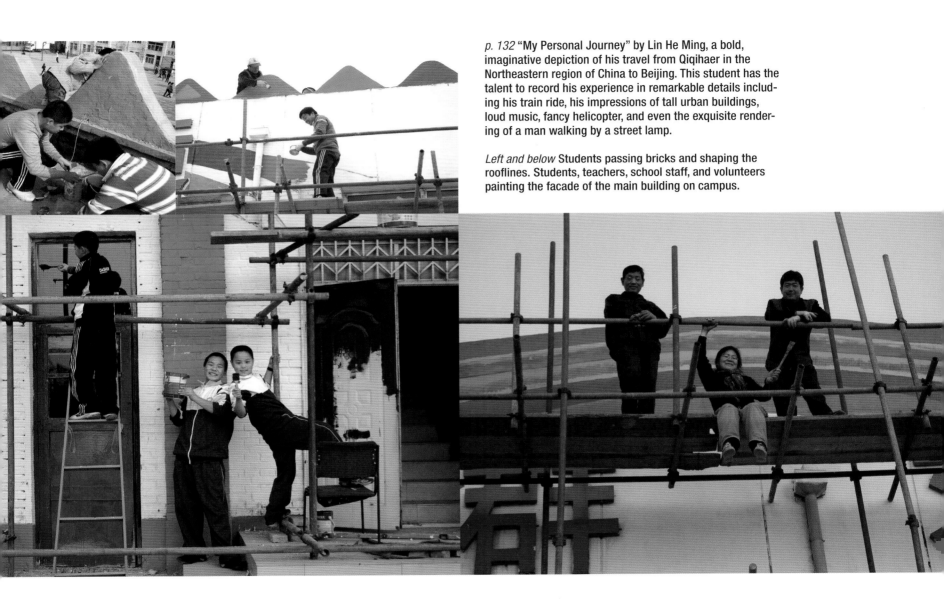

p. 132 "My Personal Journey" by Lin He Ming, a bold, imaginative depiction of his travel from Qiqihaer in the Northeastern region of China to Beijing. This student has the talent to record his experience in remarkable details including his train ride, his impressions of tall urban buildings, loud music, fancy helicopter, and even the exquisite rendering of a man walking by a street lamp.

Left and below Students passing bricks and shaping the rooflines. Students, teachers, school staff, and volunteers painting the facade of the main building on campus.

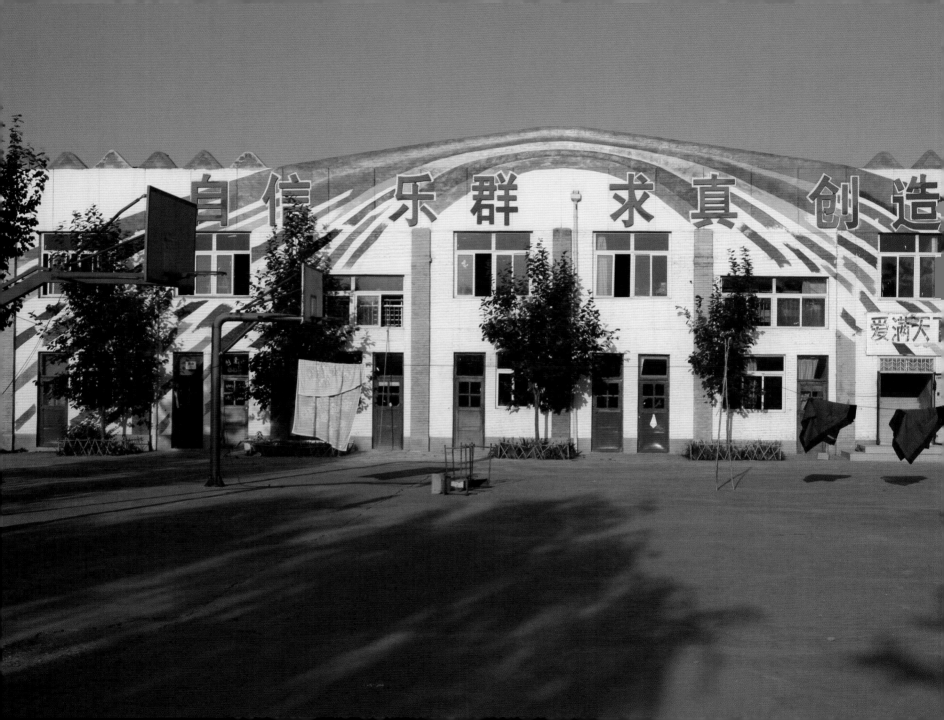

"Sometimes the rainbow seems to melt into the blue sky. It feels magical during those moments," said art teacher Pei Guang Rei.

One late October day, as the sun was setting in the gray soupy sky, I was standing on the top platform of the scaffold, hurrying to finish the work before the light disappeared. Suddenly I heard lovely singing voices rising up from the campus. With a bullhorn, thirty some students serenaded me, "Yeh Lao Shi, Jia You, Jia You [Teacher Yeh, bravo, bravo, get on with it]." The principal was also with them singing. What encouragement and confirmation! Maybe that is why the rainbow looks so sweet on the building.

Although most of our activities took place according to a well-planned schedule, I cherished the times when things happened spontaneously. On a chilly Sunday morning Principal Zheng arrived at the school with her retired elder brother, her sister-in-law, and her driver, Xiao Duan, to paint. Two teachers and several students who happened to be on campus decided to join in. We had not planned to work on Sunday. But together, including volunteer Duan, Mason Zhang, and me, we completed the painting of all eleven pillars on that cold winter day.

Student comments: "Before you started, we all tried to imagine what a rainbow would look like on the building." "Before you painted the rainbow shower, it looked like any other rainbow, kind of ordinary. But now, the rainbow showers rays of colors. It fills our campus with love."

"I feel that the rainbow is smiling toward us." "Yeh Lao Shih is smiling toward us. The whole world is smiling toward us."

My repeated drawing of the sun bird (feng huang) shows my continued fascination with this ancient symbol of life and power. *Left* A sketch made in the 1980s. *Above upper* A tile work of the feng huang in 1988. *Above lower* A study of the feng huang for the Dandelion School project in 2008.

2. THE THRONE

When entering the Dandelion campus, the first thing one sees is the flagpole with the five-starred red national flag flapping in the air. Behind it stands a cement platform. In 2006 it looked quite modest, with two three-foot-high rectangular slabs standing on either side of the platform. In 2007 the school doubled the height of the slabs to increase its visibility. After all, this was the place where the important act of raising and lowering the flag was performed. This was the place where all of the important events were announced and ceremonies carried out. What design could I come up with that would reflect the purpose of this very special place?

Secretary Wang suggested the *long*, or dragon, and the *feng huang*, or phoenix. For centuries, those motifs have been symbols in Chinese art of power and strength. The designs of some students suggested decorations of rich floral patterns. After much pondering, an image emerged in my mind, the mythic bird of the Han Dynasty of 2000 years ago.

In one of my sketchbooks, I found two images, the Tree of Life and the feng huang, standing on one leg in a circle. I could not remember when I made the drawings. The Tree of Life drawing (page 85) was from a stone slab that decorated an ancient tomb. The circle position of the bird design suggests that it came from a round clay piece that decorated the end row of roof tiles. The feng huang symbolizes the sun, heat, south, energy, and life, a popular theme in the decorative art of the Han Dynasty.

I felt that a pair of feng huang would be appropriate for the twin slabs on the stage platform. The symmetry would give the design dignity. The power and life force symbolized would best represent the potential and aspirations of Dandelion students. But how could I avoid the cliché of such an overused symbol?

The images had to feel grand and solemn. The design had to stand out from the already colorful surroundings. I decided to use strips of cut mirrors, jewel-like glass beads, and red and sky blue tiles against a black background. Surrounding the magnificent bird on each panel were stars made with broken mirror pieces in varying sizes. Reflecting the sun and electric lights in the night, the birds and stars came to life. Emerging from the dark setting, they shimmer, flicker, and glow according to the weather and the quality of light.

The school had covered the back of the two tablets with donors' name plaques, but the eighteen-inch-thick tablets on the sides still lay bare. I remembered another ancient theme, the fish-catching bird. It appeared in the Yang Shao painted pottery of the Neolithic period. Repeated numerous times through generations, the theme has been well preserved in Chinese art. The image I used here came from the rubbing of a Han Dynasty stone carving. I adapted the image to fit the particular shapes of Dandelion's cement tablets.

The front and sides of the platform also needed attention. I placed on them the simple designs of tigers and dragons, which also came from the Han Dynasty stone carvings. Dragons and tigers, like the feng huang and the turtle, are auspicious beings, symbolizing cosmic forces and directions in Chinese culture. The dragon represents east, the feng huang south, the tiger west, and the turtle and snake together represent north.

Most of the teachers and students at Dandelion come from rural China, where folk art has strong connections with the ancient art of the Han Dynasty. In their life of frequent uprooting and movement, it would be reassuring and anchoring for the migrant community to see something familiar and yet recreated in a fresh version that reflects the new reality of now.

More importantly, due to the massive importation of Western culture in contemporary China, especially of its corporate and commercial values and visual images, I sensed a great urgency to create something rooted in China's own history. Perhaps keeping in touch with our past can help steady us in the fast-moving river of change in today's society. Personally, I find confirmation and comfort when I look at the great art of the past. It helps me to remember where I came from and to know who I am now.

The pair of feng huang came off magnificently in color, form, and scale. The tigers decorating the front of the platform were not as successful. Too many hands worked at the same time and there was not enough supervision. People filled in the leg areas of the tigers with mirror shards, which made the figures float and look weightless. On the other hand, the dragons on the sides turned out wonderfully, with turquoise tiles against black background. In any case, we took satisfaction in the empowerment and growing confidence of all the participants.

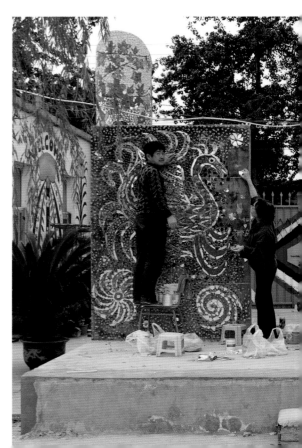

After completing the mythic beings on the cement stage, I turned my attention to the platform. I thought of the geometric patterns I had designed for the ground of Meditation Park at the Village of Arts and Humanities in Philadelphia. The origin of these patterns was Islamic art. We defined the outlines with long mirror strips and then filled them in with colorful tiles in well-defined fields.

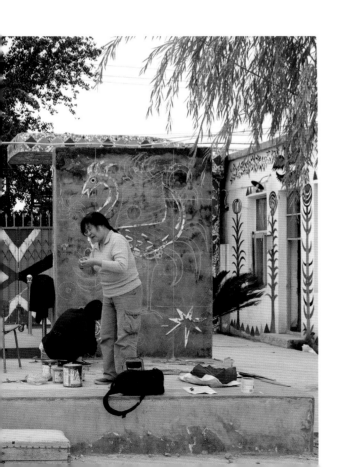

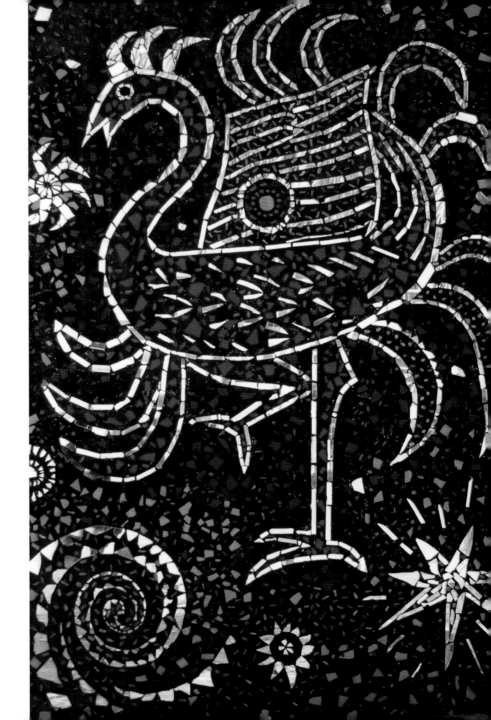

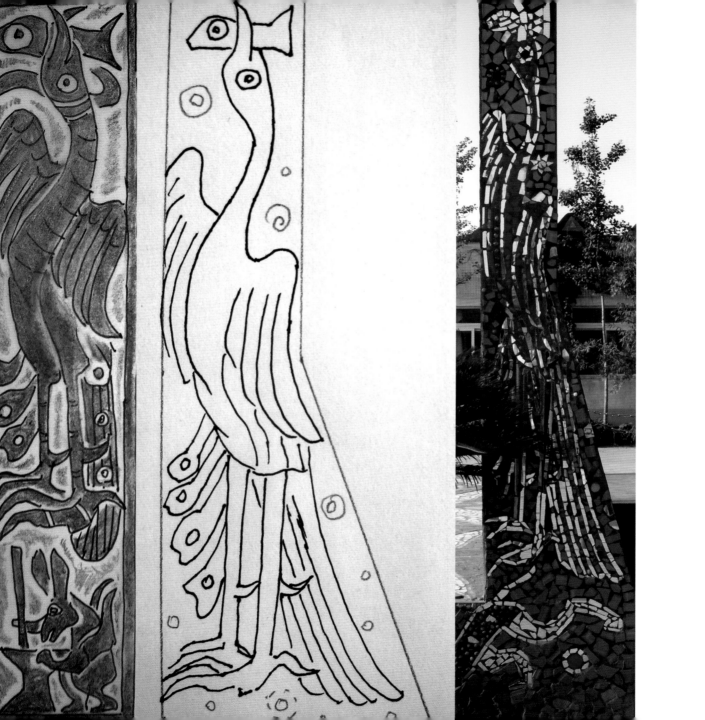

My study of a stone rubbing of the Eastern Han Dynasty, the fish-eating bird hovering over the moon hare, who, according to Chinese folklore, is making some elixir of everlasting life. My drawings evolved to become the mosaic bird decorating both sides of the stone slabs on the platform.

The accomplishments of the ancient Han Dynasty in politics, art, culture, and science were so impressive that from early times the people in this country have been calling themselves the Han people. Today, Han Chinese constitute nintey-four percent of the population.

仰韶文化彩陶壺
陝西寶雞出土的半坡型仰韶文化
鳥啣魚彩陶壺，和鳥啣魚紋彩盆缽。

Opposite upper A powerful papercut tiger reflecting the image of an ancient mythic being by a peasant artist in Luo Chuan. *Opposite lower* A paper-cut fish-eating rooster by peasant artist Cao Tien Xiang. *Opposite middle* The face of the mythic animal on the surface of an ancient Shang Dynasty bronze ware of over three thousand years ago. *Opposite right* Bird-eating-fish pattern painted on the Neolithic Yang Shao pottery. *Above upper left* Farming, a rubbing of a Han Dynasty stone carving. *Above lower left* Farming, paper cutting by peasant artist Bai Feng Lan. *Above right* Farming, paper cutting by peasant artist Li Zhu Ying.

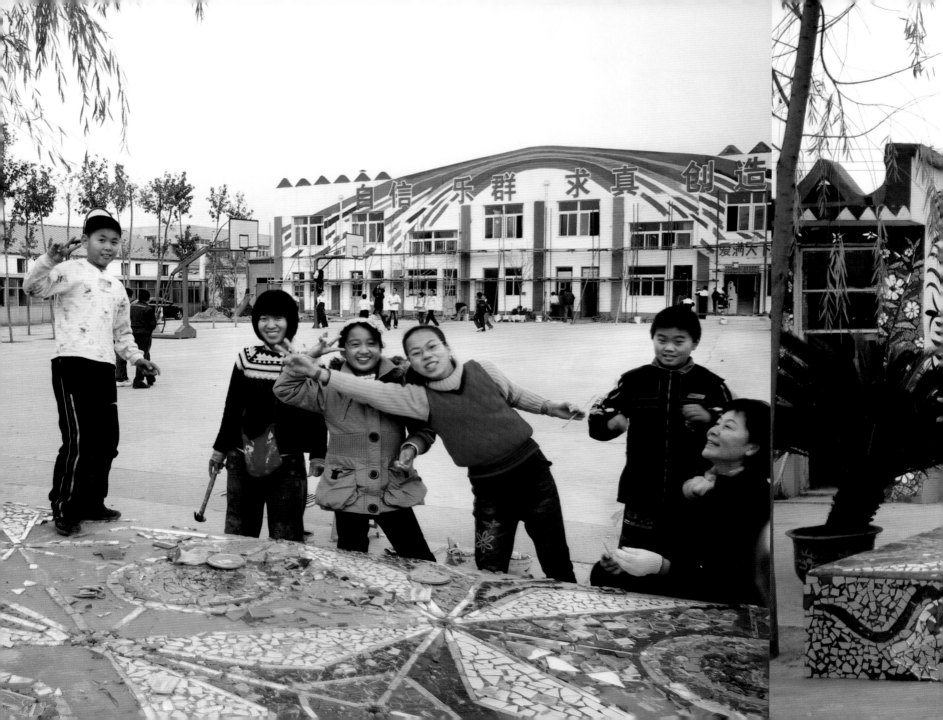

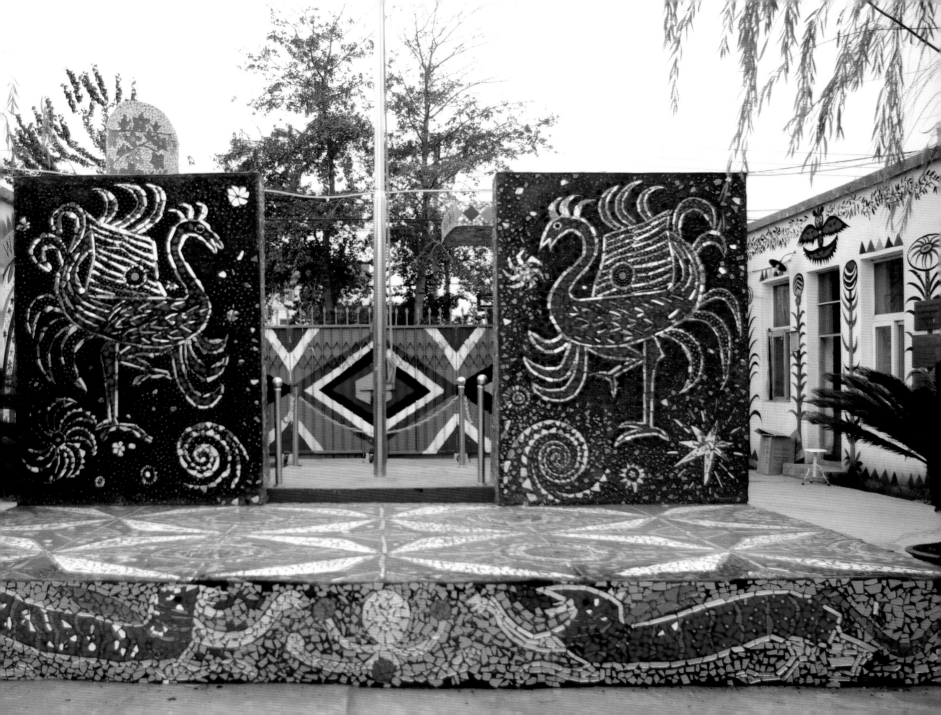

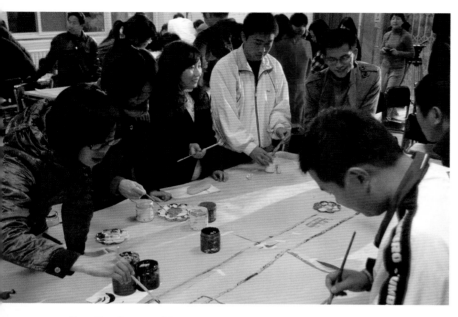

Above **Teachers working together.** *Below* **One of the finished paintings, The Dandelion School of Order and Harmony.**

3. WORKSHOP FOR TEACHERS: PERSONAL JOURNEYS TO DANDELION

During my fall 2008 visit, I had prepared to conduct three activities with the students: mapping personal journeys through storytelling and drawing; exploring the resources in their neighborhood, Shou Bao Zhuang; and documenting the talents and resources in Dandelion School through interviewing and reporting. The purpose of the first activity was to help the students to better know who they were by remembering their personal past, be it happy or sad. The other two activities were intended to encourage students to explore with open minds, and at the same time to sharpen their skills of observation, analytical thinking, and teamwork.

To implement the projects at the school, I required the help of the teachers. Since they needed to understand the concept and purpose of the projects and to experience the process, a three-hour workshop was scheduled.

Knowing that teachers were under a great deal of pressure, I began the workshop with activities such as singing and exercising to help the teachers relax and be at ease. I then divided them into five groups; each group was assigned to one of the three activities stated above. Working individually first, each person expressed his or her ideas through visual images. I called these preliminary visual expressions "seed images." Based on the seed images and the discussion, the members in each group worked together to develop their ideas into a large cohesive painting.

Within two hours, the teachers managed to create five large, colorful paintings.

Although most teachers participated in the training session with eagerness, I felt that the project was rushed. I had imagined that the map showing the teachers' journeys would be filled with routes from all over the country to Beijing. Instead, the personal journey map created by one group of teachers showed only one corner of the country, since almost all of the teachers in the group came from the

Heilungjiang province in Northeastern China. That contributed, it seemed to me, to a lack of content and depth in their painting.

Members in the other groups engaged in heated discussions and activities. Art teacher Pei got so excited that she climbed to the tabletop and worked from there. But there was not enough time to fully develop their ideas. I realized that what I wanted to do with the teachers could not be realized in a single training session.

Principal Zheng Hong liked the ideas of trainings for teachers. She suggested that we continue to pursue the project through a different structure, working with a few designated teachers and their students. We needed to give the people more time to fully explore the potential of the project themes. It turned out that we did not have time for the other two activities I have planned. They must wait for their term in the future.

4. WORKSHOPS FOR STUDENTS: "PAINTING BIG AND PAINTING TOGETHER"

Painting group self-portraits remained one of the most popular activities with students. A few students were annoyed that their clothes were spoiled by paints, and some others complained that their fellow students talked too much or were wasteful with materials. However, the majority appreciated the opportunity to work together and to paint with a lot of colors, freely expressing themselves. Having learned from the mistakes made by the students involved in the same project the previous year, they showed better control in their handling of colors and composition. In addition, the paintings were larger in scale than those of the previous year. One of them reached twenty feet in length.

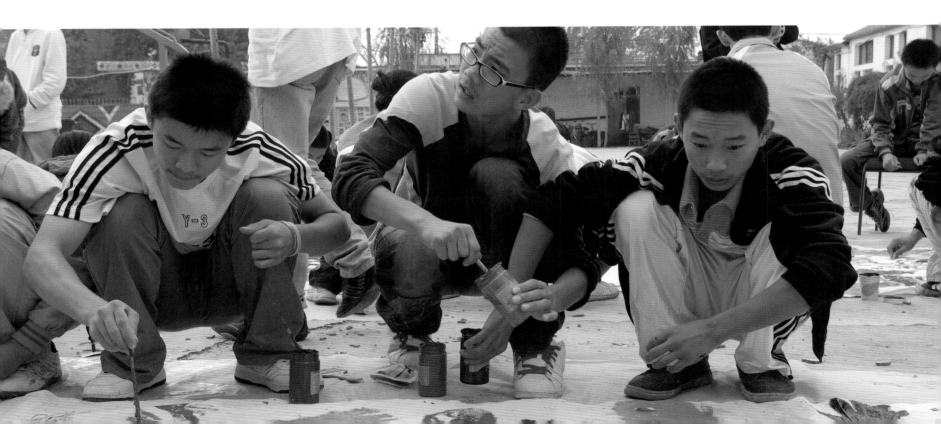

Comments from seventh-grade participants:

"Fun! We could help each other to complete the piece together. It is different from painting on sketchbook. On this big piece of canvas, it is very freeing. One can paint whatever one desires. Very fun."

"Not fun. Too chaotic. Too much smear."

"Very fun. A person lay down, another person drew the first person. When finished, the person got up. Many different colors stuck to her clothes. She looked like a multicolored cat."

"Painting big and painting together is fun. It gives us opportunity to work together, to be creative, and to express the ideas and feelings in our hearts."

A group portrait painted by students, 4.5' x 20', acrylic on canvas.

Above **A tree lane on campus.**
Opposite **Based on motifs from nature,**
students creating mural designs.

5. GREENING OF THE CAMPUS AND NATURE DRAWINGS

By the fall of 2008, Dandelion contained three open areas—the main campus in the front, a small yard in the middle, and a larger yard in the back of the school compound. The two smaller areas were completely covered with cement. The main campus, although mostly cement, now contained four rows of Yang trees and little gardens of flowers and fruit trees in front of the school buildings. The school leadership had put a major effort into making the campus green, despite the difficulty of growing something in a space heavily used by hundreds of students and the constant need to care for the plants.

In 2007, the school purchased these trees for 1 RMB (15 cents) per tree. Limbless, leafless, with tops chopped off, they did not look like trees. Masons cut up the cemented surfaces to make room for forty some open squares, in which some stick-like trees were planted. I wondered whether there was any life left in those trees.

When I returned the following spring, the trees had sprouted a few leaves here and there. Although showing some signs of life, they still looked fragile and pitiful. But by my next visit, they were putting out many branches. Thick with leaves, they cast shadows and rustled in the wind. Now the Dandelion campus had two tree groves. When the sun set in the pasty gray sky, the trees made me feel hopeful. Yes, this was the beginning of things turning around. Together we could do it.

In 2007 and 2008, students created many images about nature—mountains, rivers, trees, flowers, plants, and birds. To enhance their skills and broaden their visual vocabulary, we started a nature drawing workshop using the plants and trees in the school as their models.

6. DESIGNING MURALS FOR SCHOOL SITES

After having trained the students in creativity, design, and painting, I felt they were ready to create designs for the many bare walls still

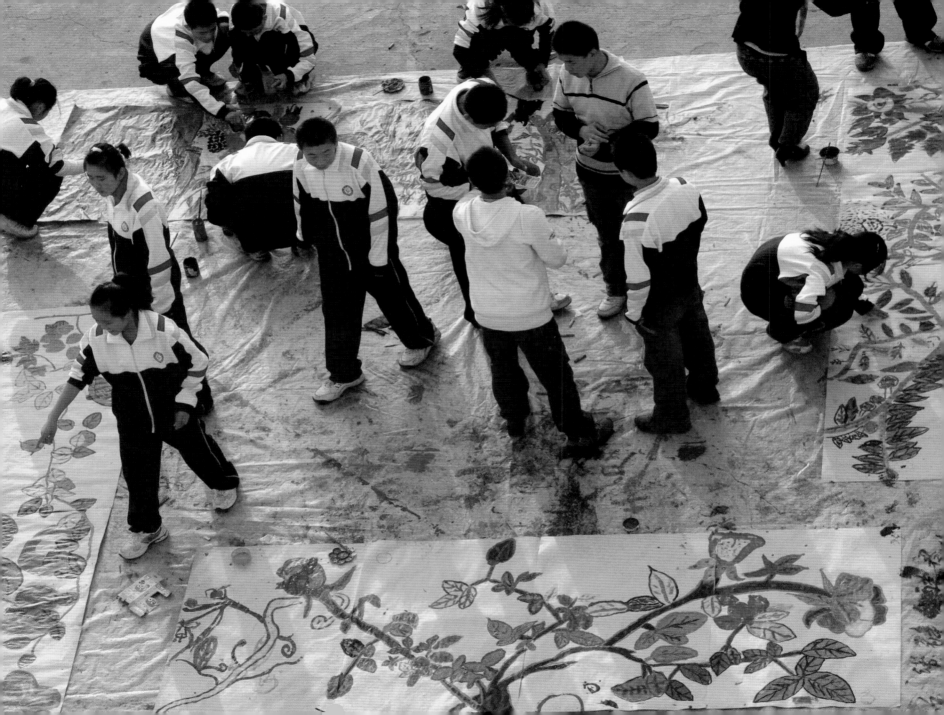

existing on campus. The excitement among them was palpable. They appreciated the opportunity to draw not only on paper, but also on large canvases that would cover the actual walls in the school.

And what images they came up with! Bold, elegant, daring, and vibrant. They honored Dandelion with their creativity and heart. "It feels like a dream, a realized dream," wrote one student. "Before I always felt that only people like Teacher Yeh were qualified to beautify our environment. I could have never imagined that I too could contribute."

7. DISCOVERING RESOURCES IN THE NEIGHBORHOOD THROUGH MAPPING SHOU BAO ZHUANG

Few people in metropolitan Beijing know much about Shou Bao Zhuang, this underdeveloped area where the immigrant poor settle. Situated on the outskirts of Beijing, Shou Bao Zhuang reminded me of inner city North Philadelphia. When I began working there, it seemed to be a place that had little resources and its people few merits. I soon realized that I had walked into a treasure chest. I wanted the students to know their neighborhood as a place full of hidden assets. They just needed to know where to look and how to decipher what they saw. I decided to take the students for a walk.

Together with Zhang Wei Guang, the main teacher of the vocational class, we divided eighteen students into two groups so that we could explore two different areas at the same time. During our walk, my students observed and took notes. Then they tried to express their understanding of the area through mapping. Some grasped quite well the abstract patterns of urban streets, while others paid more attention to concrete details like cars, goods, and stores. We discovered areas they did not know about, like a small health clinic with an open space where the elderly could hang out and relax, a little play area with some simple playthings for children, and a huge walled area filled with tall piles of trash. We saw a surprising architectural detail, a lovely curved brick wall at the end of a narrow

street. We saw a low, platform-like structure that stretched throughout the residential streets. Some people used the platform as their work table, others placed their vegetables there to dry for pickling. We realized that the streets functioned like outdoor living and working areas, since the interiors of most homes were dark and small. The other group also found numerous resources in the area—a small military airport, open and enclosed vegetable farms, pig pens, different commercial streets and residential areas, a well-established kindergarten, and much more.

We asked each student to create a map of Shou Bao Zhuang reflecting his or her exploration of the neighborhood. Then we organized them into groups. Based on the individual drawings, each group collectively created a map of Shou Bao Zhuang.

All the maps created by the student groups showed sections of Shou Bao Zhuang, including the immediate neighborhood around Dandelion School and the areas they had explored together. No group attempted to depict all of Shou Bao Zhuang. I know now that it was beyond their grasp because I did not guide them to think abstractly and analytically. It was a learning experience for them as well as for me. But they did well in their depiction of the scale and the streetscape of sections of this urban area, adding imaginative and well-observed details and turning a drab and dusty area into a place full of colors and visual delights.

Student comments included: "I wish we could plant a lot of green trees along the roads in Shou Bao Zhuang because there is just too much dust in the air in this area. If we can plant trees here, the air will become much cleaner. Then Shou Bao Zhuang will give people a very different impression [from what it is now]. This will help Shou Bao Zhuang to become more prosperous and the people who live here wealthier." "What I created is the general environment of Shou Bao Zhuang. You can discern that at the four corners of my map are cultivated areas planted with trees, corns, flowers, and crops. But they occupy a very small area. You can see other areas in purple, blue, and yellow colors signifying vacant land. I would like to turn all the unused land into places filled with trees, corns,

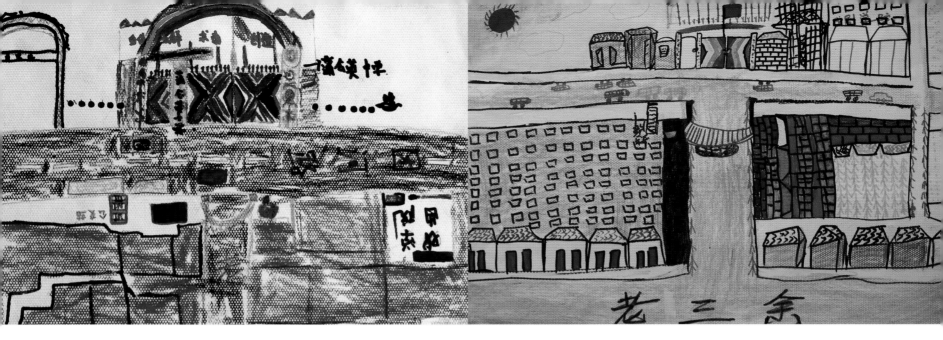

Students' drawings of the Dandelion School and surrounding urban landscape. Their renderings show the school entrance amidst shops, houses, and arched entryways of Lao San Yu (老三余), the little village within Shou Bao Zhuang. Details include traffic, an elderly person, a bag of trash, an Internet bar, and even a road accident.

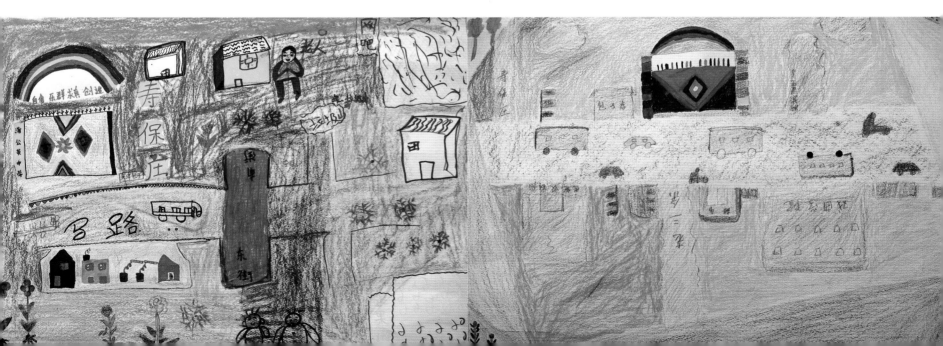

vegetations, and flowers. Let's utilize all our resources to protect and turn our surroundings into a green environment. If every place would follow suit, we could turn our country into a green China. Then when our country is hosting some important events like the Olympics, there would be no need for our foreign visitors to wear masks." "My picture depicts Dandelion School and Shou Bao Zhuang. I hope that this area is cherished and protected. On my picture, you can see trash. I hope people will not casually throw out trash. You can also see elderly people sitting at the doorsteps, breathing in fresh air, and at the same time observing this bustling and lovely Shou Bao Zhuang. In my picture, you can also find our Dandelion School. I hope that the whole world will know of our school." "I made a picture of Shou Bao Zhuang. I hope that this area has many colorful walls. I did not draw Dandelion School. It is three-dimensional, too hard for me to handle it. But I did create a little dandelion."

The project revealed what was important to the students—the Dandelion School and its immediate surroundings. They described things they knew well in great detail. They projected their ideas and emotions onto the map. Although they did not produce a conceptual or informational map, the project succeeded in other ways: the joy of experiential learning, of group action, and the creativity of producing a body of work that expressed something personal, imaginative, and visually stimulating.

Opposite An image of Shou Bao Zhuang lovingly created by another team of students. The dominant feature again is Dandelion School with its brightly colored entrance and a rainbow-hued bird, *feng huang*, next to the flagpole. A large character *yuan*, meaning good karma, stands in the center of the page. The huge airplane on the left represents a small airport. The red character *fu* (good luck) on green background indicates the residential area near the airport. The well-observed street scene contains the steel and iron factory, a hairdressing shop, a clothing store, a supermarket, and a lavatory. The six characters at the lower left mean "Unity brings strength."

Above Another drawing created collectively by students. Despite the toughness of their situation, students painted a picture of insuppressible optimism expressed through the brightly colored images of the school, the bird, the street scene, the blue sky with inviting words on the left that say "Shou Bao Zhaung welcomes you."

8. MAPPING ONE'S PERSONAL JOURNEY: DEEP ROOTING THROUGH TELLING STORIES

The struggles and pain revealed by some of the Dandelion students is a microcosm of the larger set of problems affecting eighteen to twenty millions migrant youth all over China. Their voices of struggle and discontent, though muted now, will become a formidable force for social unrest if they are not attended to. If China wants to build "a harmonious society," it must heed the voices of the people living at the bottom of society. I felt that the best way to begin the healing process was to hear people's stories.

To enhance their understanding of geography and to help them to remember, Principal Zheng Hong printed out a simple map of China with lined divisions of its provinces. There were no cities and no words on the map. Students were to fill in their personal footprints from their homeland to the Dandelion School in Beijing. I encouraged them to record in images their experiences, the sceneries of their childhood homes, and their loved ones. When students handed us their pictures, we were stunned by the vividness of their memories and the poignant content of their images. The project had unleashed deep emotions.

We decided to let students continue on with the project, telling more stories and drawing more images. These are three of their stories.

MY STORY
by Zhang Ting

My loving grandmother
The verdant greens in the springtime
As far as the eye can see
After rain, the land looked ever more enchanting and enticing
Swimming in crystalline streams
Even the fish are smiling
Apple trees bent low with juicy fruits
Here in my childhood paradise
13 years I spent.

Then came the earthquake (black smoke erupting from the hills)
The mountains broke open
Heavy rain of many days washed away soil and stones.

I came to Beijing to join my parents
Who have been working for years there to make ends meet.
They found me a new paradise, the Dandelion School,
where we are encouraged to fly with our hopes and dreams.

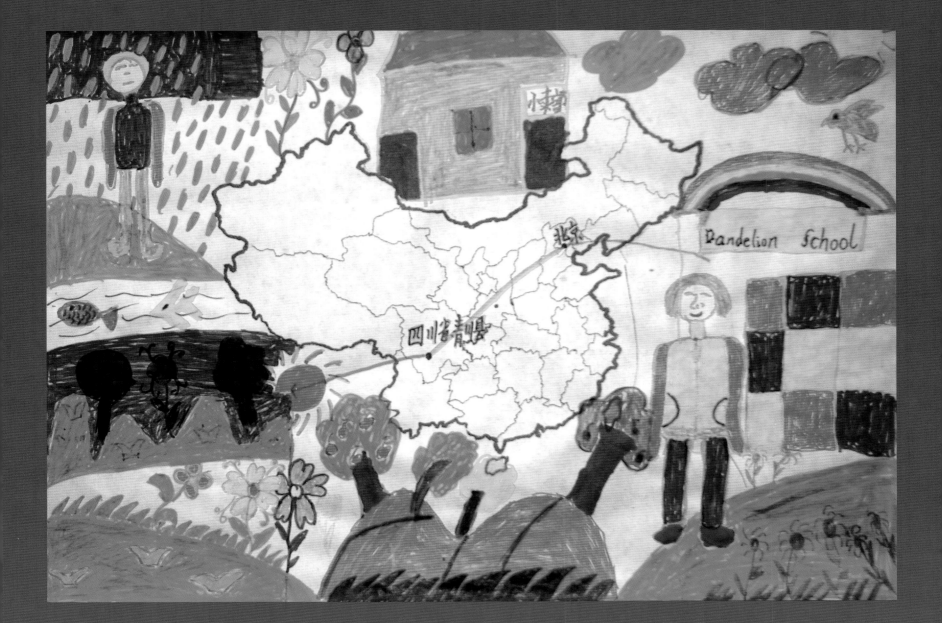

MY PERSONAL JOURNEY
By Zhang Bing Xin

This drawing shows the journey of my life. It contains my sweet, bitter, regrettable, and joyful experiences.

The first station Tracing back to my earliest memory, I see my grandfather and grandmother. They took care of me because my parents were extremely busy. I remember the very skinny hand of my grandfather and the pair of smiling eyes of my grandmother. This took place in Henan province.

The second station There were a few places before this station but I have long forgot them. I can only remember this important station—Shanxi province. I was diagnosed with a severe hip problem, which came with me at birth. My parents quit their jobs so they could travel far and wide to get help for me. Repeatedly they failed, repeatedly they rose up to face the challenge. Finally, I was cured in a hospital here. I left the hospital after staying there for one year and six months. My parents by then carried a debt of tens of thousands of dollars.

The third station My father brought mother and me to Beijing because he did not have enough money to buy tickets to get us home. We came to my uncle's house. My uncle took me to play in a park. He also lent us money to get home.

The fourth station We came home. Our garden looked abandoned and our house was ready to collapse. Father decided to go back to Beijing to find work. My mother and I went to live with grandmother. I lived in a world without the love from Father, one year, two years… Finally Father came to bring me to Beijing.

The fifth station I came to Dandelion School. Here I learned to be grateful. I got the sponsorship from the Guo Foundation. I am determined to become a diligent student in this inspiring environment. Here I want to dream my dreams. I want to be brave enough to realize these dreams.

MY JOURNEY
By Le Peng Fei

The first station My first station in life is my homeland Xin Yang, Henan. The drawing at the lower right corner of my picture is the overview of our village. The red lines indicate farmland, and the blue lines the wheat field. The yellow color points to areas where rice and vegetables grew. Located on the left side of the village was our family farm, where my parents and I planted melons, various green vegetables, sunflowers, etc.

A evil and forbidden place was situated on the upper left corner in this rectangular village map. Whenever cars passed by here, their motors would immediately stop. When animals passed through this place, they died without cause. The only thing that could live here was grass. No people were allowed here. Older people told us that a huge snake lived underground. That was not very scientific. I figured that maybe it had something to do with magnetic forces in nature.

The second station The second station in my life was somewhere in the Shaanxi province. "Cement! Cement!" "Bricks! Faster! Be careful!" "Oh no! Don't drop it!" Voices started early in the construction site. Father worked at the construction site; Mother cooked for everyone. We were happy here. Unfortunately a falling steel pipe injured my father. Our family became very unhappy. Extremely frustrated and angered, my uncle beat up the construction boss. We left this awful place.

The third station We came to Niu Shu Village in Zheng Zhou. Father worked for Ur Ye. I went to school there for my fourth and fifth grades. My English was not good so my father got me special help to improve my English. But not only it did not help, it made me sick of English. Father decided to find a good school for me in Beijing to improve my education. So without saying a word, he took the whole family to Beijing.

The fourth station I came to Shou Bao Zhuang in DaXing District in Beijing. As soon as we arrived, my father started looking everywhere to find a school for me. He searched and searched… Finally he found the Dandelion School. Here I felt that I could root myself, studying, playing… Here I witnessed the "Shen Zhou Seven" spaceship triumphantly rise into the sky. Here I see many foreign visitors. I know that I am improving myself and studying well. I also know that my journey will not end here. I want it to expand, expanding to the world, the universe, the future. Expand…

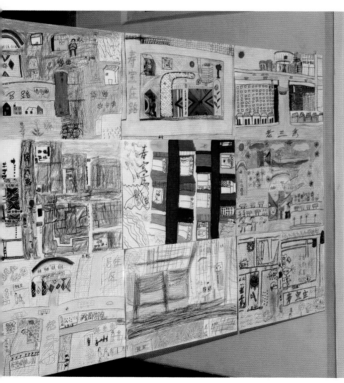

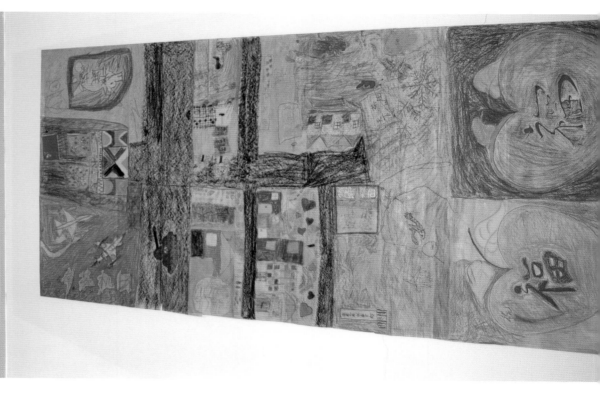

9. FALL 2008 EXHIBITION: DEEP ROOTING WHILE LOOKING AT THE WORLD

In 2008, Dandelion expanded again to include a new wing with several very large rooms. Recognizing the importance of art, the school officials designated one area for the sole purpose of exhibition. This confirmation of what we had been doing at the school gave me great satisfaction.

When I first saw the space, my heart sank. The dust-covered room looked chaotic with donated furniture, desks, and chairs randomly scattered. We found out that around that time the school was sending most of the teachers and students to the city for a prescheduled school-wide outing. I wondered how were we going to mount the show in time for the opening the following day. Then I experienced again the miracle of Dandelion. Principal Zheng Hong sent in a group of teachers, staff, and volunteers to help. The windows, big glass panels, and the marbled floor surfaces were all cleaned and polished. The furniture was moved. I organized the content and sequence of the materials and wrote the introduction and labels, which were typed and placed on the walls. At the end of the day, the exhibition was mounted.

This time the exhibition would contain only works by the Dandelion community. As I was organizing the materials, I came across a painting created by a student the previous year, with the characters saying "with the eye looking at the world." The words and the multicolored rainbow below referred to the 2008 Olympics. I felt that these words had much to do with our exhibition since the content of our project this year was looking at and understanding ourselves so that we could better understand the world. I placed the painting next to the entrance of the exhibition space to indicate that although the images in the show dealt mostly with local issues, they also reflected global political and economic movements.

For me, the most important piece of work in the whole exhibition was the collective personal journey map (page 165) created by thirty students in the seventh grade, class 1. This mapping project built on the students' stories of their personal journeys. The purpose

Upper Memory of Home, a lush painting by a student in seventh-grade class 1. *Lower* My Home, a hiku-like painting by Li Hung Wei in ninth-grade class 4.

of the project was to anchor students to their origins, the land and the people who cared for them, and then to help them re-conceive the school and its surroundings not as the fringe of society, but as a magnetic center. We put together a big map from many of the maps created by students, showing routes from many places in China converging at the Dandelion School in Beijing. In addition to geographical information, the map provided social, emotional content that very much reflected the conditions of the greater Chinese society. The concept and methodology of rooting and centering through mapping has become a yearly exercise for Dandelion students.

10. A SYMPOSIUM

During the exhibition opening, Dandelion hosted its first symposium on art and education. About forty people attended. Most were from Beijing, but several were from the Hunan and Hubei provinces. People came from the fields of art, art education, art for children, museums, and publishing. There was much discussion of the current development in and direction for contemporary Chinese art, the value of creativity in children, parents' expectations, and the high pressure children feel in such a competitive environment.

People responded to the concept of education through the arts evoked by the exhibition, affected in particular by its emotional content and original visual language. Lo Zhen, a prominent art educator in Beijing, suggested that in the tense atmosphere of competition dominating the school system, perhaps they had lost touch with the real purpose of education. "Is this why we often feel restless and unfulfilled? Did we lose our hearts somewhere along the way? We must regain and reconnect the voices in our hearts."

Xie Li Fang, director of a nonprofit organization that brings art to children in very remote places in the country, told me with urgency, "You must establish your methodology so that what is happening at Dandelion can be replicated in other places." Perhaps her request indirectly prompted the writing of this book.

164

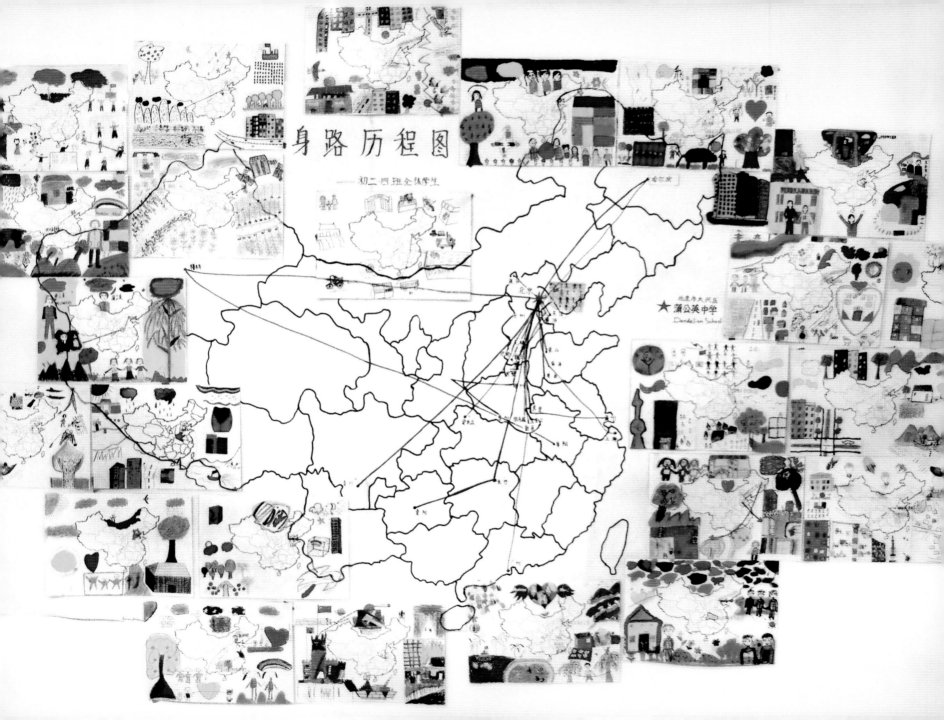

11. WANG HU ZHAN MEMORIAL AWARD PROGRAM IN CREATIVE WRITING AND EDUCATION

My mother Wang Hu Zhan was born in 1911 in a prominent family in Xuan Hua, Hebei Province. My grandfather, a highly respected scholar and a school principal in town, made sure that his daughter had an excellent education. She was among the first group of young women to attend college, the prestigious Yan Jing University (now the Beijing University). Majoring in sociology, she hoped to help the poor upon graduation.

My mother loved literature and was talented in writing. I think she would have become a fine writer if she had had the opportunity. Unfortunately, like so many in her generation, her life was disrupted by wars. She spent most of her youthful years guarding and nurturing her five children while my father, an army officer, was fighting on the frontline. When we retreated to Taiwan in 1948, our family gradually fell on hard times. Mother bravely shouldered the burden, worked, and provided for the family.

My mother was utterly dedicated to her own mother, whom we called Nai Nai. She lived with us for over thirty years. When Nai Nai passed away, in an attempt to deal with her intense grief, my mother began writing. She wrote down what she remembered of her childhood, her family, friends, travels, and the difficult years of war. Her amazing memory and writing captured for us vivid pictures of a passing era. To me, her writing preserved a part of China's recent history.

When she was little, she witnessed the crushing cruelty that foreigners imposed on the Chinese on their own soil. She wanted China to be strong and she loved the country fiercely. Although she worked hard and led a frugal life, she expressed her generosity in deeds. Using the money she had carefully saved, she contributed to the building of three Hope Schools in China for the children of the very poor. She also expressed her intention to set up scholarships for them.

My mother passed away in 2007 at the age of ninety-seven. To celebrate and remember her, we, her children, set up a Wang Hu Zhan Memorial Award Program in Creative Writing and Education at the Dandelion School. The aim of the program is to inspire students to write creatively about things that are real and authentic to them. It also recognizes and encourages the good and hard work of teachers.

This award program prompted creative writing at the school. All students participated. A committee of ten teachers selected articles from the twelve classes. The school held two school-wide competitions in rhetoric and recitation of original student work. A jury of ten teachers chose the winners. Then the school principal selected teachers to be awarded for their excellence in creative writing, innovation, and teaching. The first award ceremony took place in November 2008 and the second one in December 2009. Each year, over three dozens students and teachers were honored with cash awards.

In addition to the body of wonderful writings emerged through the process, what touched me the most was to see how eagerly some of the students practiced their speeches and how dedicated were the teachers in coaching them in voice projection and stage manners.

Above The student audience in the auditorium. *Below* Winners with their awards

12. PEN PAL PROJECT

In the fall of 2008, Mary Cowperthwaite, director of the International Club at Maple Shade High School in Maple Shade, New Jersey, orchestrated a pen pal project connecting about thirty students in the club with the students in Dandelion School. The principal asked English teacher Wang Hua to engage her students in this project.

Mary and her colleague, Terry Klaw, the art teacher, prepared the students. The letters were colorful, imaginative in design, informative, and caring. These letters from Maple Shade School inspired the youth at Dandelion. They responded with their photos, description of themselves, and uniquely designed letters.

It was rewarding to see how such a simple project as pen pal writing could generate so much interest in young people about other cultures and countries. The project broadened their horizons and stimulated their desire to learn. For the Dandelion students, the pen pal project provided an excellent opportunity to practice writing in English.

Dear Liu dong,

喜 My name is Bryan. I am 14 years old and my birthday is October 12. I am a boy and I live in Maple Shade, New Jersey. I am in eighth grade honors at Maple Shade High School. My favorite subject is Math. I am not the best in English, I'd rather sleep during English. I like ping pong and dogs. I have always lived in Maple Shade. It is very close to Philadelphia, Pennsilvania. I want to know more about China.

Sincerely,
Bryun Donahue

Dear ferind,

My name is chen zhong Yuan, I'm 13 years old. I'm boy. I like ploying Pong-Pong, but my favorite is sports is tennis. I have Parens and tow sisters. I'm good at sports. I'm bad at English and math. My favorite food is beef, chicken and banana. I'm outgoing. I want to be reporter. please visit us soon!

Chen Zhong Yuan

Left A pen pal letter written in English with Chinese characters by fourteen-year-old Brian Donahue of Maple Shade School. *Opposite and above* by Wang Lin, fifteen, and Chen Zhong Yuan, thirteen, both from the Dandelion School.

8

Spring 2009:
Preserving the Experience,
Sustaining Transformation

1. TURNING STUDENTS' PERSONAL JOURNEYS INTO A BOOK

I wanted not only to have each student make a little book, but also to have them collectively create a book for the school to keep. I felt it would be a valuable gift for the school, a book that would contain not only the footprint of each student but also the imprint of this particular time of tumultuous change in China's society.

In the fall of 2008, the thirty ninth-grade students in teacher Wang Jian Hua's class produced a series of marvelous drawings and writings in the "personal journey through mapping project." I wanted these students to make a book collectively and to offer it to the Dandelion School as a token of appreciation. I asked art teacher Pei Guang Rei to join me in this effort. Just recently graduated from college, Pei was young, energetic, and full of ideas.

We asked the students to create their own pages, each of which would contain a photograph of him or herself, a self-portrait drawing, a map of his or her personal journey, and writing about childhood memories and wishes for the future. The result was pages upon pages of well-designed and well-written narratives reflecting the experiences and sentiments of a group of aspiring students.

Pei designed a brilliant cover page. The drawing of a train arriving in Beijing came from student Lin He Ming. He had traveled by train from Qiqihar in the far northeastern province of He Lung Jiang to Beijing. He filled his drawings with keenly observed details of life in a big city (page 132).

I chose to make the book in landscape format, which lends itself to storytelling and reminds me of the Chinese horizontal scrolls. I chose light bronze-colored paper. The light-colored silks of ancient paintings have all turned brown. This color represents to me a timeless realm of distilled emotions. These stories unfold against this subdued color background.

Above Personal Journeys book cover. *Opposite* Interior pages.

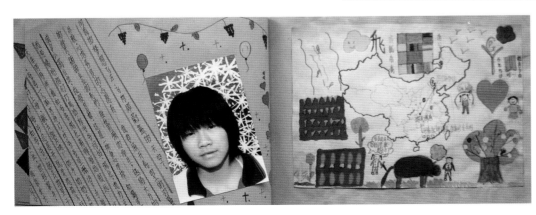

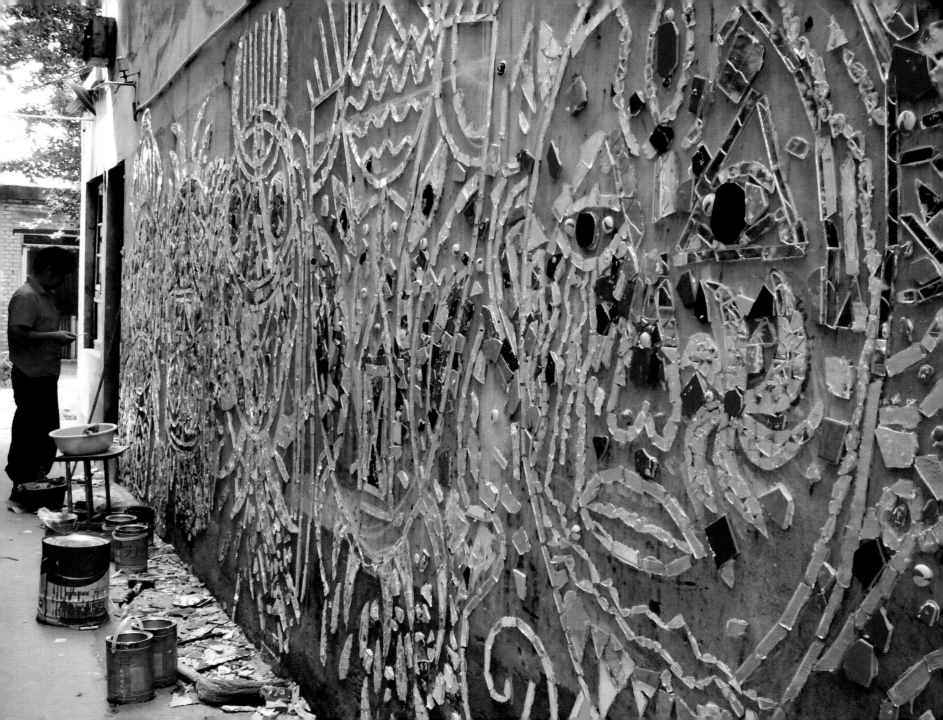

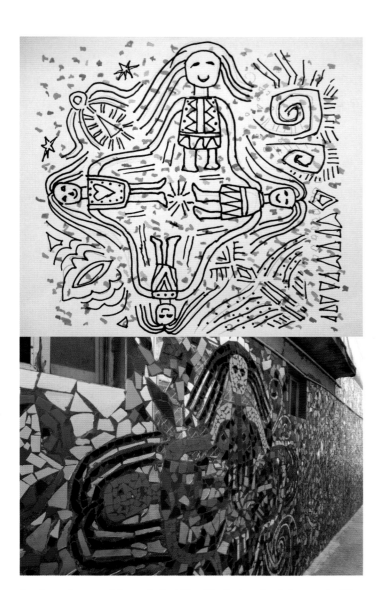

Turning a fragment from student Tien Tien's drawing into a part of the Dream Alley mosaic mural, and the transformed Dream Alley.

2. TURNING STUDENTS' ART INTO PUBLIC ART: THE DREAM ALLEY MURAL OF MOSAICS

During the four years of its existence, Dandelion School has continued to expand. Last year it rented another factory-style building adjacent to the existing school complex. A long and narrow alleyway between two blank concrete walls connects the middle and back courtyards of the campus. Teachers and students pass through this tight corridor numerous times everyday, an experience that was for me unpleasant and at times claustrophobic.

I imagined an alleyway of mirrors, catching light and reflecting images into each other. It could become an alleyway of fantasy and dreams.

By now, students in various workshops had created many wonderful images, many of which could be turned into public art decorating these two blank walls. The pictures illustrate how an image from a student's work was developed into a part of the Dream Alley mosaic mural.

The making of the Dream Alley provided an opportunity for many students to participate, but the light-filled fantasy I had imagined was not fully realized. Even though I repeatedly urged that more mirrors be used, people used the more readily available tiles instead. The mosaic alley, however, greatly pleases visitors and school residents alike.

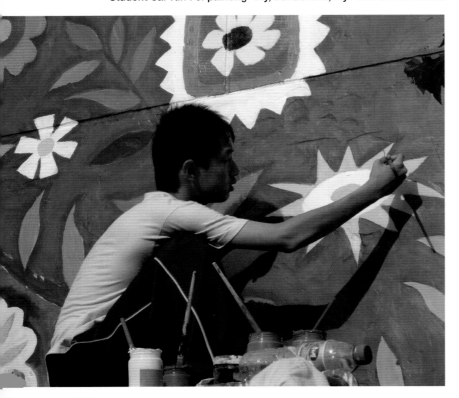

Student Cai Yun Fei painting "Fly, Dandelions, Fly" Tree of Life mural.

3. "FLY, DANDELIONS, FLY": THE SECOND DANDELION TREE OF LIFE MURAL

Adjacent to the Dandelion mural stood another blank cement wall, inert and silent, near the center of which was a large framed announcement box. The colorful murals that we painted in 2007 were not enough to totally transform the courtyard space. So during my visit, I designed another mural for this wall, which by this time had become a part of a two-story building containing more dorm rooms for teachers.

To strengthen what we had already created, the design of this mural had to echo that of the first one, the Dandelion Tree of Life. Occupying the root center of this vital and blossom-filled tree is a full, snowball-like dandelion ready to disseminate its numerous feathery seeds. This mural represents the incubation period of the students, the little dandelions, learning and growing under the close watch of the Dandelion community.

The new mural, "Fly, Dandelions, Fly" represents the next stage in the life of the students. Similar to the scattering of dandelion seeds by the wind, Dandelion community understands that upon graduation its students will be carried away by the force of life to different places in society. Wherever they may land, the school expects that the education Dandelion has provided them will help them establish their lives with confidence and buoyancy. It hopes that the students will realize the school's values—to continue to learn, be creative, be grateful, and be of service to others.

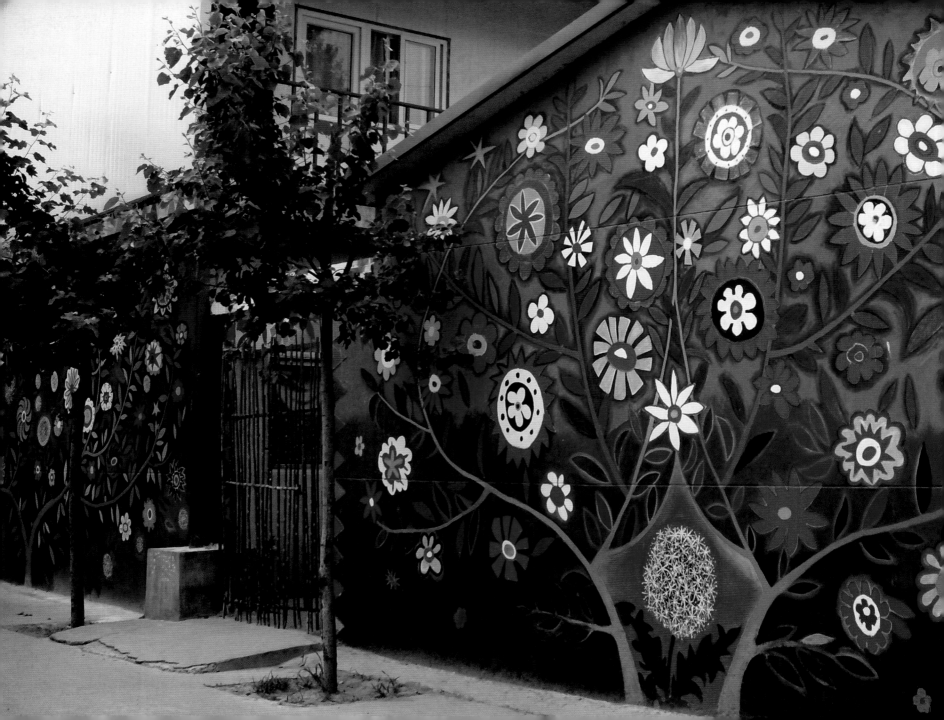

9 Impact

Teachers brainstorming session, and their chart showing the problem tree with root causes, manifestations, and results.

1. PHYSICAL ENVIRONMENT OF DANDELION SCHOOL

In the spring of 2009, we felt it important to assess the impact of the project in a more formal way than had previously been done. With the help of Sandra Chou of World Education, a nonprofit organization based in Boston, we sent out evaluation forms to teachers and students. Their feedback was positive and extremely encouraging. "Environment is so very important to me," said art teacher Pei Guang Rei. "This new environment makes me feel worthy, calm, and inspired. I sense the force of life here. It provides me with an opportunity to dream." "The school is changed from a monotonous environment to a place full of vitality," reported head librarian Niu Hua Lin. "Although our school does not have a lot of expensive hardware like many other schools, we have a special and unique campus. The best words to describe it are energy and life." "The new students coming into our school," commented art teacher Fu Tao, "behave better than the older students when they first came in. I think it has to do with our new improved environment. It affected their behavior." "This transformed environment makes us feel very proud," wrote Principal Zheng Hong. " There is not another place like this anywhere else in China. Its beauty and uniqueness impress everyone who walks into the school. It empowers the students because they witness, contribute, and participate in the conversion process. They feel that this newly transformed place belongs to them. It is totally magical."

The transformation, as these comments suggest, is more than a physical one. Party Secretary Wang Bao Cai articulated it this way: "When our students attend public events sponsored by the city or the state such as presentations, performances, and art, they act responsively, with poise. They are full of ideas and eager to be involved. Their participation in the Dandelion Transformation Project helped to build their self-esteem and enhanced their ability to imagine and take action."

2. ART AS A TOOL TO ADDRESS URGENT SOCIAL ISSUES, THE TREE OF PROBLEMS AND THE TREE OF LIFE

Tao Xin Zhi spoke of "society as school and life as education." "In our school," said Principal Zheng Hong, "we empower students to excel in academic learning. We also teach students social skills to tackle life's many difficult problems."

During my spring visit in 2008, I was intrigued by a picture of two painted trees displayed in the corridor. Zhang Wei Guang, teacher of psychology and vocational education, explained the trees: "One of our most pressing problems is the belligerent and destructive behavior of some students. It is especially serious in the newcomers. Some of them do bring in bad habits from the street, like fighting, cursing, smoking, drinking, and associating with gangs. Inspired by the image of your Tree of Life and your inclusive and bottom-up methodology, we decided to engage the whole school community in tackling this difficult problem. We named it the Tree of Problems and Tree of Life Project."

There were several steps to the project. First, Zhang Wei Guang asked the teachers to brainstorm on the roots of problems and to come up with suggestions for changing student behavior. The teachers developed charts of the root causes of such behaviors, their manifestations, and their impact on individuals and families.

Teachers then took the methodology they had created to their twelve classes. The whole student body of 620 children participated, creating twelve pairs of images that pointed to causes of the problems as well as solutions.

After a month of work, the project culminated in a daylong event named "the battle against uncivilized behaviors." All of the images created by the students were exhibited on the main campus. Students expressed their determination through writing and performance. All students took pledges and signed their names on a twenty-foot-long Banner of Determination.

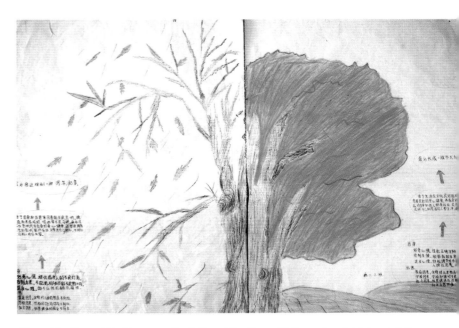

Above The Tree of Problems on the left and the Tree of Life on the right, by eighth grade students. *Below left* The Tree of Problems with characters signifying fighting and alienation on the tree trunk. *Below right* The Tree of Life with words on the fruit saying diligence, thoughtfulness, kindness, etc., by seventh grade students.

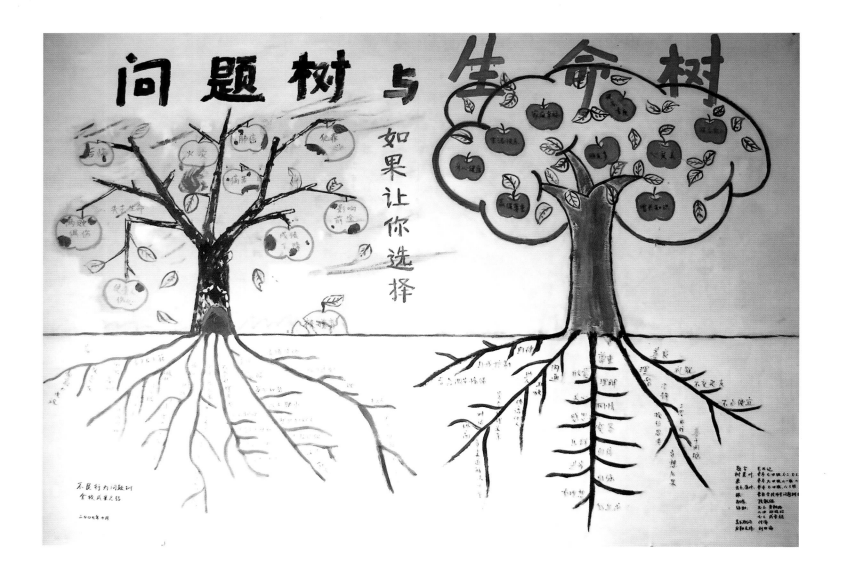

182

Above Name signing, exhibition, performance, and pledging ceremony in the one-day event at Dandelion in the school-wide effort to eradicate vulgar and uncivilized behaviors.

Finally, under the leadership of Zhang Wei Guang, a team of teachers and students summed up and refined the images and insight offered by each class into a picture of two trees with multiple words, some black, some red, some big, and some small (see page 182). On the left, the Tree of Problems—its name in purple and its broken leaves and branches, rotten fruit, feeble roots, and insect-infested trunk—is dying. The end of one fragile branch has even caught on fire. Lining the fragile network of the roots are words and phrases such as jealousy, listlessness, reading bad books, influence from internet games, small-mindedness, gang activities, blackmail, inability to communicate, cruelty to the weak, power display, and easily agitated. All the fruits are spoiled. Each contains words indicating the results of the root causes: bad grades, pain, loss of life, regret, bringing sadness to family, committing crimes, and abandonment.

On the right side of the picture stands a healthy tree with vital roots spreading out in the underground, and a thick, youthful, and healthy trunk supporting a crown of bulky and heavy leaves. So thick are the leaves that we do not even see its branches. Plump bright red fruits are hanging solidly from the tree. The name of the tree, written in big red characters, is the Tree of Life. Next to the roots are these words and phrases: empathy, sympathy, self-control, respect, understanding, tolerance, taking action after thinking, appreciation, gratitude, politeness, and kindness. Within the colorful fruits we read: increasing knowledge, many friends, serene mindset, improved quality of life, happy family, healthy body and heart, gaining respect, many friends. "If you had to, what would you choose?" is written between the trees.

The school authorities reported that during that year incidents caused by offensive behavior among students declined by seventy percent. A powerful and effective process, indeed.

3. CULTURE AND ART CREATE ASSETS: DANDELION CRAFTS STUDIO

When I worked at the Village of Arts and Humanities, the organization was sustained through grants from the government and private foundations. Funders repeatedly encouraged us to create resources so that we could become more independent. I thought long and hard, and realized that we were sitting on a treasure mine of artworks created by our children in various workshops. My good friend Ji Ping Chang, an excellent designer, turned children's art into wonderful crafts that felt fresh, earthy, and unique. We invited Andres Chomorro, a young and talented Ecuadorian artist, to head our newly established Village crafts production studio to turn the models into beautiful handmade objects. He trained neighborhood jobless adults to become productive craftspeople. Our products sold well. We soon realized that despite their popularity, if we wanted to pursue such a production, we had to treat it as a business with a plan and investment money. Working with several graduate students from Eastern University in Pennsylvania, we created a substantial business plan detailing facility and staff requirements, timeline, promotion strategy, and budget. It established a process for turning children's art into a product that honored their artistic sensitivity while harvesting proceeds that would support education for children. And more importantly, through the process we found our own identity in the world of commerce. We realized that the more freedom we gave to our students, and the deeper we rooted our activities in our creative imagination, the more resources and possibilities we would create for our productions.

This experience prepared me to guide the crafts production at the Dandelion School several years later.

In spite of the considerable reputation and success of Dandelion, there is an urgent need for a stable source of income to offset increasing operational cost and to stabilize the school. With a small crafts production team composed of three women, Duan Xiao Lin, Wang Xue Mei, a sales person, an expert seamstress, and

The Dandelion crafts production team at their stand at Yu Jin Garden Villa, Beijing.

at times volunteer students, the school began putting out products such as greeting cards, aprons, bedding covers, handbags, and other household accessories. Stands were set in various locations to make sales, take orders, and understand the market. In addition, Duan Xiao Lin, who is passionate about painting and making things, continued to experiment, turning the public art already existing in Dandelion into new products.

Although this effort is producing some income for Dandelion, it is far from enough to stabilize the school. For that, production and sales have to increase and intensify.

In the fall of 2008, Dandelion had the good fortune of being visited by a venture capitalist investor based in Beijing. He had years of experience working closely with local venture communities in China to identify and nurture local talents, and to build innovative companies according to business models that uniquely leverage China's competitive advantages. During his visit, he chanced upon the colorful sets of cards made from students' art. The story of the school, the beauty of its public art works, and the unique cocreative and collaborative process involved in producing these images caught

his interest. He sensed that there might be a market for beautiful craft products that contain rich cultural content and social meaning. His generous sponsorship made it possible for Dandelion to set up a crafts production business.

The investor's interest prompted the school to establish a team for the start-up business. Since the production was to be based on the artworks created through the Dandelion School transformation project, the school leadership asked me to serve on the team with several other members who have expertise in business planning, product design, marketing, and production. Our goal was to have a line of production for sale for the 2009 holiday season. Our target was corporate buyers.

Once again I asked my friend Professor Chang, who is professor at the renowned Fudan University, Shanghai Institute of Visual Arts, to be our designer. After years of experience working for industries such as Nike, Du Pont, and Philips, she understands what it takes to design for business. Based on the images I provided her with, Professor Chang experimented with various possibilities.

The statement in the Dandelion Sales Catalogue clearly

186

Middle My sketch for the Dream Alley mosaic mural based on the drawings created by students in art teacher Pei Guang Rei's classes. *Above* Based on this sketch and other public artworks at Dandelion, designer Ji Ping Chang developed a series of product samples for jewelry and a beautiful box filled with gifts.

declares the meaning, intention, and purpose of launching the creative crafts production project:

At Dandelion School the children of migrant workers are given the chance to receive a meaningful education. However, the operation of the school depends heavily on the help of the greater society. As a nonprofit school, we face the challenge of balancing sustainable development through donations with growing on our own assets. The successful operation of this balance is both imperative and strategically important.

As part of their curriculum, the students at Dandelion take part in a work-study program as well as a series of creative activities. The school has the aim of seeking the highest creative potential and to change the future with our own hands. With this spirit, our simple schoolyard becomes an inviting learning environment. It is due to the combination of character building and life-skill education that the school is able to undergo this very transformation.

We plan for our already established creative program to serve as a springboard for further developments and to grow into a more advanced practice. Our goal is to produce marketable products,

which can then be sold for profitable returns that will all be used to benefit the school. This joint venture in social enterprise and public service not only promotes imagination and creative thinking, but also cultivates a sense of self-reliance for the students. Rather than passively receive help as a marginalized group of migrants, the students can now actively contribute to society and to their own education through their hard efforts.

There is a familiar adage: don't just give people fish, better to teach them how to fish. I believe the whole process of the Dandelion School Transformation Project—from the change in the school environment and in student and teacher attitudes to the production of creative crafts—has been about teaching people how to fish.

Dandelion Creative Studio produced and sold 1600 boxed sets of holiday gifts. The production team has learned much about consumer taste, quality control, and marketing. We are all proud to have met our production date as well as our goal to create unique, culturally rich, and high quality products for the market. Now, with more experience, we are confident that the production in 2010 will be smoother and more profitable.

10 Methodology

After five years, the Dandelion School Project has come to a conclusion for me with the writing of this book. I structured the process of the project so that I was able to pass on to the school my vision of community transformation through art. I would like to share that vision further and to have the work at Dandelion School continue. My hope is that this book will be of help to other people who want to do similar kinds of work.

First, there is the need, the need of a person—an artist in my case—to create, and the need for one's creation to have meaning and palpable effect, to make a difference. Then, there is the community's need to better itself. My search for meaning has led me to places that are broken. It has been a privilege to work in communities in crisis, for the effort has given depth to my existence. The haunting stories shared by some of the students at Dandelion furthered my understanding of the challenges many are facing and of the indomitable human spirit.

Next, how is the right person matched with the community in need? In my experience, if one is sincere and open, life provides opportunity. Chance meetings might seem accidental and undependable, but an understanding of the interconnectedness of all things suggests that synchronicity takes place with regularity. The chance meeting with Zheng Hong made the Dandelion Project possible. A similar chance meeting with Jean Bosco Musana led to my work with genocide survivors through the Rwanda Healing Project.

The leadership team and I agreed that a transformation project was needed at Dandelion. We hoped for a transformation that would manifest itself physically, emotionally, and mentally, from the physical environment to the hearts and minds of people. We listened to the community and provided the means for people to express themselves. That led to workshops for teachers and students. I made sure that the workshops were fun, inspiring, participatory, and filled with information. We sought improvement through evaluation and results analysis. We empowered the participants by encouraging and incorporating their ideas, images, and initiative.

During the five years of the project at Dandelion, the images used in the project shifted from being conceived by the artist to being created by the students. With support from teachers, the participation of students in designing and implementing the project increased as well. We learned that mistakes were beneficial, for they kept us nimble in mind and humble in heart. We also learned that in crowded, deprived, and restrictive places, we could generate new nurturing spaces of freedom, openness, and abundance through creativity and imagination.

My life's journey has been about returning to that "dustless world" depicted in the Chinese landscape painting. It is a place filled with beauty and poignant meaning. Time and again, I have found my way back through working with people in broken places. When fragments are made whole, beauty returns. When people's voices are heard, when the community is given opportunity to envision and be empowered, people's lives become richly meaningful.

I am not a brave person. But the one daring action I took in the summer of 1986 was that I listened to my inner voice and acted accordingly. It ignited my passion and changed the course of my life. This flame within, the light of creativity, has been guiding me along my life's journey. In my work, I try to pass it on and light other people's pilot lights so that we can all shine together to dispel the darkness around us. I believe that through self-awareness and actions that benefit others, together we make our world a better place.

We can do no great things,
only small things with great love.

— Mother Teresa

EXPLANATION OF METHODOLOGY—ORGANIC DESIGN

I have found diagrams more successful than verbal descriptions to capture my methodology. It is in this spirit that I offer this diagram, which renders the elements of the methodology and their relationship to each other. There is a clear order in the process, although it is never hierarchical or linear. The growth of the components depends on the right timing and available resources, very much resembling the pattern of growth in nature. I have named the chart Methodology—Organic Design. In making the chart, surprisingly, a Tree of Life emerged.

People often ask me whether my work can be replicated. Definitely, I say—not so much in its form, but in its intention and methodology. If projects evolve organically, no two will look alike, since their evolution will depend on their respective location, timing, resources, local culture, leadership, and the resolve of the people involved. Yet the underlying structure of the projects is similar in its multifaceted, multileveled, and interconnected nature.

These projects need to contain the qualities of flexibility, openness, imagination, and innovation. Weakness can be strength, difficulty is to be embraced, danger creates opportunity, and our inner voices provide good guidance. Well-intentioned actions are like stones thrown into a pond. The rippling effect can impact the whole environment. Such acts of kindness comfort our hearts and ease our anxiety, like the gentle rain that brings relief to the parched land. Patiently and with persistence, we can help make peace and harmony prevail.

Guiding Principles

We must be clear about our values and beliefs because they lie at the heart of our being. Shaping our development and activities, they anchor us in times of uncertainty.

The Dandelion Transformation Project has been guided by our core belief that each person is endowed with the innate gift of creativity. Throughout the project, we strived to ignite the spark of creativity within each participant by providing opportunities for personal expression and innovation. We encouraged teamwork and cultivated harmony throughout the process.

Looking back, our core belief not only helped us to structure our five-year long program, it served as the constant reminder of the meaning and purpose of our work.

Needs

We often think of needs as deficits, something negative and unwelcomed, but needs help to root us in a particular place, time, and community. They keep us humble through our vulnerability, and this offers opportunities to build relationships, trust, and to engage in meaningful collaborations.

At Dandelion, the need to cultivate a whole person in each and every student through education helped the school to search for innovative methodology. It provided the openness for the unusual Dandelion Transformation Project to take place. The realization of the project, as the result of responding to needs did lead the school community to the discovery of its inner strengths, such as imagination and innovation. It also helped Dandelion in attracting external resources, such as its partnerships with a venture capitalist in Beijing and Parsons The New School for Design in New York.

Vision

Whenever we start a project, it is important to have a vision, which provides us with a sense of direction. Vision inspires and gives hope.

Our vision for the Dandelion project was a transformed environment of beauty, creativity, and joy. We intended that the project would bring about significant and beneficial changes physically, emotionally, and mentally in the Dandelion community.

Five years after the launching of the project, we celebrated the transformed environment of the school; we witnessed the emotional and mental growth of the school community in its increased self-confidence, ability to find solutions to problems, and a permeating sense of joy on campus.

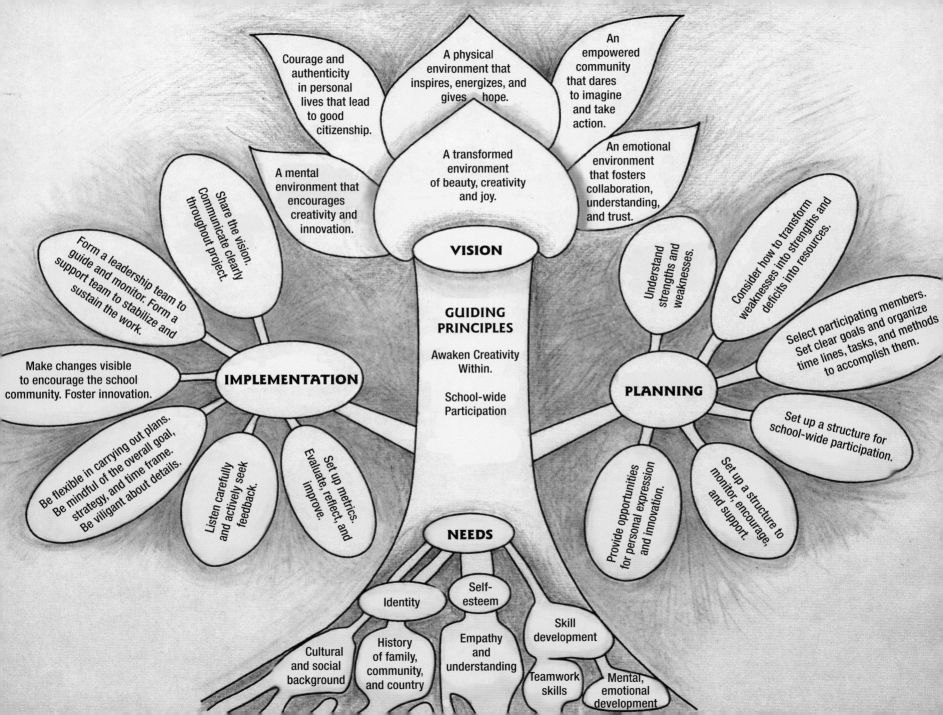

Planning

Planning allows the participants to identify the strengths and weaknesses within themselves and their situations. It provides the project with a structure, which allows the work to evolve with a sense of order and clarity. Planning is all the more important when the project is complex and endowed with multiple dimensions and activities.

The success of "The Tree of Problems and The Tree of Life" project demonstrated the importance of planning. Planning gave order to the multiple ideas that emerged during the teachers' brainstorming session and gave structure to its school-wide execution.

Implementation

Implementation brings the project into existence. It requires adaptability, for circumstances often change. We must be generous and inclusive, but at the same time we must also attend to our values and beliefs. Improper compromises will eventually deprive us of our dreams. We must also be meticulous in execution, for quality expresses sincerity and respect, and quality lies in the details.

Among the six items listed in the chart in the Implementation group, I would like to emphasize the importance of two points—making changes visible and setting up metrics for evaluation. The goal of visible change is to energize the participants by making the transformation concrete and observable. The goal of evaluation metrics is to provide participants a measurement of accomplishment and the opportunity to improve the next endeavor.

In the end, it helps to know that organic design is more a journey than a fixed action plan. Taking on the shape of a tree with its roots, branches, and floral crown, Dandelion Transformation Project's organic design process symbolically indicates the implicitness of change. Unfolding in time, like a tree, the design adapts according to opportunities, place, and other factors. In this way, the basic structure also expresses the process of its growth and renewal.

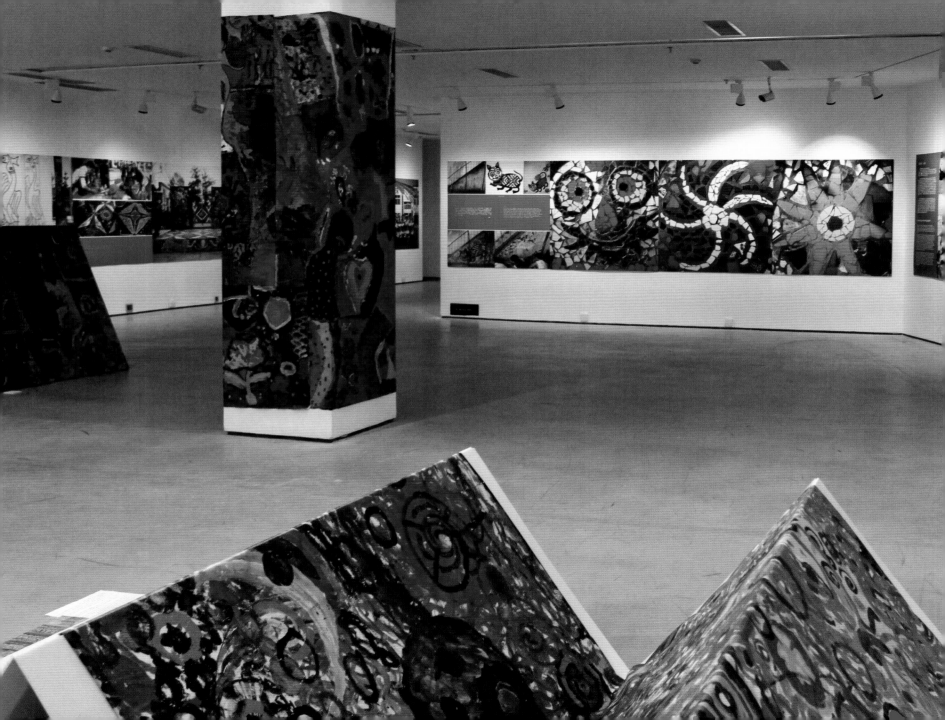

Afterword

In mid June of 2010, I returned to Beijing to complete two projects: to edit the Chinese version of this book, *Awakening Creativity,* and to help Dandelion School mount an exhibition at the Today Art Museum.

The translation of my book was carried out by the English teachers and some of the best students in the school. What a brilliant idea and so befitting of this school! Through the process, they grasped and preserved the intention and evolution of the project for the Dandelion community of now and the future. As China's urban centers all over the country continue to expand, it is only a matter of time until old buildings and infrastructures give way to the new. There is already talk about the relocation of the school because Dandelion stands right on the side of the main road, which is slated for expansion in the future development of Shou Bao Zhuang. In this light, the translation of the book seems all the more important for the preservation of Dandelion's creativity and daring action. Thus its future teachers and students, wherever they may be, will be empowered to know that they have the imagination and the ability.

Remembering the humbleness of the first show in the makeshift room on Dandelion campus, I felt excited about the upcoming exhibition in the Today Art Museum, a prestigious art space located in the posh business section of Beijing. But the process of setting up the exhibition caught me by surprise in every way.

To begin with, even though I was supposed to play a leading role in mounting the exhibition, I missed the planning meeting due to miscommunication. So, some important decisions were made without my involvement. The planning committee hired a young designer, Feng Xiao Dong, a recent graduate of the Central Institute of Fine Arts, to design the exhibition. They required that the exhibition consist of themes that have been explored in this book. Zhao Jing, the main organizer of the exhibition wrote the text for the show, mostly quoting from the translated text of my book. Luo Zhen, a national authority on children's art education and an experienced curator functioned as the chief adviser of the exhibition.

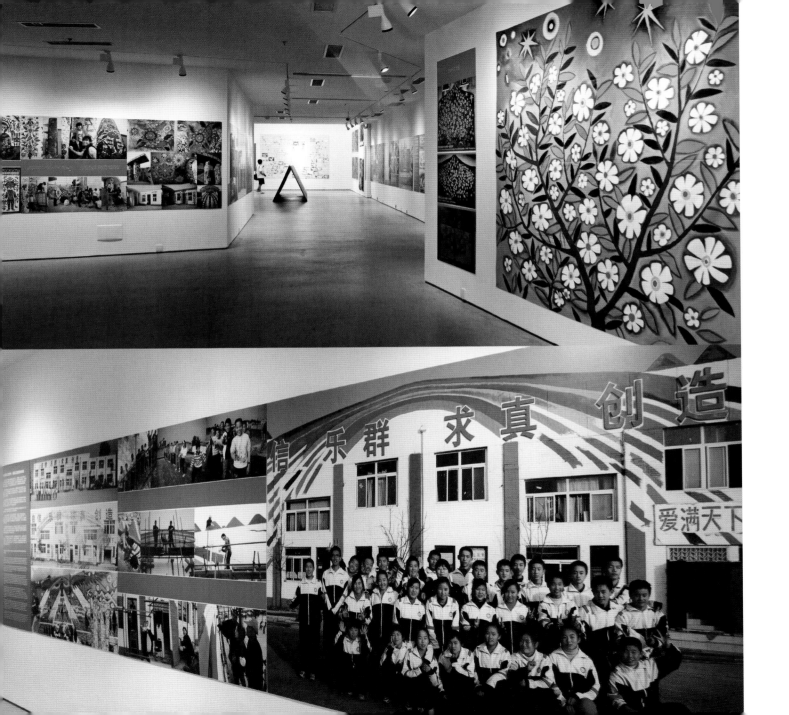

200

By the time we all got together, there were only three days until the mounting of the show. I was worried and at a loss. How could the display of a four-year project be entrusted to a young man who hardly knew it? In addition, needing to attend to his full time job during the day, he could only design for us in the evening.

The explanation text also posed a problem. The words were taken directly from my book and, being written in the first person, would not serve well in the context of an exhibition. Once I got over my anxiety about the time factor, I was able to explain to Zhao Jing the problem. Remaining calm, professional, and confident throughout, she assured me that the explanatory text would be done in the correct manner.

I was also anxious about the quality of the photos in the exhibition. I knew Dandelion School could not afford the printing cost of thirty-some four-foot-high photos. And, besides, there was no time to do fine photo printing. What was their solution, I wondered?

Another challenge was that we were not allowed to experiment with our exhibition concepts in real space until the day before the opening. In others words, we had one day to put up the exhibition. The concept, the display panels, and the art objects had to all be in place to meet the one-day timeline in mounting the exhibition.

The last thing that bothered me was that the exhibition would last only three days. By the time we opened the show, we needed to get ready to close it. Why so short, and should we even bother?

In the first three exhibitions that I had at Dandelion, I was in full control of the content and the design of the displays. The feeling of not being in control and having so many questions in my mind certainly unsettled me. But since I was already there and a part of the exhibition team, I offered help to the best of my ability on the themes, sequence of the display, and the text. The team worked tirelessly day and night to get everything ready. And they did get everything ready. The images were created through offset printing, which proved to be affordable, speedy in production, and appropriate for the purpose of the show. The Today Art Museum has an excellent exhibition staff that mounted the show with proficiency. After

accepting the design job two weeks prior, Feng Xiao Dong had been working hard to grasp the essence of the exhibition. His ability to generate three-dimensional designs on the computer proved to be life saving. It helped us to understand the scale, the placement of things in space, and their interrelationships.

I also found out the reason for the three-day schedule. Since the Today Art Museum is a nonprofit organization, for its own survival it asks the exhibitors to carry the cost of their own exhibitions. From time to time the museum provides free space to benefit nonprofit organizations. At the beginning of July, it had a five-day open time window, July 1st to 5th, in which it offered to host Dandelion's exhibition. This time frame included one day to mount, one day to dismount, and three days for the display. I was fortunate to be able to participate during my visit. In addition, it was powerful and moving to know that the funds supporting this exhibition had been raised by many dedicated teachers, who mobilized their colleagues, friends, and family members to make this possible.

I left when my work was done, but the rest of the exhibition team and school staff worked late into the night.

At ten o'clock the next morning, I came back to be at the opening. I was full of apprehension. Was the installation completed? Were all things in good order? The minute I stepped into the reception area, I felt energy and excitement emanating from the gallery spaces, which were already filled with guests and students. People were clearly stimulated by the vivid photos and the large, colorful panels on the wall. There were interactive sculptures, the Tree of Problems and the Tree of Life. As photo images on the wall, they stood in space carrying their messages on their leaves and fruits. Fascinated, many a child tried to reach and touch them.

Most surprising were the large twenty-foot-long canvases created in the Painting Big, Painting Together workshops. Presented in their new three-dimensional format at Luo Zhen's suggestion, they came to life spilling colors and energy into the exhibition space. It was then I realized how old-fashioned I was in my thinking and ways of doing things. The feeling of not being in control made me

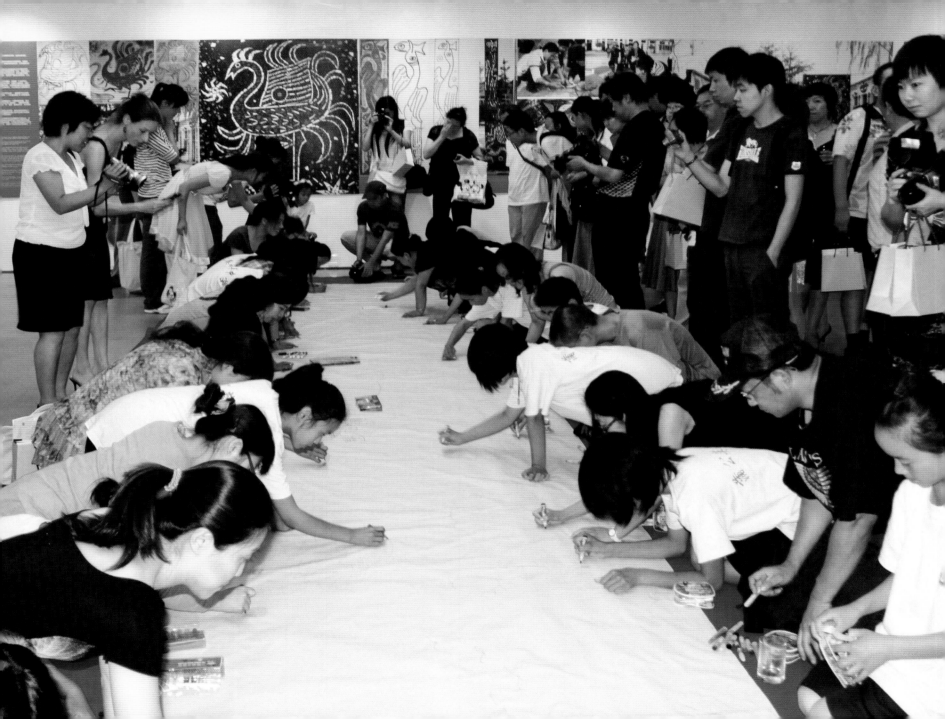

panic sometimes. But at that moment, I realized the power of team-work and the wonder of letting go.

Amidst so many memorable moments in that marvelous day, two came to the fore. When the students, who had been tutored by the volunteer professors from the Central Academy of Music in Beijing, played Bach's Chaconne in front of the bold mosaic patterns of the cat, flowers, and stars, the audience was moved to a hushed silence. The occasion bore witness to how beauty, art, and creativity were transforming young lives.

And when the Dandelion students invited their guests, hand-in-hand, to create a vision for the future of their beloved school on a rolled out canvas on the floor, I realized that these students have the confidence to reach out, imagine, and make their voices heard through collaboration and action. Although these students face more than their fair share of predicaments, the school is doing its best to prepare them physically, mentally, and emotionally to lead imaginative, caring, and wholesome lives.

Dandelion staff and volunteers promoted the event successfully. Reporters from seventeen prominent newspapers and magazines attended, and several articles appeared shortly after the exhibition. The business community showed strong support by sponsoring crafts production, and providing catering, gifts, and prizes at the exhibition.

People's responses were heartwarming. Many came to the opening in the morning and stayed on till the end of my presentation at five o'clock in the afternoon. Some wrote comments:

"This is a great project for the heart and spirit."

"A powerful and deeply moving documentary exhibition!
I see hope.
I see beauty of the spirit.
I feel life force moving.
I wish very much to see more of this (kind of art)
in more spaces, so more people will understand."

My original intention in launching the Dandelion Project was not only to transform the school and its community, but also to create a ripple in society that would call attention to the importance and the power of art in education, our lives, and society at large. I feel that through the exhibition we have thrown a rock into the pond, sending ripples through people's minds and hearts in ever-expanding circles.

Zheng Hong mentioned in our recent conversation that the prestigious Parsons The New School for Design in New York is part-nering with Dandelion School for the purpose of helping Dandelion develop its unique and culturally rich craftwares. Parsons plans to send selected senior students to live on the Dandelion campus for several weeks to understand its core values and aesthetics. These students will then focus their graduating thesis on product design for Dandelion. Through the talent and creativity of the graduating students, Parsons will help Dandelion create a line of products that are rooted in the Chinese culture and at the same time infused with contemporary energy and sensitivity.

Dandelion School will be able to market these unique and high quality craftwares. The sale of these products can help financially stabilize Dandelion, a courageous institution that dares to place creativity, ethics, and excellence at the center of its education.

Above Lovely image of a spiral amidst stars bathed in shafts of colorful lights. This detail from one of the very large paintings created by students in 2007 is the basis for my recent painting *Right* depicting the ripple effect of the Dandelion School Transformation Project.

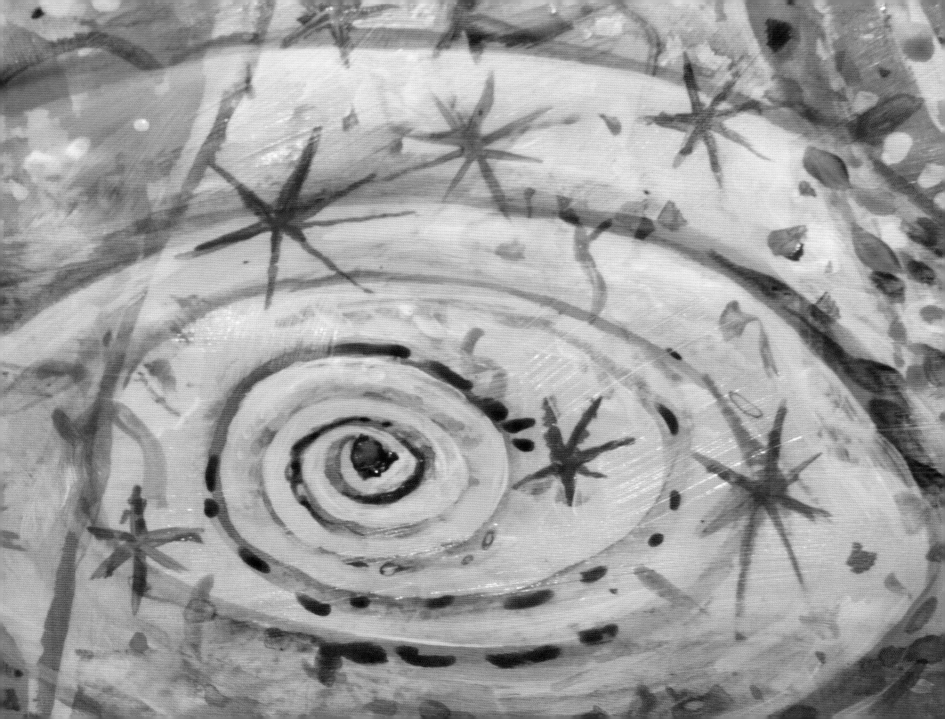

Acknowledgments

I am deeply grateful to the following people and organizations for their help and support in realizing the Dandelion Transformation Project:

Principal Zheng Hong, whose insight, courage, leadership, and support made this project possible.

ArtVenture (now ArtAction) and New Path Foundation provided generous sponsorships that launched and sustained the Dandelion School Transformation Project for a period of five years. World Education also supported some of our activities.

My father Kei Gao Yeh, for his unconditional love which gives me the sense of deep-rootedness in life.

My brothers Raymond, Hsiang Tao, Randy, and sister Lulu for their understanding of my work and years of unwavering support, which made it possible for me to pursue what my heart believes.

Barefoot Artists, through which I carried out this project.

Art teachers Fu Tao and Pei Guang Rei for their collaboration, documentation, and innovative ideas.

Duan Xiao Lin, whose dedication to the project and passion for art helped to make this transformation program a success.

Sandy Chou, whose skill in organizing activities and analytical thinking brought order and clarity to our work.

Huang Yong Song provided photos of Ku Shu Lan and her work. His two-volume book, Ku Shu Lan, enlightened me and anchored the artistic sensibility of the project.

He Yun Lan, for her guidance and deep friendship; her leadership in Women's Art in China and her promotion of art for children broadened my horizon.

X. R. Yong, for his years of encouragement and understanding and his deep love and knowledge of Chinese folk art, which reconnected me to my own cultural heritage.

Isaiah Zagar, for teaching me the art of mosaics some twenty years ago. I have benefitted ever since.

I am especially appreciative of all of the Dandelion teachers, students, and staff for their collaboration and joyful participation. The memory of the time spent together at Dandelion warms my heart and increases my confidence that art and cooperation can change our world for the better.

Additionally, I am truly grateful to several people whose guidance and encouragement were essential in the development of this book:

Susan Viguers, for coaching me in the process of writing the book and editing the manuscript. Her encouragement bestowed me with strength and her gentle steering gave me a clear sense of direction.

Lynne Elizabeth, whose patience and encouragement restored my confidence in moments of doubt and whose guidance and commitment made the publication of this book a reality.

Laurie Churchman, for taking on the design of the book in her very busy international work schedule, and for her extraordinary artistic sensitivity and expertise.

Kelly Brooks Tannen, for her keen observation, excellent advice, and continuous support for my writing and work.

Stefania DePetris, for her exceptional skill fine-tuning the text.

Ingrid Chang, for her generosity and her acumen correcting the color and clarity of many photos.

Elizabeth Murray, for her gentle guidance and the inspiration from the beauty of her books.

My brother Raymond Yeh, for sharing with me his knowledge of community and leadership building, and for his invaluable suggestions to my writing.

My son Daniel Traub, for his many fine photos in the book and his understanding and support of my work over the years.

Lily Yeh

Artist, Activist, and Founding Director, Barefoot Artists, Inc.

From 1986 to 2004, Lily Yeh served as the co-founder, executive and artistic director of The Village of Arts and Humanities in Philadelphia, a non-profit organization with the mission to build community through art, learning, land transformation and economic development. Under her leadership of eighteen years, a summer park-building project developed into an organization with twenty full-time and part-time employees, hundreds of volunteers, and a $1.3 million budget. The Village became a multi-faceted community building organization with activities such as after-school and weekend programs, ecological land restoration, housing renovation, theater, and economic development initiatives. The center works on local, national, and international projects, and is a leading model of community revitalizations throughout the country.

Lily's vision has rippled out far beyond North Philadelphia's borders. She inspires and collaborates with prison inmates to create beauty and art, and does the same with thousands of adults and children who live in some of the world's most broken communities. She has collaborated with residents of the Korogocho slum near Nairobi to transform a barren churchyard through murals and sculptures and traveled to Ghana, Ecuador, the Ivory Coast and the Republic of Georgia to work on similar projects. Her most recent endeavors include the Rwanda Healing Project in Rwanda and the Dandelion Transformation Project in Beijing in which she worked with hundreds of children and adults in the respective community to transform their bleak environment into a place of beauty and joy.

Born in China, Lily immigrated to the United States in the early 1960s to attend the University of Pennsylvania's Graduate School of Fine Arts. A successful painter and professor at University of the Arts in Philadelphia, Lily traveled to Beijing in 1989 to show her work at the Central Institute of Fine Art. There, she witnessed the tragic events of Tiananmen Square. These momentous happenings made Lily realize the meaning of her own life and that being an artist "is not just about making art...it is about delivering the vision one is given...and about doing the right thing without sparing oneself." She continues pursuing her vision through her new organization, Barefoot Artists, Inc., which teaches residents and artists in devastated communities around the world how to use the transformative power of art to bring healing, self-empowerment, and social change.

Photography Credits

All other photographs, except for those on page 20, were taken by Lily Yeh.

Page 24: Daniel Traub (bottom)
Page 45: Daniel Traub
Page 51: Daniel Traub
Page 78: Fu Tao of Dandelion School
Page 82: Fu Tao (right)
Page 85: Echo Press (upper left)
Page 86: Alejandro Lopez
Page 95: Yannis Koïka
Page 101: Fu Tao (left)
Page 104: Fu Tao
Page 106: Huang Yong Song, Echo Press (lower right)
Page 107: Huang Yong Song, Echo Press (left)
Page 108-9: Huang Yong Song, Echo Press
Page 117: Echo Press (far right)
Page 118: Huang Yong Song, Echo Press
Page 128: Fu Tao (top)
Page 136: Daniel Traub
Page 144-5: The Yellow Earth Plateau,
 Mothers' Art, courtesy of Echo Press
Page 152: Daniel Traub
Page 167: Fu Tao (bottom)
Page 175: Daniel Traub (bottom)
Page 178: Daniel Traub
Page 180: Fu Tao
Page 183: Fu Tao
Page 186: Ji Ping Chang (middle)
Page 187: Ji Ping Chang (right)
Page 202: Courtesy of Today Art Museum, Beijing
Page 207: Duan Xiao Lin

This book was brought to you by New Village Press, the first publisher to serve the field of community building. Communities are the cauldron for social change, and the healthiest changes rise from the grassroots. Our books focus on creative, collaborative works—good news and inspiring tools for growth.

If you liked *Awakening Creativity*, we recommend the following New Village titles.

Books featuring the work of Lily Yeh in North Philadelphia:

Works of Heart: Building Village through the Arts
 edited by Lynne Elizabeth and Suzanne Young
Beginner's Guide to Community-Based Arts
 by Mat Schwarzman, Keith Knight, Ellen Forney and others

More books about community-based arts and the metamorphosis of schools and other shared environments:

Asphalt to Ecosystems: Design Ideas for Schoolyard Transformation
 by Sharon Gamson Danks
Building Commons and Community
 by Karl Linn
Arts for Change: Teaching Outside the Frame
 by Beverly Naidus
Art and Upheaval: Artists on the World's Frontlines
 by William Cleveland
New Creative Community: The Art of Cultural Development
 by Arlene Goldbard

See what else we publish: www.newvillagepress.net